JOURNEY THROUGH
JAPAN

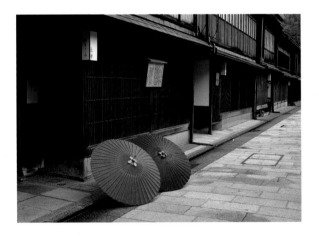

Photographs by Keystone/Keyphotos Japan
Text by Hans H. Krüger

TUTTLE PUBLISHING
Boston • Rutland, Vermont • Tokyo

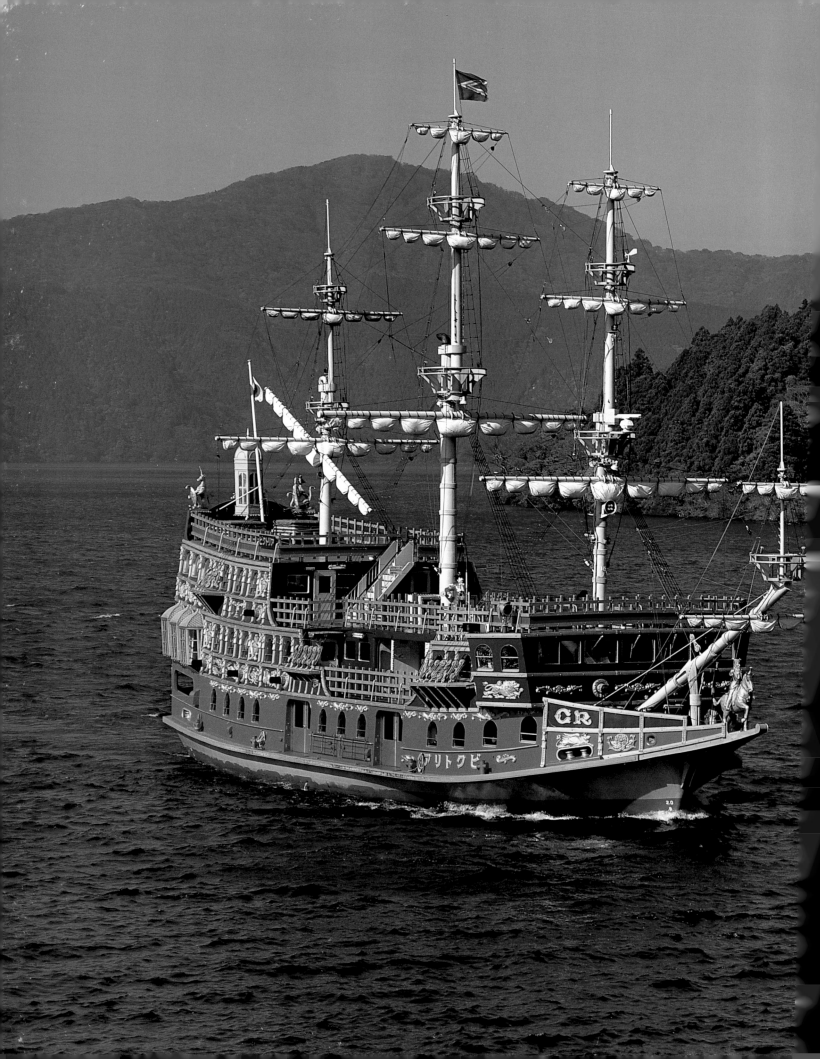

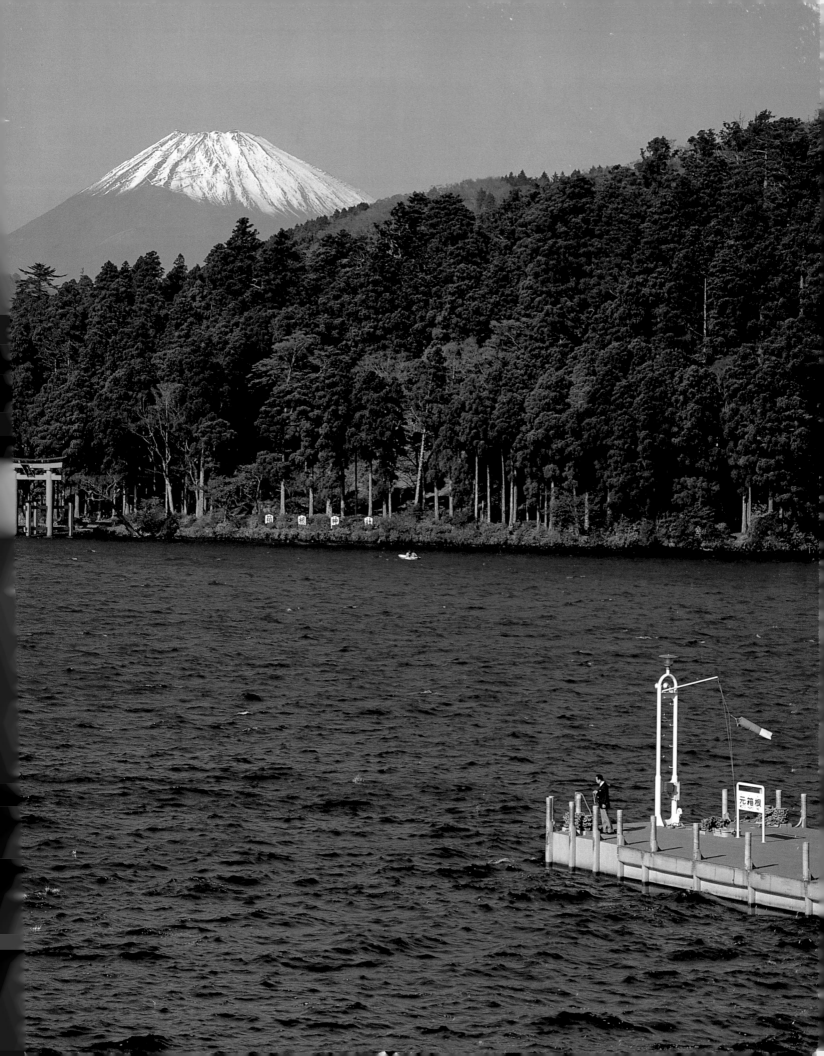

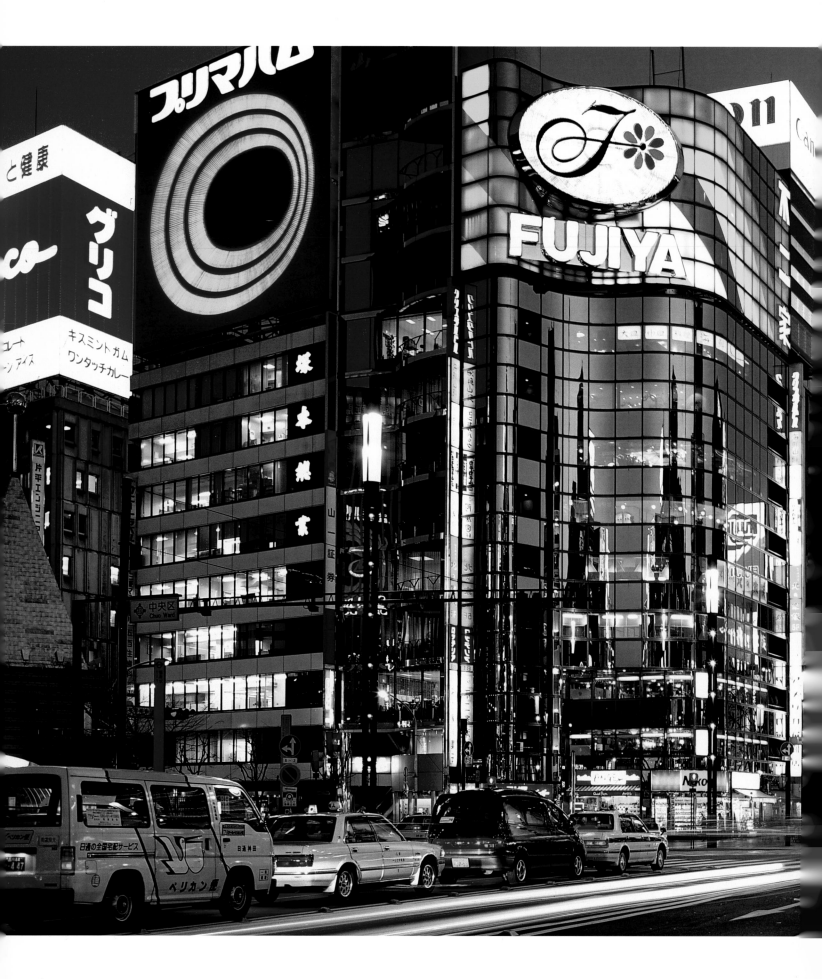

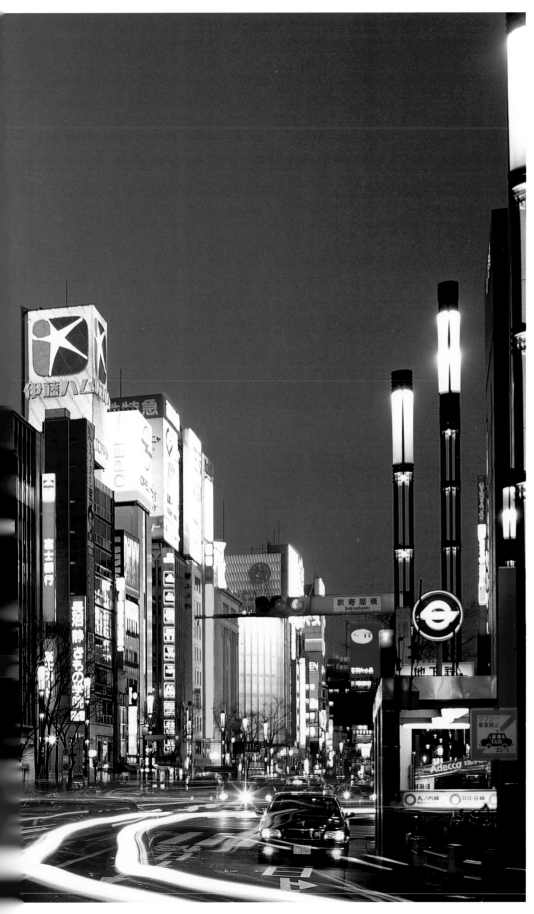

CONTENTS

Title page: The past lives on: colorful bamboo umbrellas before a traditional tea shop in Kanazawa.
Previous page: View of Mount Fuji with its crown of snow: This brightly-colored replica of a Spanish galleon glides along Ashino Lake near Hakone.
Left: A landing stage for Western culture and one of the most expensive shopping streets in the world: The Ginza in Tokyo at-tracts shoppers with its varied, glittering façades.
Next page: Because of its more than 1,000 bridges, Osaka once was called "the Venice of the East." Today this castle is the only reminder of its one-time splendor. The present building, erected in 1931, is a reconstruction of the original of 1586.

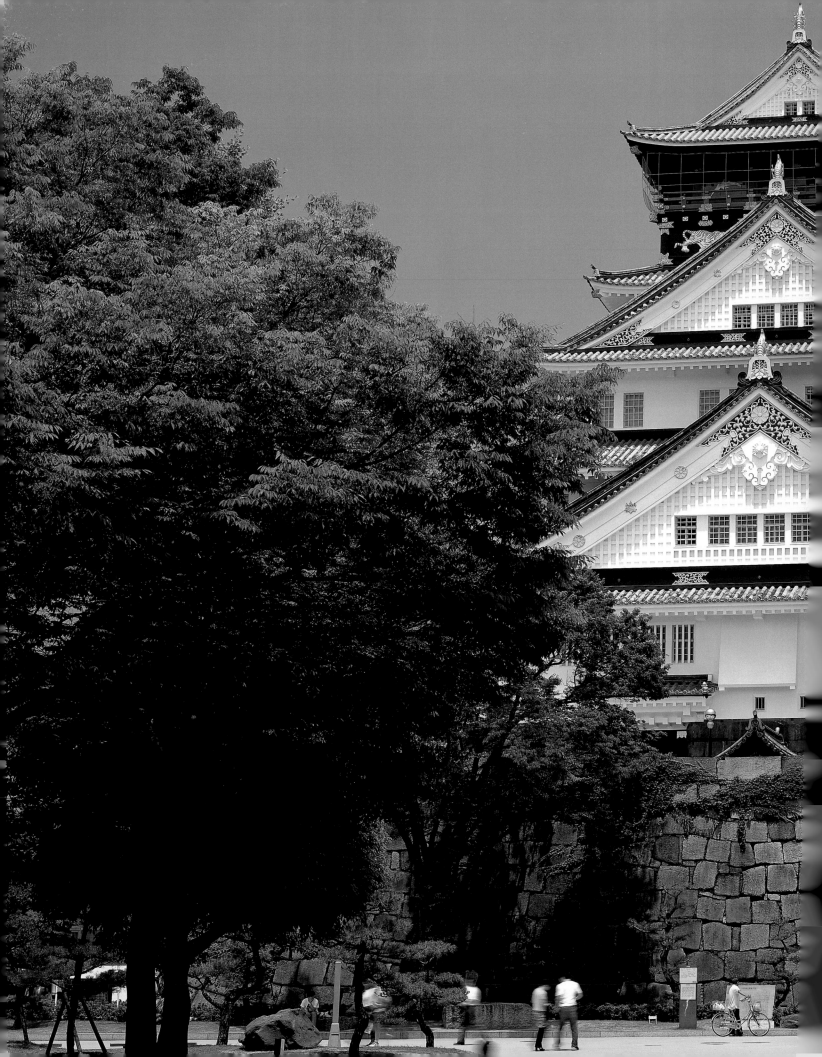

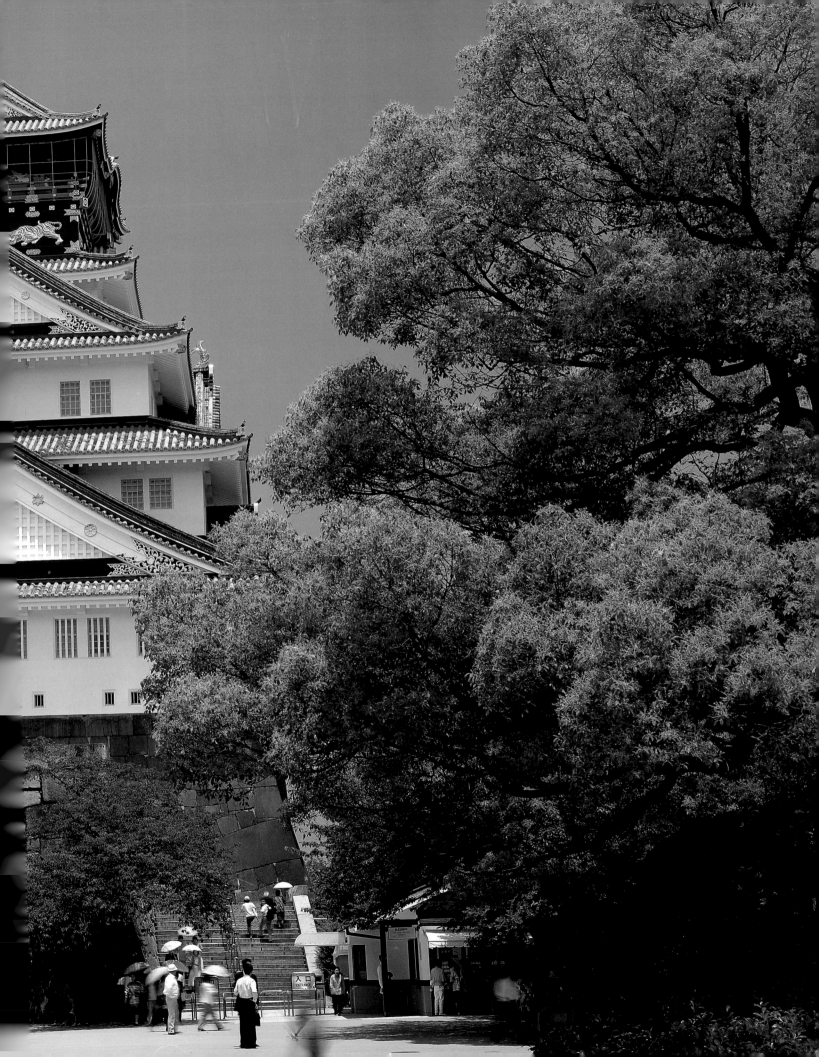

ELUSIVE JAPAN
A Nation of Myth and History

Japan sometimes seems less a reality than an illusion, hiding itself elaborately behind its clichés: employees crowding into packed subways, geishas tripping through alleys of flowering cherry trees, Zen monks observing the growth of cliffs, workers dying from *karo-shi*, or "death through overwork." None of these clichés is completely true, yet none is wholly false.

In Japanese, the land is called Nippon or Nihon, which means "The Origin of the Sun." According to Japanese mythology, the god Izanagi thrust his bejeweled staff into the ocean. When he pulled it out and shook it, 3,325 drops of water fell into the sea, creating the Japanese islands. Until 1945, when Japan lost the Second World War and the Japanese emperor his divinity, the 11th of February, 600 BC was understood as the beginning of Japanese history. On that date the Emperor Jimmu, as the successor to the sun goddess Amaterasu, laid the foundations for the Japanese empire and its ruling dynasty. The current emperor Akihito is held to be that dynasty's 125th successor.

Myths do not encapsulate historical truths; they represent the hopes of the present. In modern Japan, symbols and ceremonies still are seen as important pillars of the state. The past lives on in tea ceremonies and ikebana, in grand temple celebrations and joyful public festivals. Gods are carried through the streets in shrines, huge drums beat out ancient rhythms, participants and spectators transform into sweating, boisterous crowds. For several hours paradise returns—yesterday and today become one.

The simplest aspect of Japan to explain is its geographic situation. Japan is a group of almost 7,000 islands off the eastern coast of Asia. These extend from the northeast to the southwest over a distance of approximately 4,000 kilometers. The largest islands are Honshu, Hokkaido, Kyushu, Shikoku and Okinawa.

Because of its immense expanse, Japan lies in three climate zones: subarctic, temperate and subtropical. The islands are located in a geologically unstable region. Approximately 60 of their

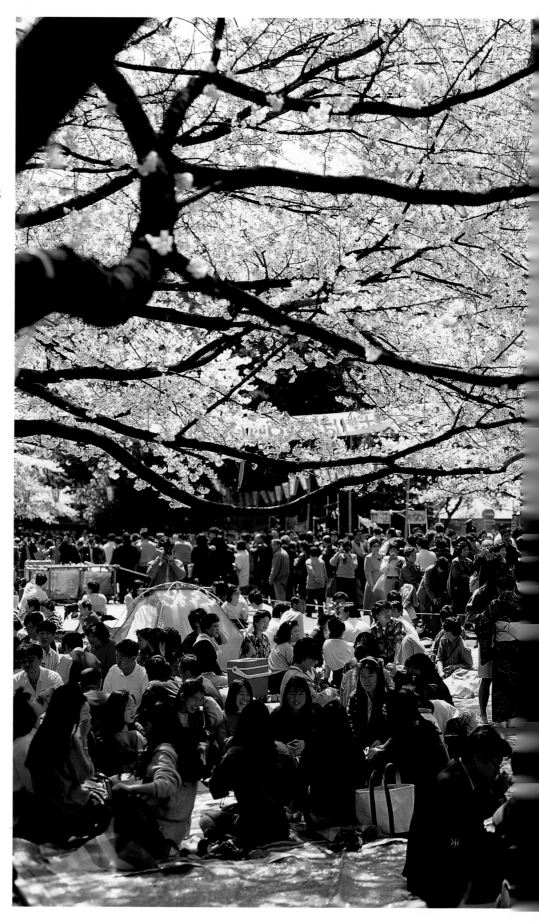

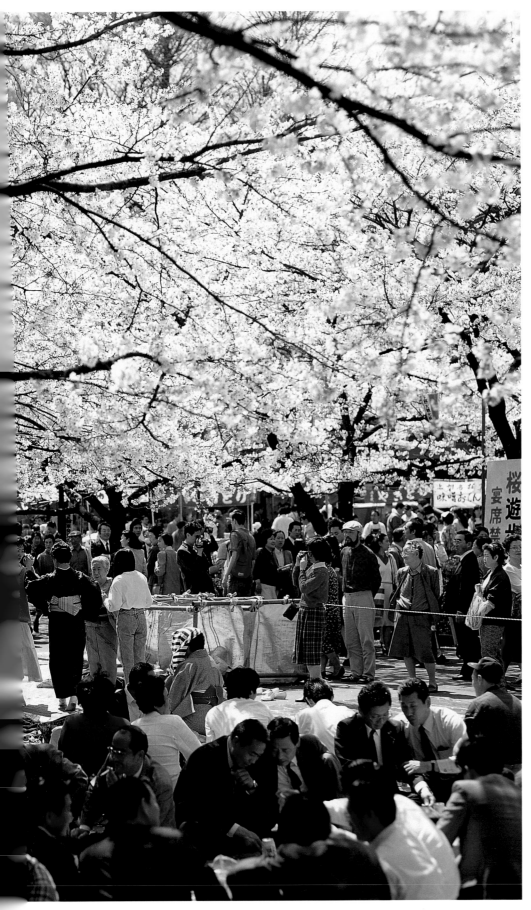

186 volcanoes are still active. Every year, up to 1,200 earthquakes are registered. The last great catastrophe took place on January 17, 1995 in the port city of Kobe, when more than 600 people died in a major earthquake.

Japan is somewhat larger than Germany and has 126 million residents. Almost 80 percent of the land surface is mountainous; people, industry and agriculture are crowded into the remaining 20 percent.

Tokyo-Yokohama-Chiba and Kobe-Osaka-Kyoto, the metropolitan clusters on the Pacific coast, are the epicenters and incubators of Asian popular culture: superficial pop music and the latest in fashions, playful software and the newest in traffic-control techniques. Every trend established here is copied from Seoul to Bangkok.

From here, too, consumer goods and ideas eventually spread throughout the developed world: Walkman, Discman, Tamagotchi, karaoke, fat sumo wrestlers and low-calorie sushi. Only those who can still remember lament the loss of innocence. Fashion designer Issey Miyake says: "Once Japan was wonderful, because it was not a rich country."

Japan Closes its Doors

Above all, one historical factor still leaves its stamp on Japanese society—its voluntary departure from the rest of the world. Around 1600, at the beginning of the Tokugawa shogunate, Japan cut itself off from all outside influences. European missionaries, who were largely active in Kyushu, were expelled or executed, and uprisings by Japanese Christians were suppressed bloodily.

A wall of silence enclosed the island world. Those who tried to leave the country were punished by death, and no foreigner was allowed to set foot in Japan. The only exception was the port city of Nagasaki on the southern island of Kyushu. Beginning in 1641, a Dutch trading center was set up on its tiny, scattered island of Dejima—196 meters long and 65 meters wide—while in the city's Shinchi district Chinese and Korean merchants were allowed to operate. The rest of

It is cherry-blossom time. In Tokyo's Ueno Park people sit on blue plastic sheets, eat, drink and sing karaoke, then suffer the next day from hangovers. The park with the cherry-tree hill (Sakuragaoka) was first opened to the public in 1878.

the country, however, was as removed from the outside world as the dark side of the moon. If knowledge is corrupting, then an entire people was living in a state of innocence.

Japanese society was a solidly built pyramid, in which every person had his place. At the top were the sword-bearing samurai, followed by farmers, then by craftsmen and artists and finally—at the very bottom—by merchants. By 1853, when four black American steamships (the "black fleet") arrived in Tokyo's harbor, the Tokugawa dynasty had ruled with its back to the world for approximately 250 years. The American fleet's commander, Admiral Matthew Perry, had received orders from President Fillmore to force Japan to negotiate a trade agreement with the United States. The thunder of cannon and the demonstration of Western technological and scientific expertise put an end to Japanese feudal rule, eventually leading to the reestablishment of the empire and the opening of the nation to the outside world. When Perry returned to the United States in 1854, the Kanagawa treaty had been signed by representatives of both countries, opening the ports of Shimoda and Hakodate to American ships. Trade agreements with Russia, England, Holland, France and Prussia followed.

Under the slogan "Japanese soul, Western technology," a simple agricultural country with strong social and moral ties set itself on the path to becoming a world power. It also demonstrated its new strength militarily, occupying Taiwan (1874), winning the Sino-Japanese War (1894-1895), destroying the czarist fleet during the Russo-Japanese War (1904-1905), annexing Korea (1910) and occupying Manchuria (1931-1933). Fusty militarism and overrated self-confidence led to the attack on Pearl Harbor in December 1941 and thus to the outbreak of the Pacific war.

After a series of spectacular early victories by the imperial army, the allies achieved the upper hand. In August 1945, American atomic bombs fell on Hiroshima and Nagasaki. At noon on August 15th, Emperor Hirohito announced Japan's capitulation over the radio, speaking in archaic idioms that few of his subjects understood. His high voice, recorded the day before, interrupted work in the entire country: "... how else will we be able to save our millions of subjects or to justify ourselves to the holy spirits of our ancestors." Most Japanese were struck dumb

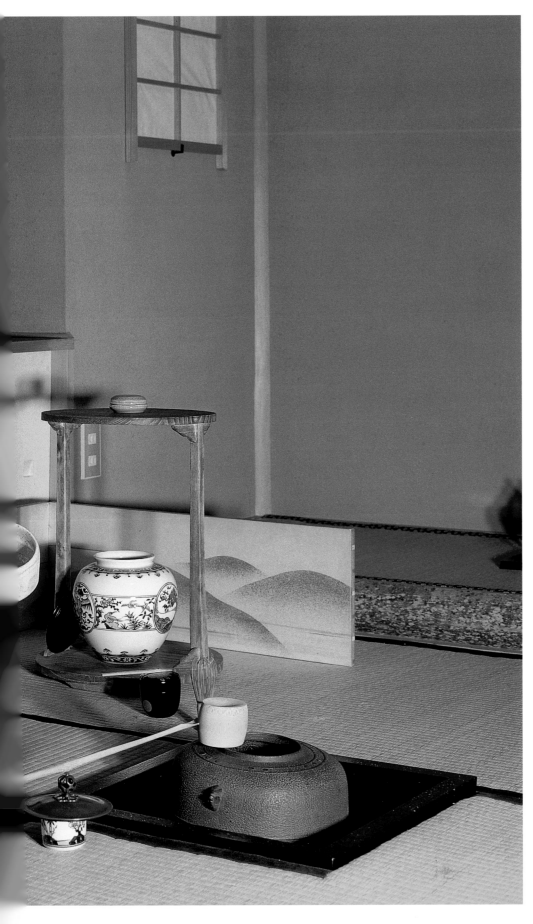

with amazement. Not only had God spoken to them for the first time, but He had revealed that He was mortal.

The Japanese Economic Miracle

Defeat was followed by occupation, a new constitution, democratization and reconstruction. As in Germany, Japan also experienced an extraordinary economic revival. Unlike in Germany, however, the country strenuously avoided facing the dark side of its history. The Japanese way of overcoming the past has combined a victim's mentality with systematic repression.

The country lives on contradictions and contrasts. Japan has the second-largest political economy in the world and yet appears to doubt its success. "Rich nation, poor people," its residents scoff. Although one of its major religions, Buddhism, focuses on renunciation, Japan also is a country of unrestrained consumerism. It imported philosophy and text characters from China, art and ceramics from Korea, new technologies and clothing from the West yet still believes in its own uniqueness. Instead of rewarding creativity, it rewards the willingness to work hard.

It admires beauty yet nonchalantly disfigures nature. It speaks of the importance of internationalism but cannot teach its schoolchildren English. It exports products rather than ideas.

Despite or even because of these contradictions and flaws, Japan exerts an extraordinary fascination on outsiders. It is the most Westernized country in Asia yet still retains its own identity. In Japan materialism and spiritualism, gaudiness and simplicity, noise and silence intermingle, forming an exquisite dreamlike creation. Japan is less a reality than an illusion.

The preparation, serving and drinking of tea is viewed as a high art form in Japan. The tea ceremony is called Cha no Yu in Japanese, which means "Hot Water for the Tea."

Welcome to Tokyo

The morning caws of crows; the chiming of bells at zebra crossings; twittering voices over relentless loudspeaker systems in department stores and railroad stations, issuing constant instructions not to leave anything behind, to watch out or to stand to the left on escalators; unbendingly efficient taxi- and bus drivers; a faceless army of employees; jerky bows from the hip: Welcome to Tokyo.

We stand in the middle of all this—bleary-eyed, dazed, confused. The Japanese are at home, while we are only present. They are inside, but we find ourselves on the outside.

The world may be a global village, yet Tokyo exists beyond time. As Wim Wenders once put it: "Living in Tokyo is like living in someone else's dream." At first the nightmares predominate: pushing, shoving, exhaust fumes, noise. Greater Tokyo is made up of 23 administrative districts, 26 towns, three rural districts, seven islands. The city has 11.8 million residents. During the daytime commuters from surrounding areas bring the number to above 15 million. In a radius of 50 kilometers around the emperor's palace live more than 32 million Japanese. Beginning at 8:30 in the morning, one meets hundreds of thousands of them in the Yamamote line, the railroad line encircling Tokyo—2,400 passengers per train, with trains arriving every two minutes. A passenger on one of the packed train cars who inadvertently steps on another's toe apologies Japanese-fashion: "Suimasen".

A Fascinating Maze

Tokyo means "eastern capital." "Eastern" refers to its geographical relation to Beijing, China, once the Japanese world's focal point—the center of culture and beginning of everything. Edo, as Tokyo originally was called, was planned according to the ideas of Shogun Ieyasu Tokugawa. This warrior prince, who lived from 1542 to 1616, oversaw the building of a labyrinth of streets and alleys intended to confuse invaders. Modern Tokyo still reflects its mazelike origins. Straight boulevards and streets are the exception, winding lines and curves the rule. Even below the ground, destinations are reached only in roundabout ways. Tokyo's first subway, the 14.3-kilometer-long Ginza Line, which opened in 1927, doubles back on itself like a hare chased by hunters. From the Shibuya neighborhood it travels first in a

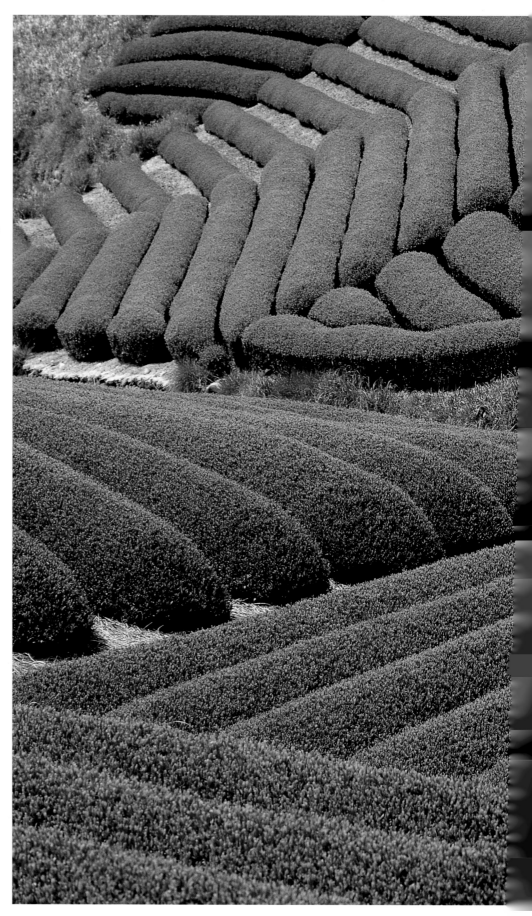

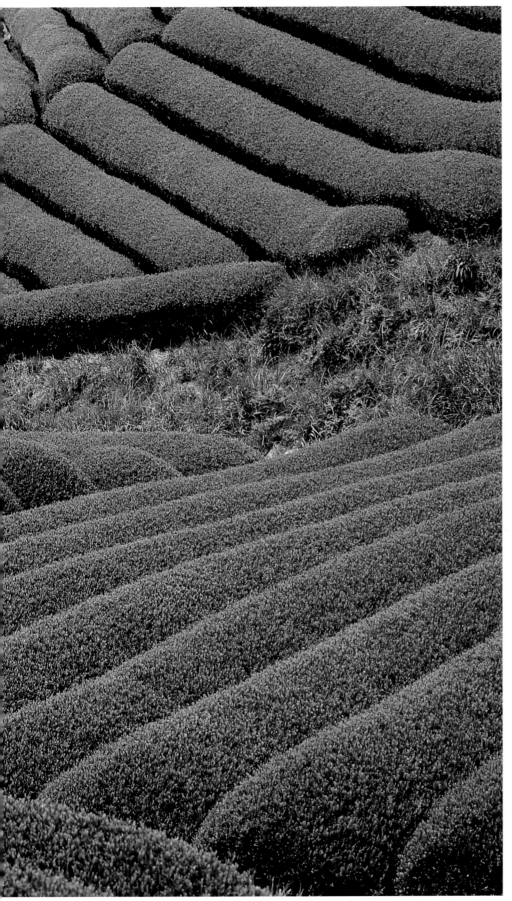

northeasterly direction, then bends to the southwest, winds around the emperor's palace, then heads north to end in Ueno.

Western visitors to Tokyo are simultaneously puzzled and fascinated by the ways the Japanese capital is completely opposite to European cities. Metropolises like Paris, Vienna or Madrid are homogeneous, monolithic structures, stamped by more or less uniform architectural styles. In Europe, architecture is an expression of history and identity. Distinctions are made between closed spaces (buildings) and open spaces (parks). Hosts of bureaucrats dedicate themselves to the preservation of antique monuments, while building regulations dictate the height of floors, the color of paints, the proper materials to be used. Europeans live in museums, whose displays lay claim to eternity.

Tokyo, on the other hand, is a jumble of settlements positively luxuriating in their lack of cohesion or uniformity. This was evident even in the early 1930s, when the German Kurt Singer went to Tokyo. Singer wrote: "The first days and weeks in the capital city are a source of oppressive sorrow for educated admirers of the country. The anarchic coexistence of differing architectural and clothing styles, traffic customs and ways of thinking—all these assault the outsider like a nightmare." In the 1980s the Japanese novelist Abe Kobo described Tokyo as a "limitless number of villages. These villages and their inhabitants all appear identical. No matter how far you walk, you remain where you began. And wherever you are in Tokyo, you get lost."

Streets have public functions; railway stations are arteries through which the masses flow. There is nothing in Tokyo to which the eye can cling. The whole city seems like a video clip—a series of disjointed images, dismembered plot threads, artificial activities. Only those who can shut out reality avoid being carried away in a flood of impressions. Local people use superficial post-modern terms to attempt to explain the unexplainable. City planners speak of "anti-hierarchical growth." Architects attempt to apply chaos theory from the worlds of mathematics and physics to the city. Since there is no center to

A tea plantation in the Shizuoka Prefecture. Green tea, *o-cha* in Japanese, is the most popular daily drink in Japan. At a tea ceremony, it is prepared following a strict set of rules.

Tokyo, everything is peripheral. No other metropolis illustrates so precisely the features of a city for the new millennium: volatility, transience, a constant change of face.

White and Black Swans

Where, then, lies the mystical Japan of our imagination and clichés? It is hidden behind thick, hewn stones: the emperor's palace in central Tokyo. Located on more than a million square meters of prime city property, it is the spiritual heart of the nation. No subway line cuts through the holy ground; no helicopter is allowed to fly through its airspace. It is an island of stillness in the midst of big-city noise.

White swans—a gift of the now-deceased German chancellor Konrad Adenauer—swim back and forth in the palace moat (the black swans come from Australia). Behind a curtain of walls and pine trees lives Emperor Akihito. His residence bears the old-fashioned name Fukiage-Gosho, which can be translated as "Breath-exalting, Elevating Abode." In the springtime he plants the first rice in the palace's own rice field—a spiritual act. Only on his birthday (December 23rd) and for the New Year festival (January 1st) are the gates opened to the people. The palace gardens' broad gravel paths, on the other hand, are a center of attraction year-round. Joggers make their rounds, groups of visitors hurry from somewhere to nowhere. Below the two bridges leading to the main entrance (known therefore as Niju-bashi or "Twin Bridge"), photographers wait to snap pictures of school classes visiting from the provinces. The pupils wear the black navy uniforms of imperial Germany.

Tokyo's other main tourist attractions are a remarkable hodgepodge of old and new. One example is the 243.4-meter-high twin towers of Shinjuku's town hall. The Tokyo Metropolitan Government Office, as it is officially called, cost approximately 600 million euros to build. From the towers' observation platforms (both on the 45th floor) one has a splendid view of the metropolis. Another attraction is Akihabara, the electronics capital of the world. Here are more than 340 shops selling computers, technical amusements and entertainment electronics. Then there is "Tokyo Disneyland," where one pays an entry fee equivalent to almost 100 euros to visit a perfected version of the American original. Mickey Mouse looks like Mickey Mouse, but

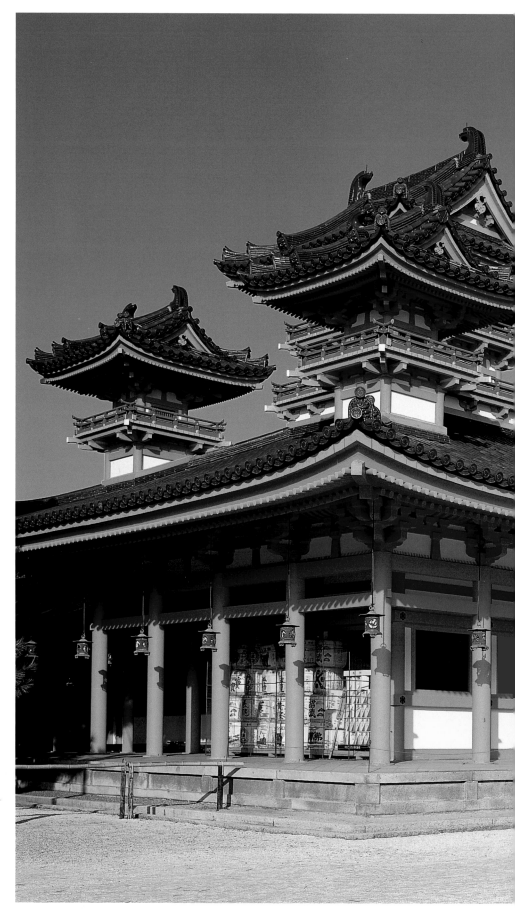

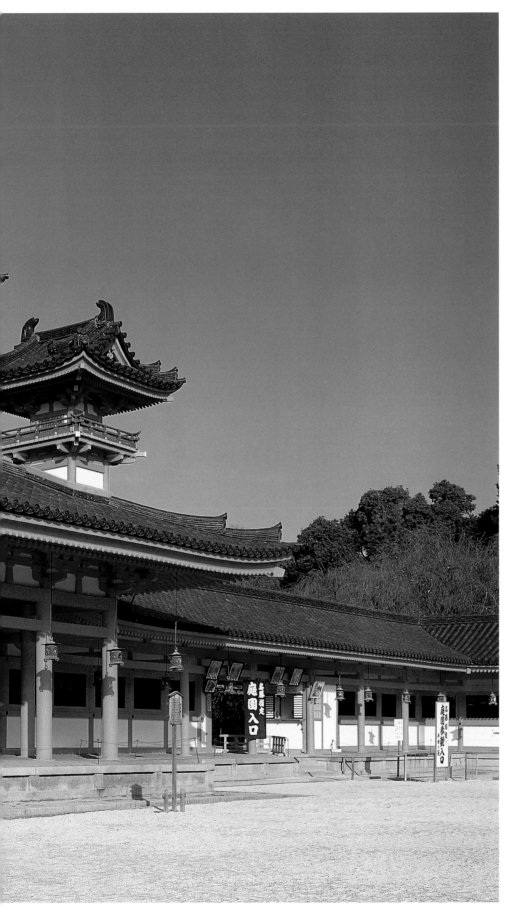

he squeaks "Irriashimase," the Japanese for "You are cordially welcome."

Fashion and art can be found on the Ginza, Tokyo's most expensive shopping mile and the landing stage for Western culture since the turn of the last century. On this elegant street appeared the first French-style cafés, dance halls and beer restaurants, cabarets and nightclubs, department stores and galleries. Here, for once, Tokyo is geometrical: up to the Shinbashi railway station the street is divided into eight blocks. Left of the station lie the eight blocks of West Ginza, to the right the eight blocks of East Ginza. In this area are found such famous shopping temples as Matsuya, Matsuzakaya, Mitsukoshi and Louis Vuitton. Cars are forbidden on Sundays, turning the six-lane Ginza into the liveliest pedestrian zone in the world, with black heads of hair as far as the eye can see. In some cafés a cup of tea costs the equivalent of 20 euros and a tiny slice of Viennese-style chocolate cake seven.

In the Asakusa-Kannon temple district, visitors can discover Tokyo's past. At the turn of the 20th century, Asakusa was Tokyo's red-light district, with shady dives and disreputable theaters. Today one walks through the "Gate of the Thunder God," then along a narrow street to the main temple to burn fake money in iron basins, ignite sticks of incense and call on the gods for help.

Modern Savages and Restless Nomads

Ethnologists might call Tokyo's inhabitants tribes or modern savages. According to the architect Toyo Ito, the city's residents are restless nomads: "They no longer live in solid houses but in continually changing ,identity points of the city." One of these booming deserts is Shibuya, located north of the railway station. This playground for young people is a jumble of narrow alleys, a whining cluster of restaurants, cafés, karaoke bars, second-hand stores, game halls, boutiques, discos, nightclubs, fast-food chains, beer halls and cabarets. On the weekends it is practically impenetrable. A compact mass of pleasure-seeking students and office workers streams out of the subway pits. News items and advertisements flicker across huge billboards. The air smells of exhaust fumes and fried squid. Nothing is free;

Red columns, curved roofs and the crunch of gravel under one's feet: The Heian Shrine in Kyoto was built in 1895 to commemorate the city's 1,100th birthday.

15

everything costs money. Telephone boxes are stuffed with brochures from one-hour hotels, telephone-sex purveyors and the most bombastic promises of supposedly underage hostesses. Elegant characters—the aesthetic formulas of the allegedly spiritual East—decorate purple-colored calling cards. In reality these are advertisements for shops that sell used pants to teenagers.

A Place to Disappear

There are cities to which one flees in order to get lost. Tokyo provides the perfect example. Here people appear and disappear—Chinese assistant cooks, Australian English teachers, Filipino bargirls. In Tokyo Iranian telephone-card thieves, Israeli street vendors and American stockbrokers vanish into thin air. This Moloch swallows even natives.

Some years ago in my neighborhood in the Sangen-Jaya district, a member of the Japanese terrorist Red Army Faction was arrested. He had concealed himself for more than ten years in the neighborhood's anonymous tangle of buildings. Nobody knew him, no one appeared to have noticed him, almost no person could remember him at all. He was a modern-day Trotsky, reappearing to everyone's surprise from the darkness of oblivion.

Sangen-Jaya means "Three Tea Houses." It appears neither in travel books nor in works of reference. It is a subway station on the Shin-Tamagawa line, another piece in Tokyo's puzzle of throwaway architecture—a mixed residential and business neighborhood with box-shaped apartments bearing fanciful names like "Hollywood Highs" or "London Tower." The six-lane Tamagawa Avenue, over which runs a two-storied high street, slices brutally through Sangen-Jaya. At nighttime rowdy youths buzz through the narrow canyons between the houses on motorcycles without exhausts.

In my neighborhood are a lumberyard, a storage space for tatami mats, numerous dry cleaners, a car-repair shop, grocery stores and restaurants. It is only a three-minute walk to the next supermarket, which is open 24 hours a day. Most alleys are so narrow that they can only be used as one-way streets. The seasons can be read on plastic ornaments decorating the shopping areas: green shrubs in spring, fake autumn leaves beginning in October. Rarely does one glimpse a star. The sky is an image of the city in which

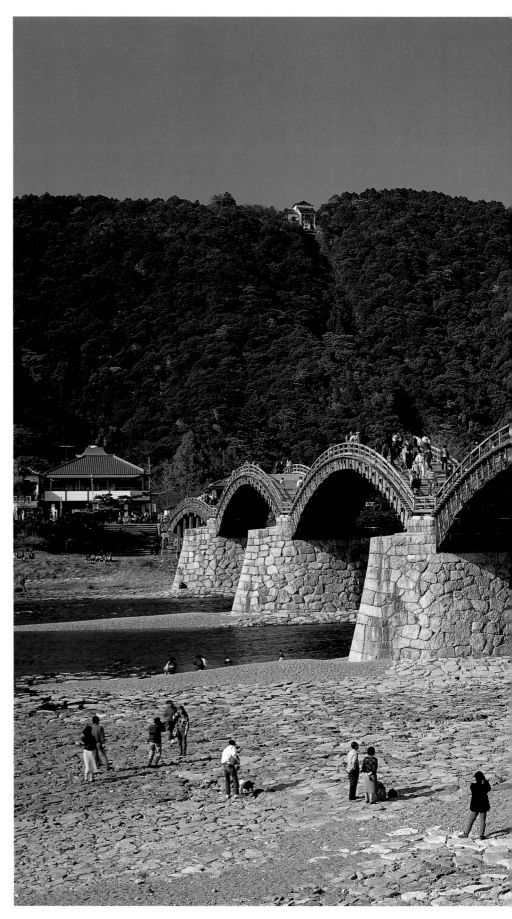

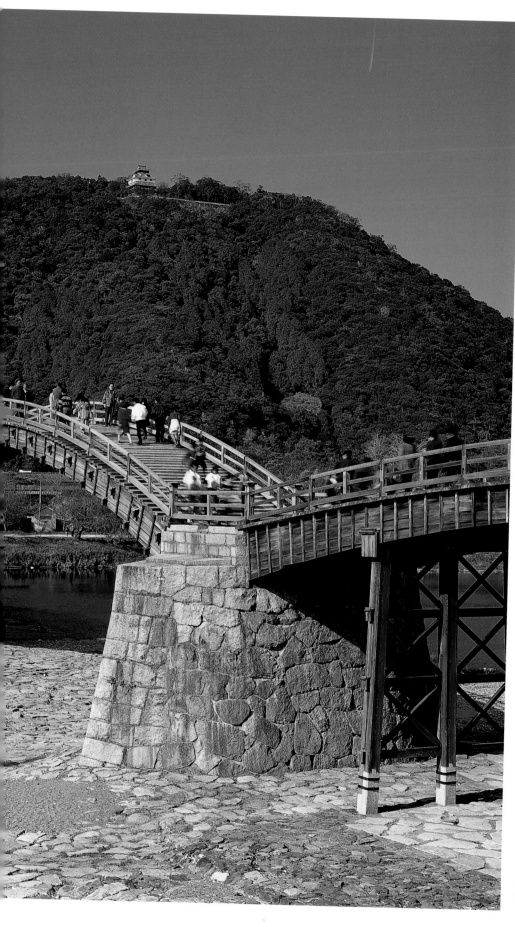

neon advertising signs are reflected. Those who look upward in Tokyo see not the eternity of the universe but themselves.

Sangen-Jaya is a microcosm of Tokyo itself. The sensible newcomer submits himself to the initiation rites of another culture. A stranger here is not captured but absorbed. After a few weeks the temporary guest possesses his social fixed points—favorite pubs, a supermarket, a café. He knows the drugstore owners and greets the garrulous Kenyan who works in the railroad-station boutique. He knows that the best white bread can be found in a bakery called "Mutter Lisa" and that the owner of the Chinese restaurant once studied geography at Tokyo University. He learns that Tokyo is no paradise but an ordered chaos: the garbage collection works, water runs, electricity comes out of wall sockets and the next subway arrives in at most three minutes. Someone who lives long enough in the metropolis becomes accustomed to its rhythm, a rhythm combining acceleration, immobility and vitality.

Outside the sliding doors made of aluminum, jackhammers clatter, buildings vanish and new high-rises spring up. Yet at some point one no longer notices the ugliness but instead admires the functionality. For those who wish to be intoxicated with the beauty of big world capitals, there are always maps of Paris.

Left: The old Kintai Bridge in the small town of Iwakuni on the main island of Honshu. Such arched bridges were not built for vehicles; in the past, people or animals carried all burdens.

Next page: Consumerism dictates: In Tokyo's district of Shibuya, skyscrapers are covered with gigantic advertising billboards.

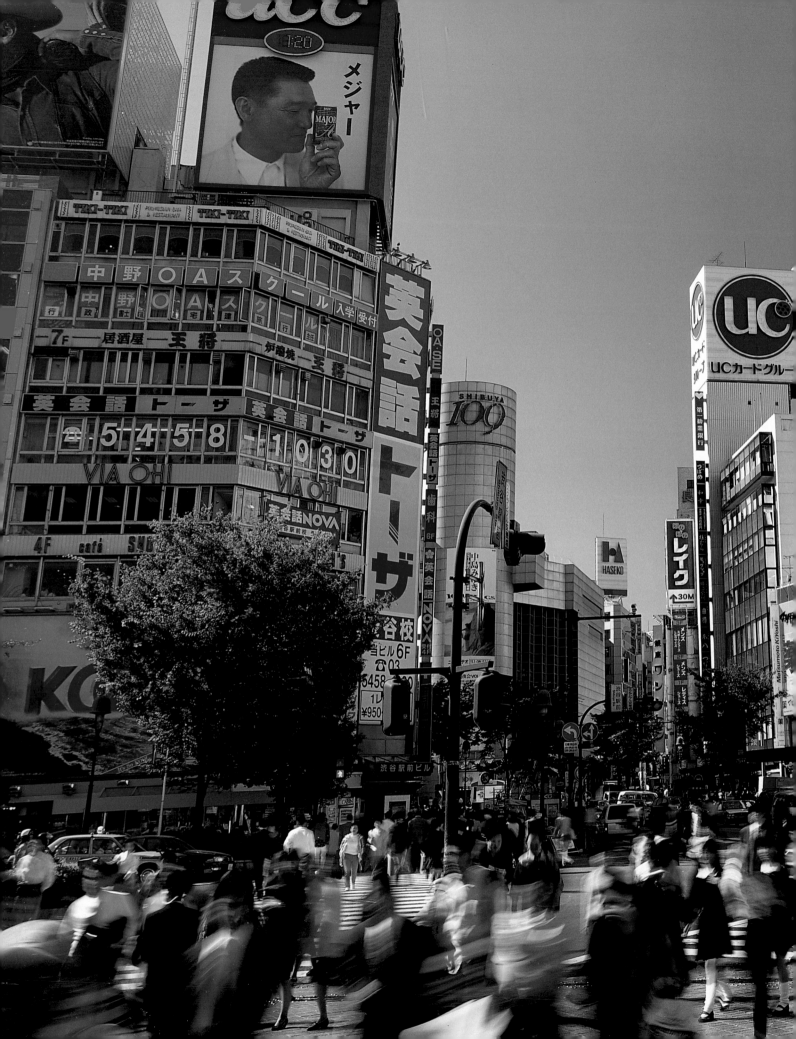

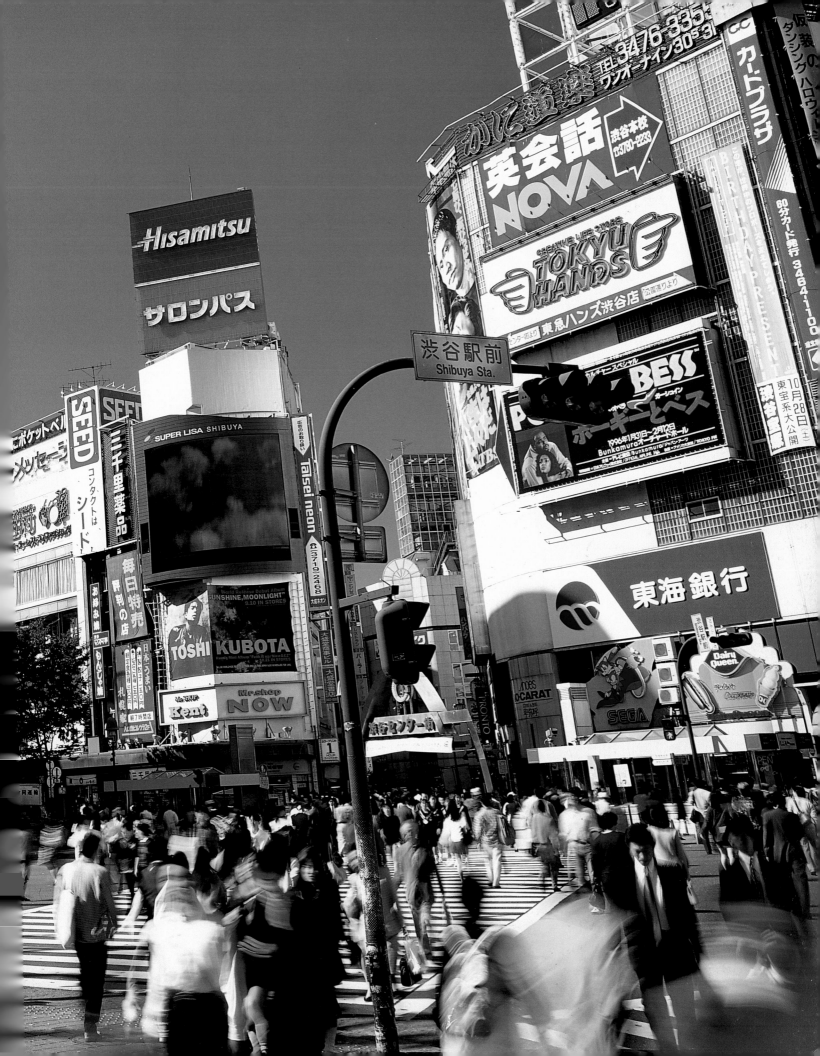

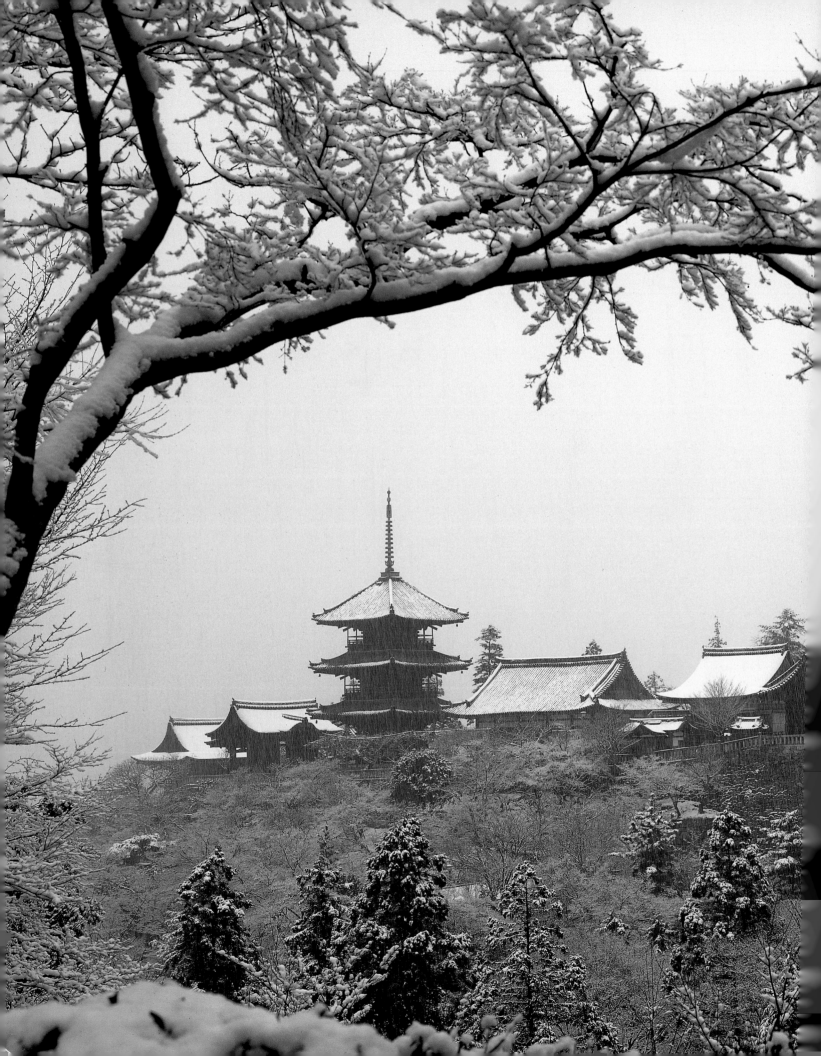

HOKKAIDO
Japan's Idyllic Northern Paradise

Nothing is as it should be. Here are no familiar chessboards of rice fields, no expanding cityscapes, no cherry-blossom trees. Instead there are lonely farmhouses, whose large barns remind one of American farms, and broad fields planted with potatoes, corn or oats. Black and white Holsteins graze in green meadows. An empty sky stretches above.

Until the 18th century, Ezo, as Hokkaido was then called, was a borderland, a strange terrain inhabited by hairy natives and bears, an area beyond the imaginations of most Japanese. The winters were long and hard. With the Ainu, the native people, there was a small amount of trade in skins, furs and eagle feathers. Only in 1896 did the government in Tokyo name a "commission for [the island's] colonization." American cartographers surveyed the unknown area for the first time. Ezo then received a new name: Hokkaido, or "northern sea province."

Even today Hokkaido symbolizes the other Japan—an idyll of woods, volcanoes and crater lakes, of untouched landscapes like the Shikotsu-Toya and Daisetsuzan national parks, of such famous bathing places as Noboribetsu and picturesque fishing villages like Abashiri on the icy Sea of Okhotsk. The city of Sapporo is an unusual mélange of East and West. Founded in 1871, the island metropolis is a grid of wide, tree-lined boulevards. During the first week of February, Sapporo's Odori Park plays host to the famous snow festival. Palaces and sculptures made of snow and ice attract hundreds of thousands of visitors. In the summer people enjoy drinking beer and listening to music from brass bands. It was in Sapporo that the first Japanese brewery was founded.

Previous page: Snow falling on cedars: The enormous Kiyomizu Temple complex in northeastern Kyoto, which dates to 798, is considered to be part of the world's cultural heritage.
Right: This is Jizo-bosatsu, the Buddhist god who guards pregnant women, children and travelers. The little stone figure is often seen on roadsides.

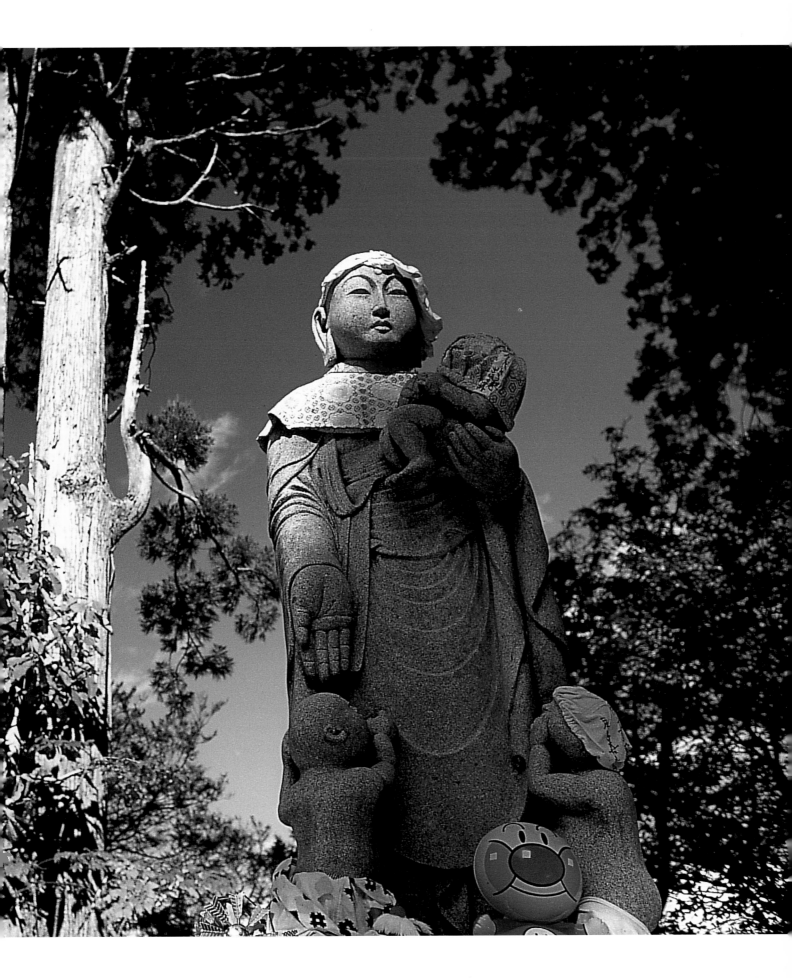

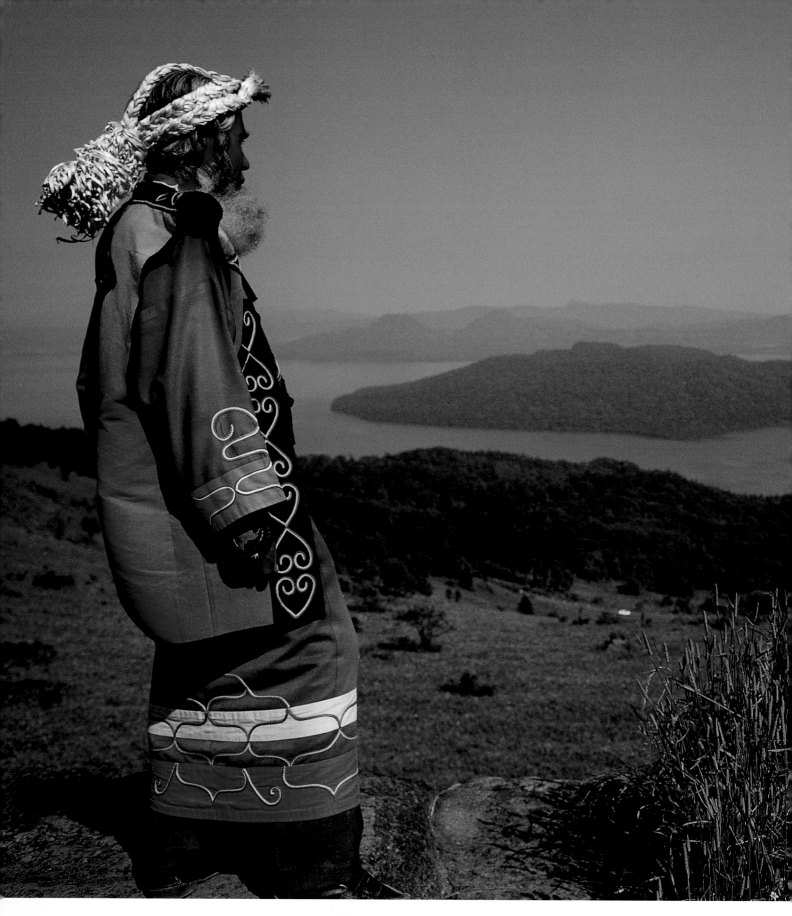

Above: A member of the Ainu tribe, the aboriginal people of Japan, on the Kussharo Lake in northeastern Hokkaido. Today the Ainu's traditional clothing is rarely worn.
Opposite, top: On his back a snow paddle, in his right hand a spear: Matsuji Suzuki is a fifth-generation bear hunter.

Opposite, middle: The translation of sake as "rice wine" is misleading, because sake is brewed, not pressed. This worker is using a wooden pole to stir fermented rice in a va
Opposite, bottom: Thoroughbred breeder Mr. Morita and an oil painting of his best mare, "Sunshine."

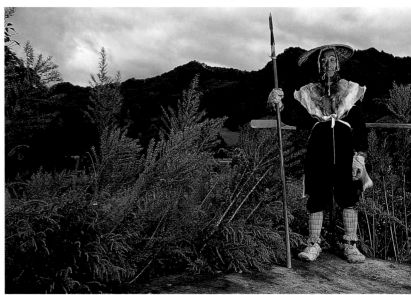

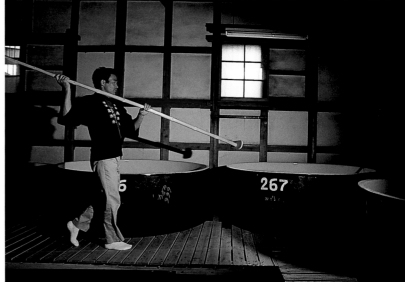

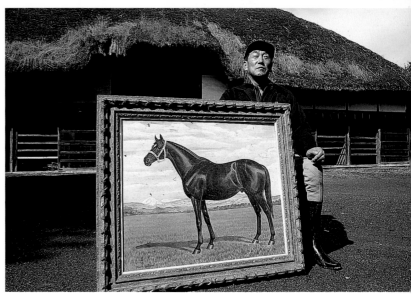

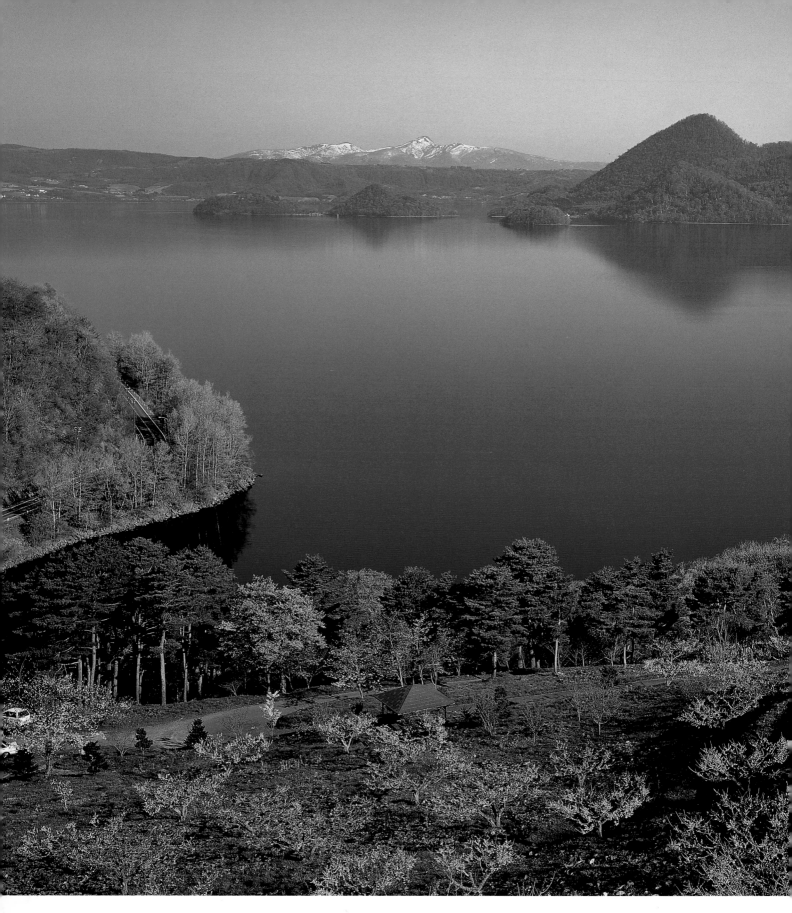

Above: A place for rest and relaxation: Lakes, woods and mountains characterize the landscape of Hokkaido, the northernmost of Japan's four main islands.
Opposite, top: The stunning autumn colors of Japan are reflected in the still waters of Oneto lake.

Opposite, middle: Steam, heat and sulfur deposits: Noboribetsu on the southern coast of Hokkaido is the largest thermal bath on the island.
Opposite, bottom: A pause on a long flight: cranes on a frozen Akan Lake. The birds come from Siberia to spend the winter.

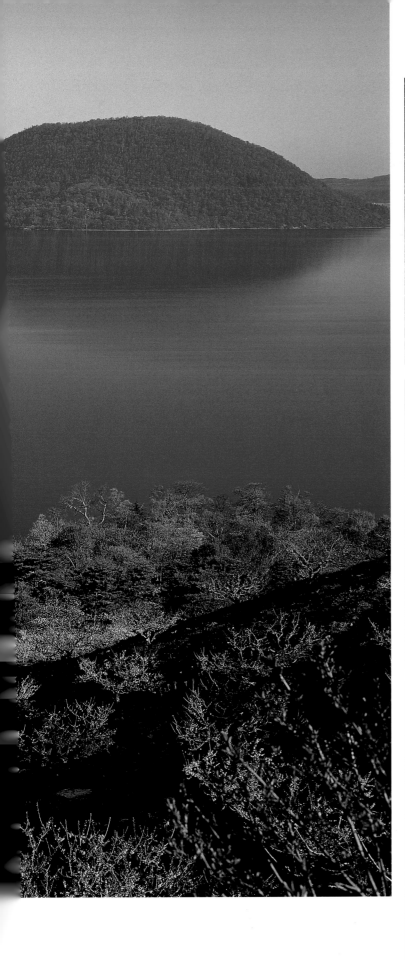

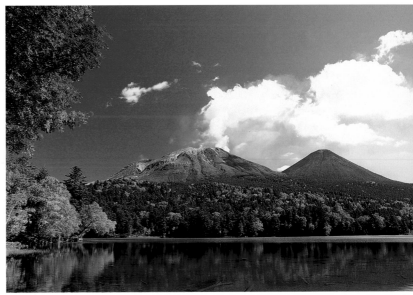

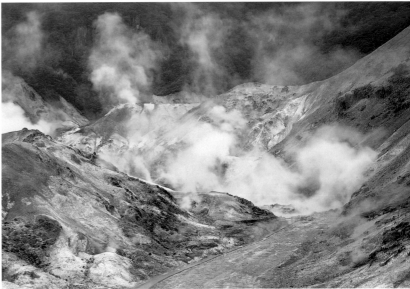

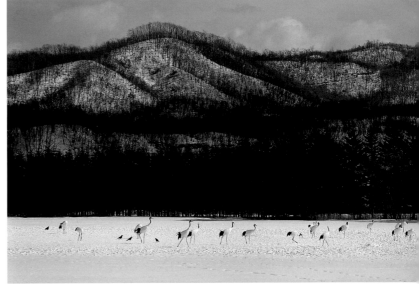

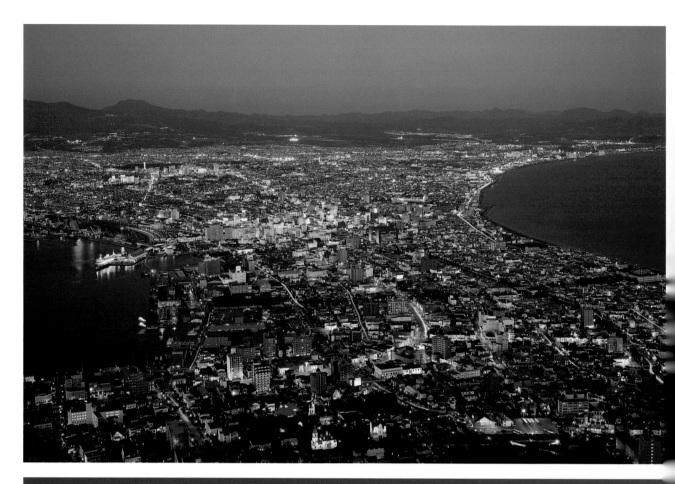

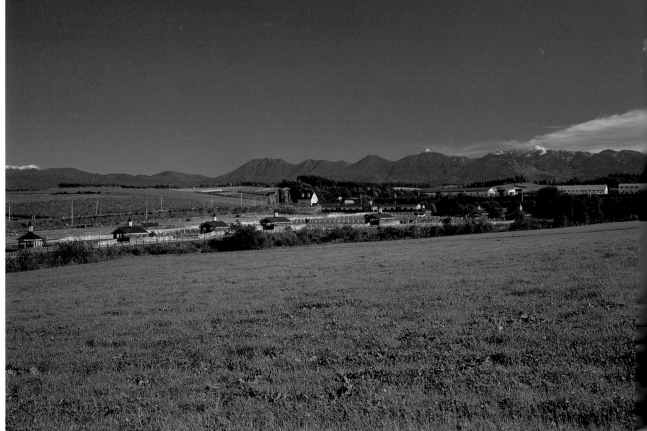

Top: Evening over Hakodate. The first settlers came in the 13th century. Today the city's lights are testament to its modernity.

Right: The small town of Biei lies in the exact middle of Hokkaido. Nearby are the Tokachi-Dake Mountains with the 2,077-meter volcano Tokachi, which last erupted in 1962.

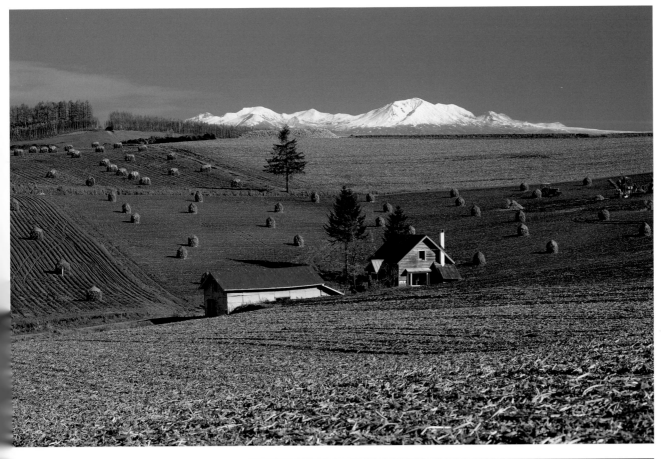

Top: Like a picture out of America: a farm still life on the island of Hokkaido, complete with wooden house, barn and haystacks against a backdrop of snow-covered mountains.
Left: Japanese impressions: Rainbow colors illuminate fields of flowers near Furano.
Next page: Siberia lies beyond the horizon: The lighthouse of Kamui-Misaki on Hokkaido's west coast faces the Sea of Japan.

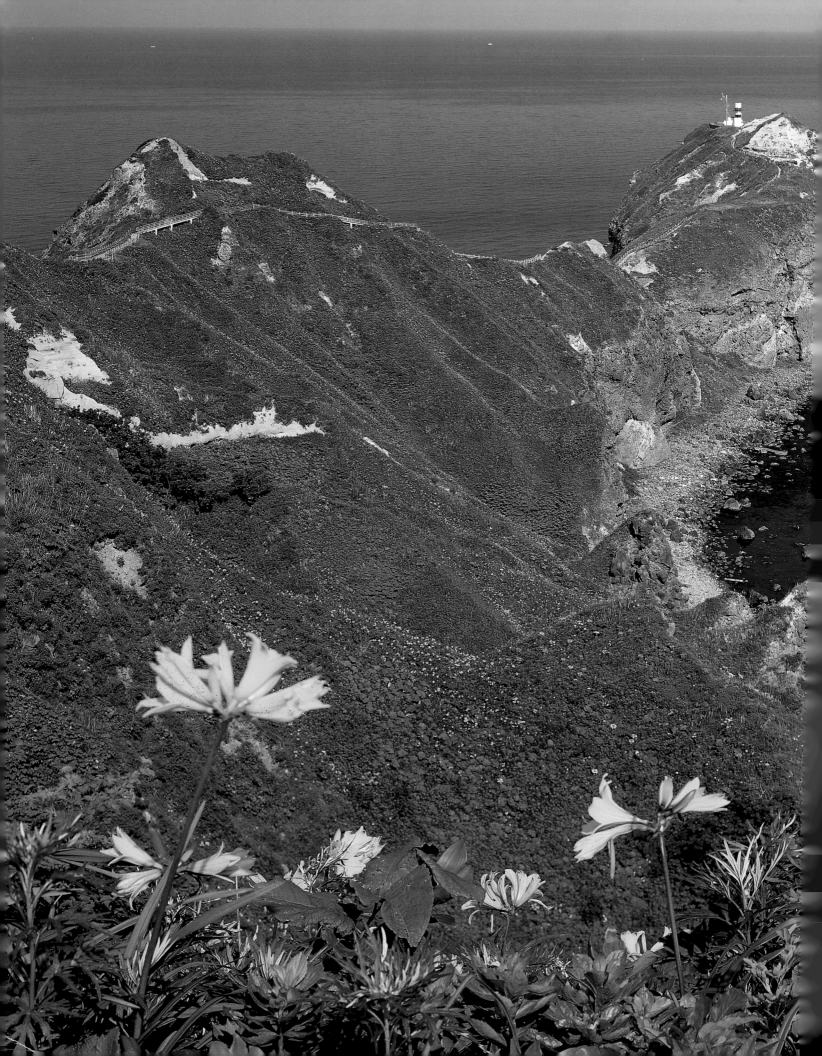

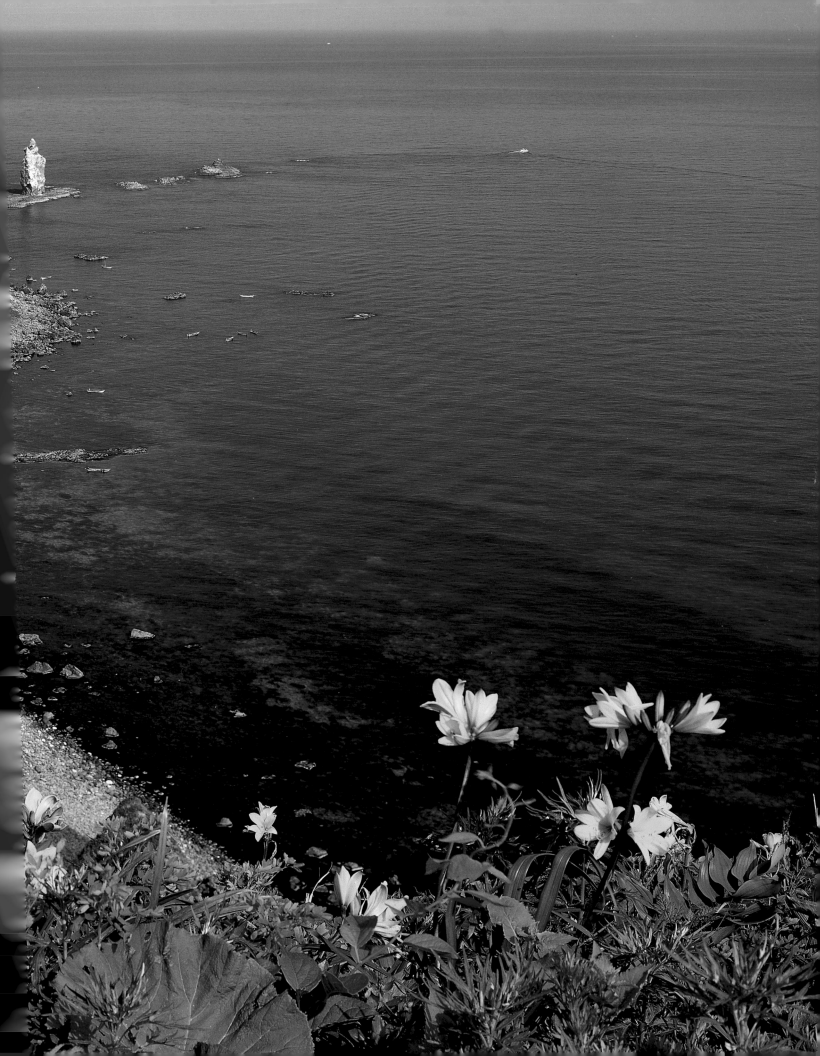

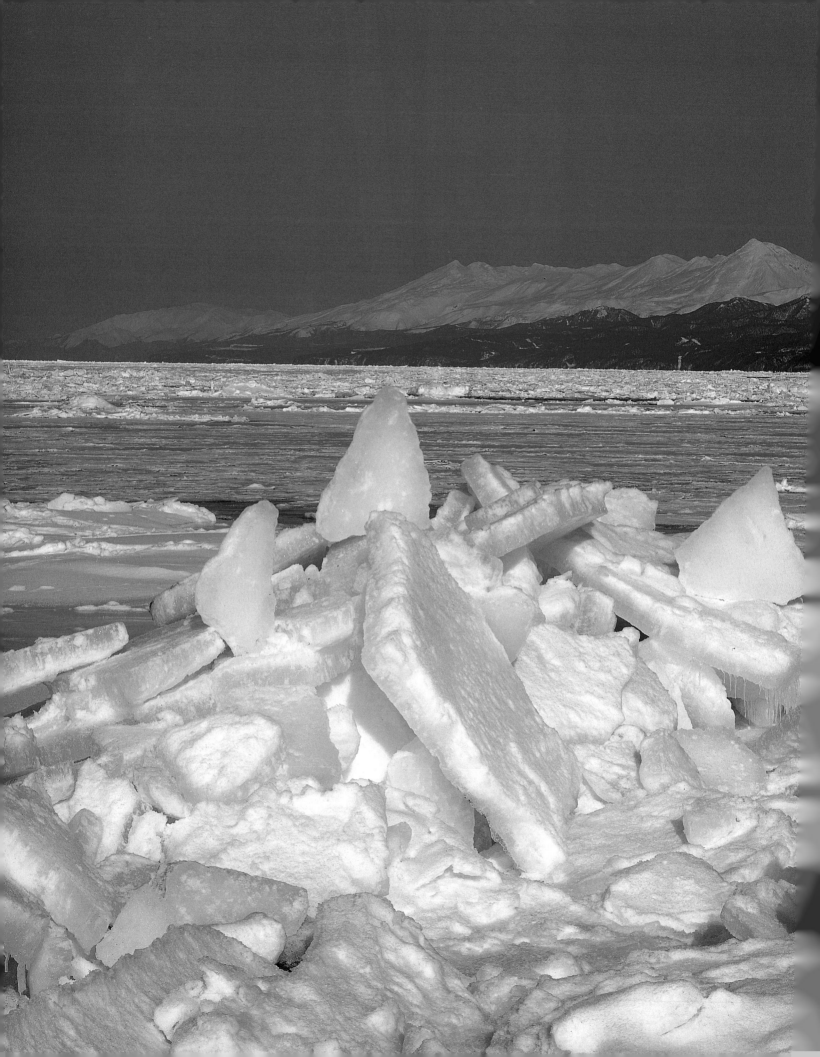

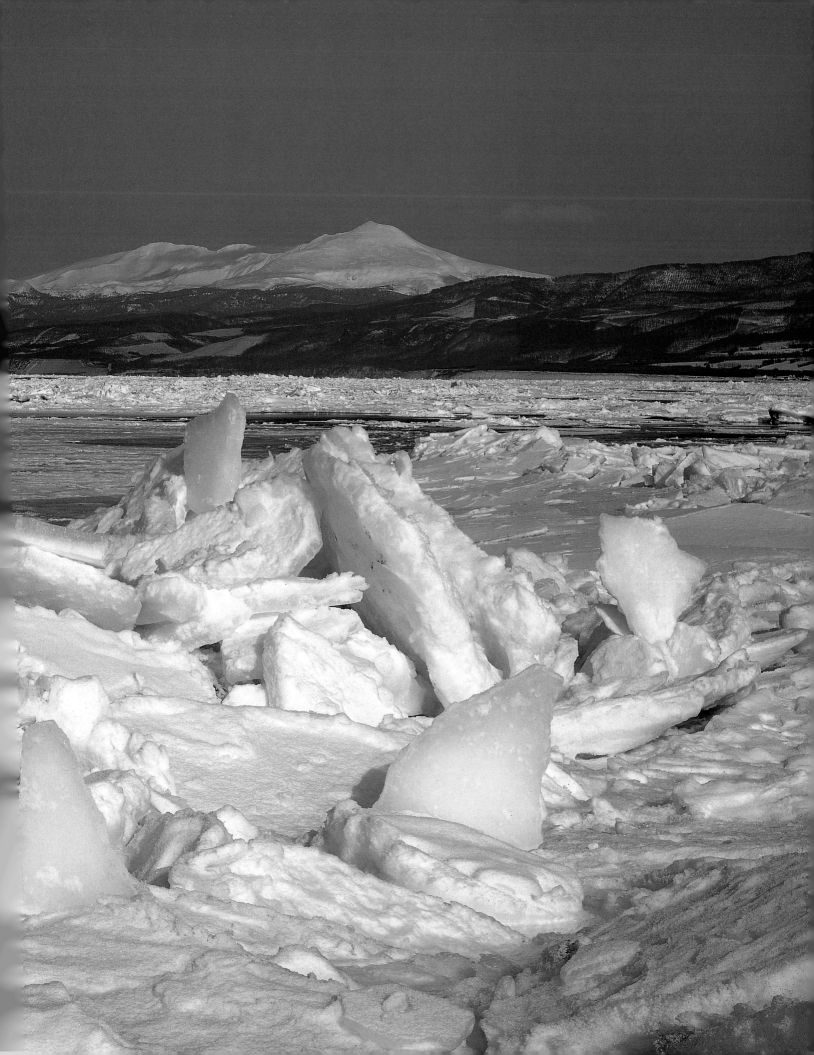

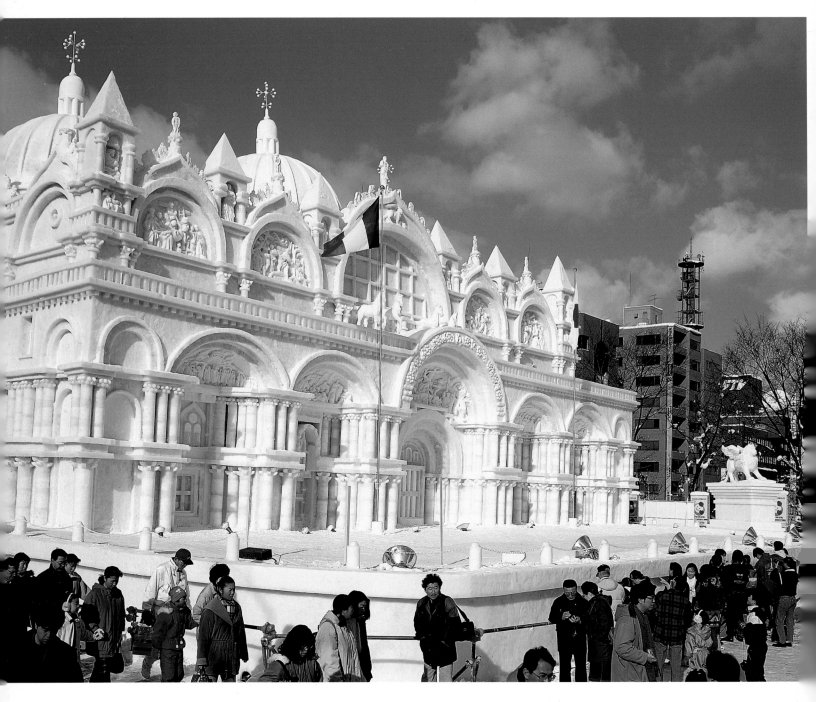

Previous page: Ice floes off the Shiretoko Peninsula on the Sea of Okhotsk.
Top: Exotic mixture of confectionery and Baroque styles at the snow festival in Sapporo, Hokkaido's largest city. Sapporo is the political, economic and cultural center of the most northerly of Japan's main islands.

Right: Sapporo's famous snow festival takes place during the first week of February Odori Park. At night spotlights illuminate the huge, twinkling ice sculptures.

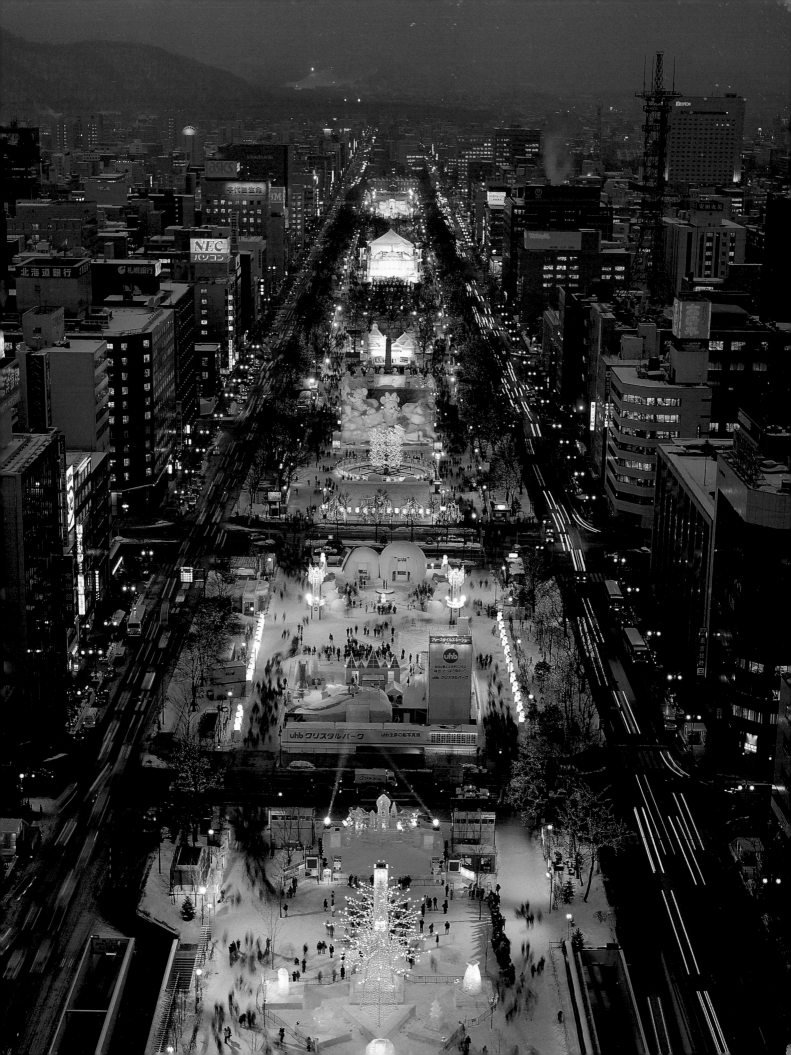

THE GREAT NORTHWEST
Life on Japan's "Back Page"

There are landscapes that write their own stories almost by themselves. One of those stories begins like this: "As the train crept out of the long border tunnel, the snowy landscape lay stretched out wide before it. The night was a pure, untouched white." These are the first sentences of the novel The Snow Country by Yasunari Kawabata, the story of an unhappy love affair between a cynical Tokyo man of the world and a young geisha. Skiers do not appear in the book. Instead, the future Nobel Prize winner writes about cold solitude, lost dreams and the inability to love—all overhung by a gray sky threatening snow.

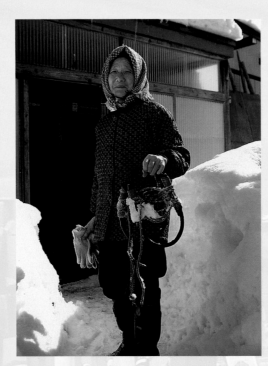

The story takes place in a nameless bathing resort in the mountains. Kawabata does not say what the term "snow country" means; it would be superfluous to explain what any Japanese schoolchild knows. Although Kawabata's snow country is a product of his imagination, it is at

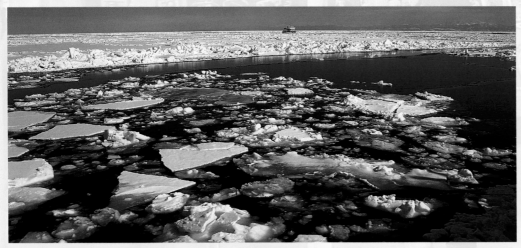

the same time a geographical location: Niigata, Yamagata, Akita and Aomori, the four northwestern provinces of the main island of Honshu bordering on the Sea of Japan. In the past this area was called Ura Nihon, the "Flip Side of Japan."

Top: Homemade snowshoes are part of a farmwoman's normal winter apparel. With some difficulty, the entrances to the houses are cleared of snow.
Above: Ice floes during winter make it nearly impossible for fishermen to work.

All things undergo change, but the north of Honshu remains the backyard of Japan, characterized by limited industry and a small gross national product, poor infrastructure and rural exodus. Winter here is a tyrant dictating the way people lead their lives. The first snowflakes fall in the beginning of November, initiating the time of the winter monsoons. Cold, dry polar air from eastern Siberia streams over the Sea of Japan, where it takes on moisture that eventually falls in the form of snow on Japan's western

coast. In the mountains the snow reaches as hi as four to five meters, burying streets and hou es, fields and pathways. The houses are built as to withstand landslides, with supporting beam under the roofs and long boards and thigh-thi tree trunks leaning against the walls to protect the windows. In the gardens, bushes and the crowns of trees are either bent together or bound up high. A shield made out of rice strav protects the trunks of apple and plum trees fr nighttime frost, and plants are covered with

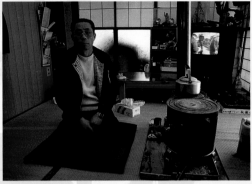

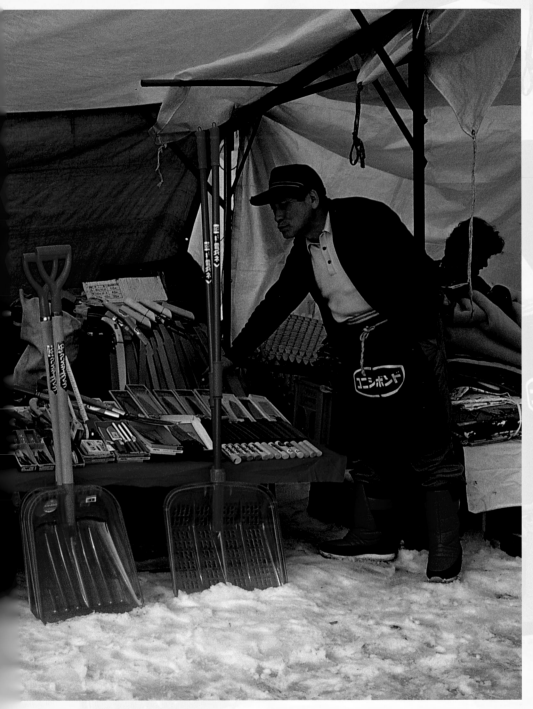

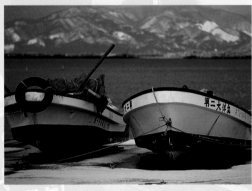

science. Here mountain ascetics, called *yamabushi* in Japanese, practice their secret rites and devotions.

The showy dress of the *yamabushi* is incompatible with the discreet way they practice their religion. They wear a long white robe and carry a rattle staff and a square shoulder basket. They own a shell horn in which they blow as if it were a trumpet without a mouthpiece; its deep tones seem both to entice and to warn. In the autumn the novices are instructed in the Tendai doctrine. During their weeklong training they do not sleep but spend their time meditating and repeating endless prayers. During the day the novices wander through the holy mountains, old-fashioned straw sandals on their feet and the singsong of archaic invocations on their lips.

...raw mats. Street lamps already burn in the ...rly afternoon. The only places where one can ...arm up are the public bathhouses. When the ...rmers undress, one is reminded of the layers of ... onion: winter jacket, pullover, pants, cotton ...irt, kidney protector, long-sleeved undershirt, ...o pairs of wool socks, long underwear, short ...derwear. In the mountains there are outlying ...lages that are completely snowed in, where old ...en sit for hours in hot water up to their necks, ...inking warm rice wine.

Yamabushi—The Mountain Ascetics

The holiest places in the northwest are the three mountains of Dewa Sanza in Yamagata prefecture: Haguro (418 meters), Gassan (1980 meters) and Yudono (1504 meters). An ancient stone path made up of 2,446 steps, worn smooth as parquet, snakes around Haguro. Centuries-old cypress trees line the path on both sides. At the top spreads a conglomerate of magnificent temples and shrines, in which Tendai Buddhists worship the Buddha vision of light and omni-

Above, left: On a biting-cold market day in the village of Animaeda, snow shovels sell especially well.
Top: At Mr. Morikawa's house. The high-pressure furnace is his only source of heat in the depths of winter.
Above: When winter comes, the fishermen take refuge from the extreme cold at home.

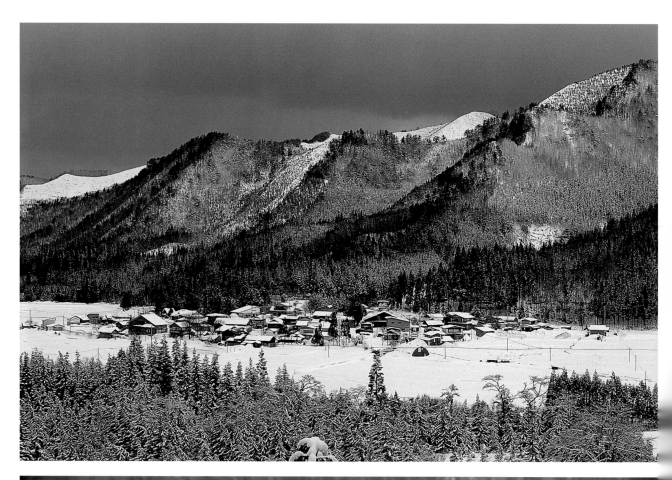

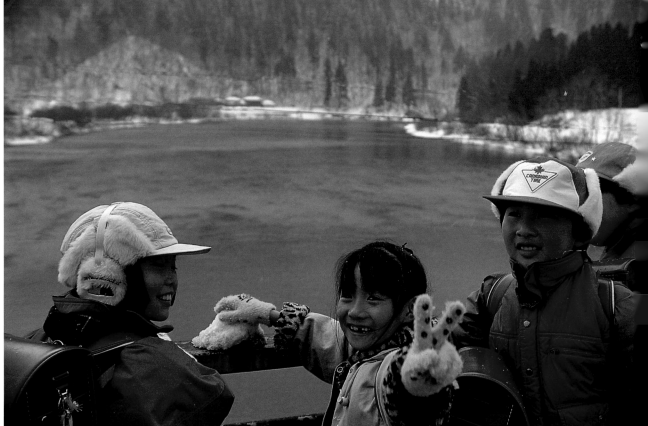

Top: A village in the Akita Prefecture. Here the cold, snowy winters can last up to six months.
Right: The important thing is to keep the head warm. The cold doesn't dampen the spirits of these children on their way to school.

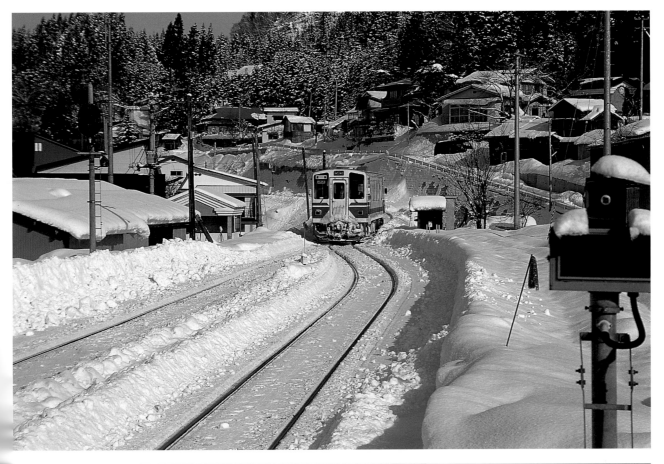

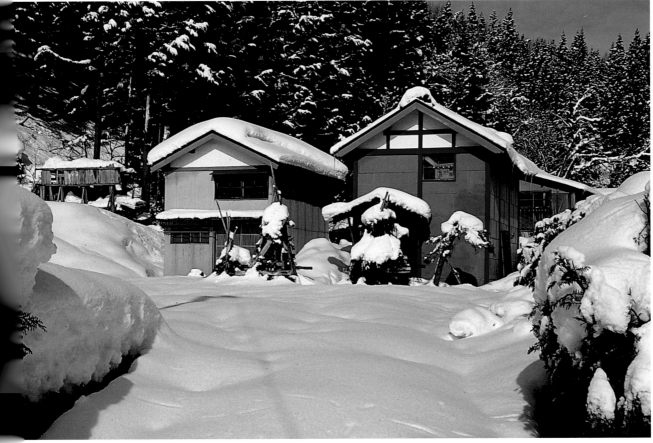

Top: A dependable means of transport when nothing else is working: The suburban train in the province of Akita always runs.

Left: A snowed-in house. During some winters in northern Japan, it is hard to stay warm even indoors.

HONSHU AND SHIKOKU
The Japanese Heartland

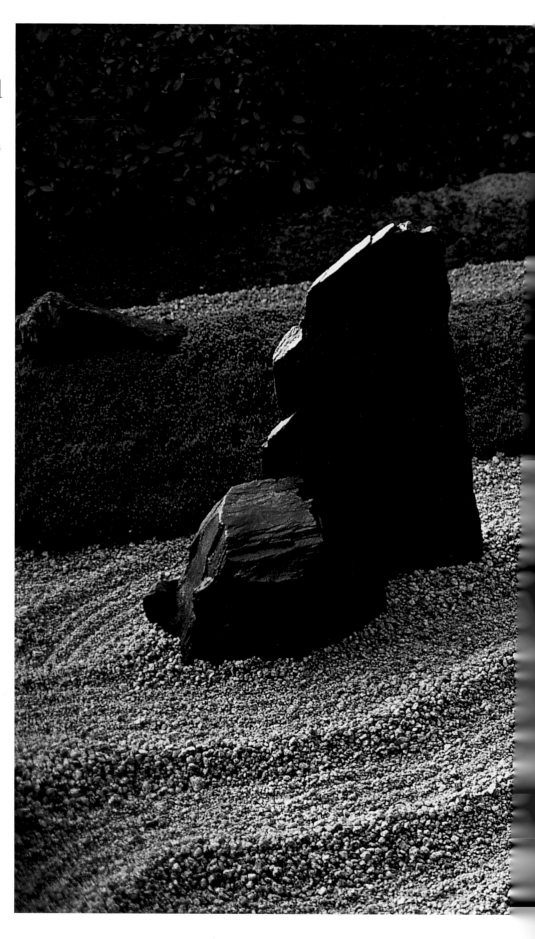

At 8:30 in the morning organized chaos reigns in the Tokyo train station Shinjuku. Hundreds of thousands of people on their way to school and work overfill the subways and stuff the suburban trains. Uniformed workers wearing white gloves push stragglers into train cars. At almost the same time in the old imperial city of Nara, streaks of sunlight glide over pagodas and temples, shrines and Buddha statues. Tame deer wander through the city's old park.

Concrete and nature, crowds of people and solitude—on Honshu these are divided not by worlds but by a few kilometers. Honshu means "main country." It is Japan's largest island, the country's bustling heart. A powerful chain of mountains divides the island into two contrasting landscapes. Omote Nihon, the "Front Page" of Japan, is the region containing the most important cities, the most significant cultural and business centers. On its narrow Pacific coast lie the old centers of power Nara and Kyoto, as well as industrial cities like Nagoya, Osaka and Hiroshima. Between Tokyo and Kobe, industrial parks and factories, city centers and residential neighborhoods seem to melt into one another. By contrast, Ura Nihon, the "Back Page" of Japan, which faces the Sea of Japan, is made up of small, sleepy towns and quiet rural villages. In the wintertime all are buried in deep snow.

Since 1988 a band of six steel bridges has linked Honshu and Shikoku, Japan's fourth-largest island. Shikoku is one of the world's most famous pilgrimage centers. Here pilgrims in white clothing visit the 88 temples established more than 1,200 years ago by Kobo Daishi, the founder of Shingon Esoteric Buddhism. Those who have honored the gods can expect a long life, good luck and happiness.

A monk rakes the rock garden of the Zuiho-in Temple in Kyoto. The name means "garden of the mountain of beatitude." The lower temple Zuiho-in is part of Daitoku-ji, the most famous Zen Buddhist temple complex in Japan.

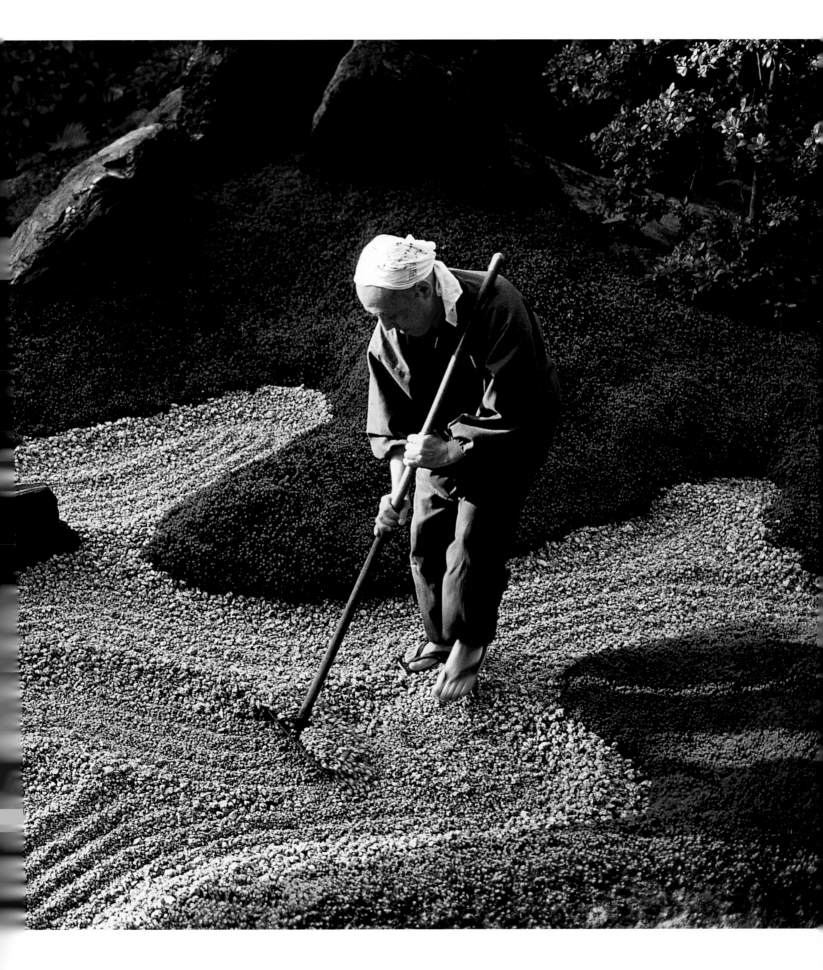

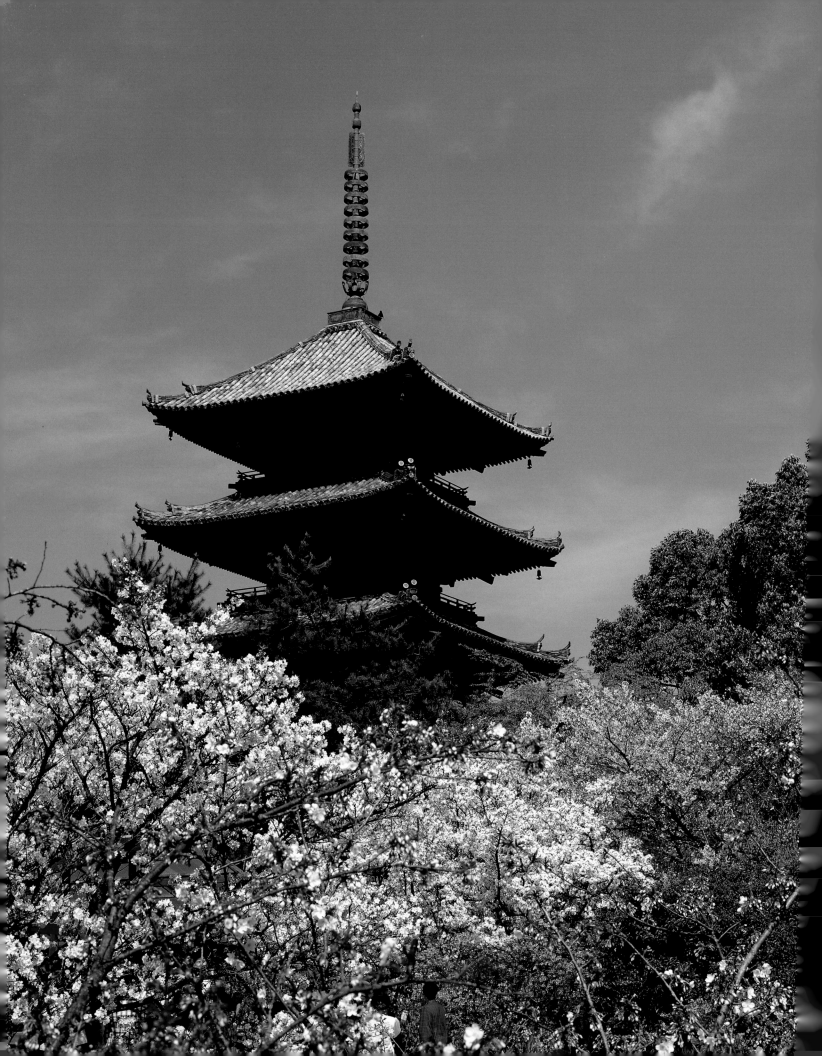

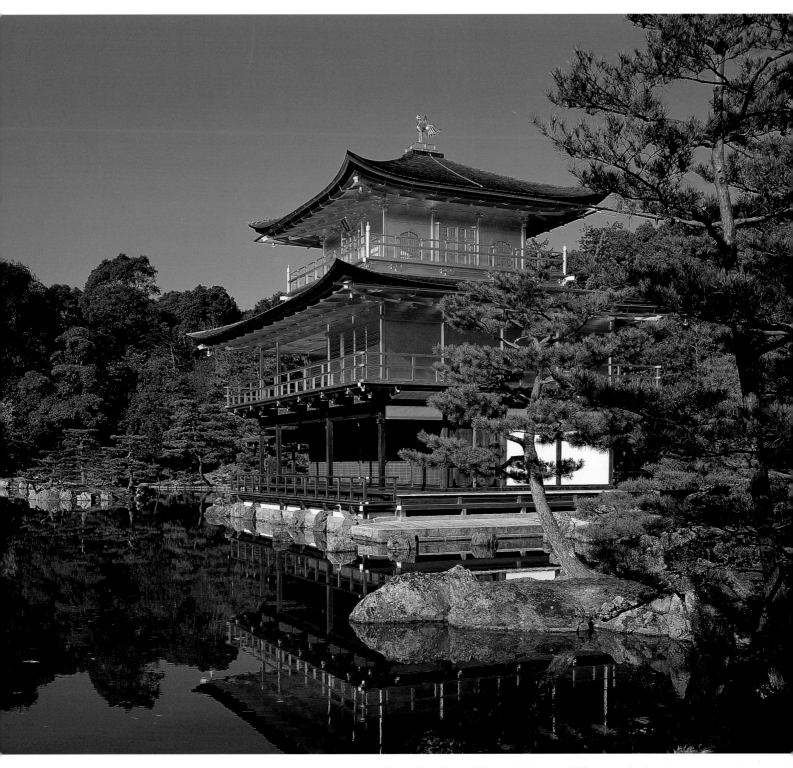

Opposite: The 33-meter-tall, five-story pagoda of the Ninnaji Temple in Kyoto dates the 17th century. The temple grounds' many cherry-blossom trees make it a rite destination during blossom time.

Above: The Kinkaku-ji Temple in Kyoto. In 1955 a mentally disturbed person set the "Golden Pavilion" on fire. The current building, covered in gold leaf, is an exact copy of the original temple, which was commissioned in 1394.

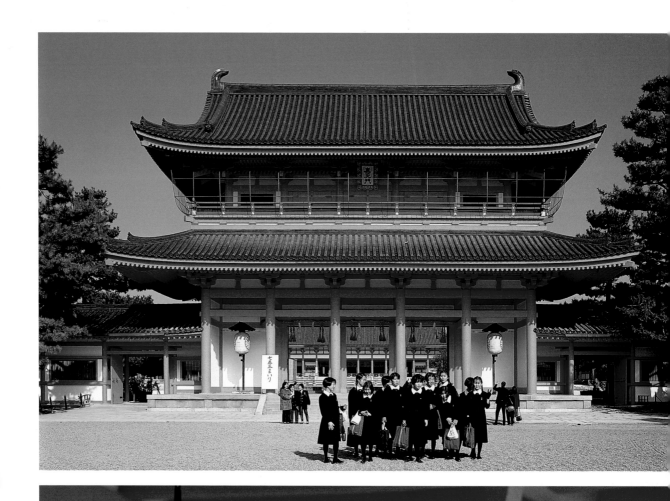

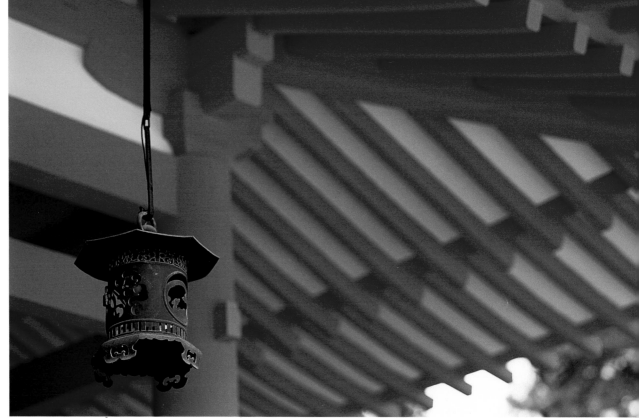

Top: A school class poses in front of the Heian Shrine in Kyoto. The shrine was built in 1895 to commemorate the imperial city's founding 1,100 years before.
Right: The Chinese influences are unmistakable: red roof beams and a black iron lamp at the Heian Shrine in Kyoto.
Opposite: A first snowfall covers trees and the roofs of the Kiyomizu Temple's three-story pagoda in Kyoto. The temple complex, established in 798, is part of the world's cultural heritage.

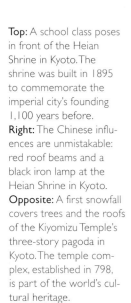

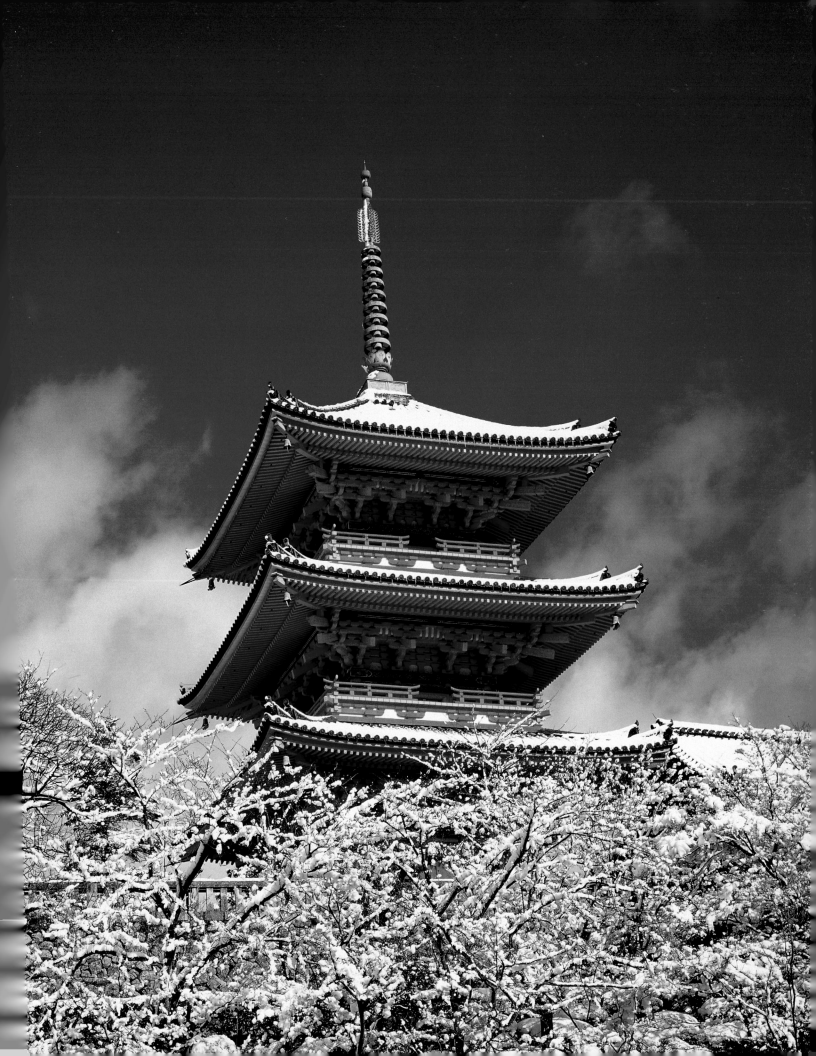

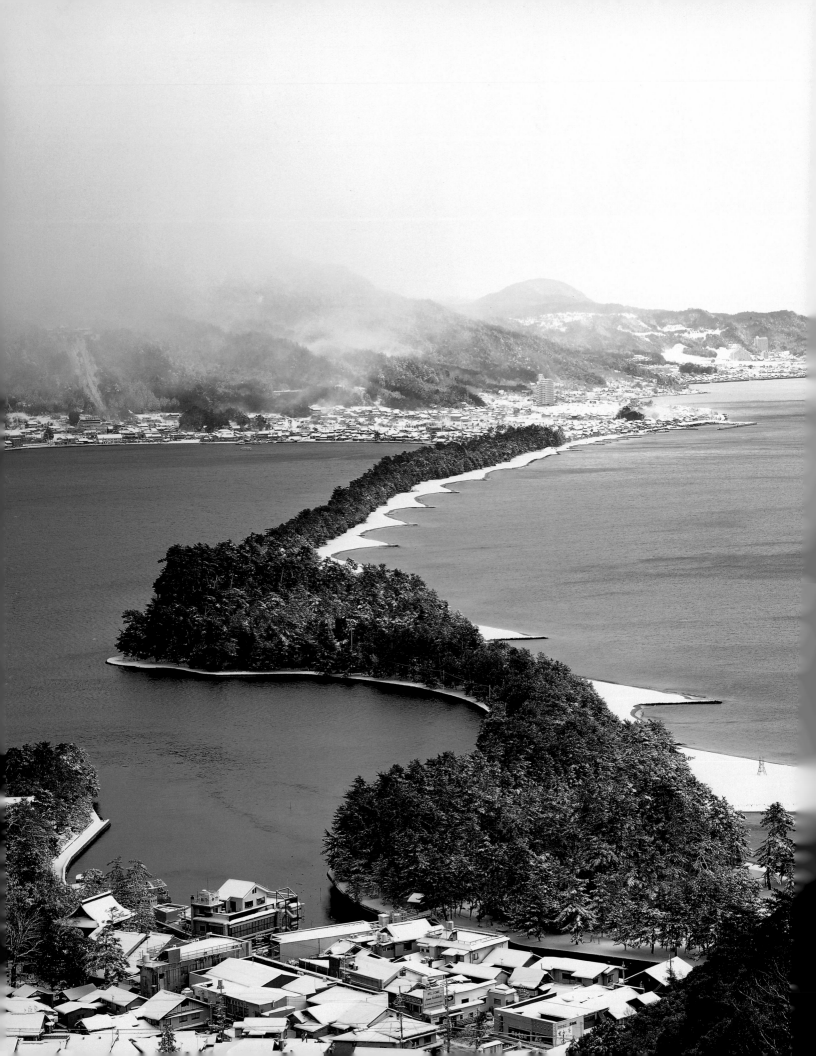

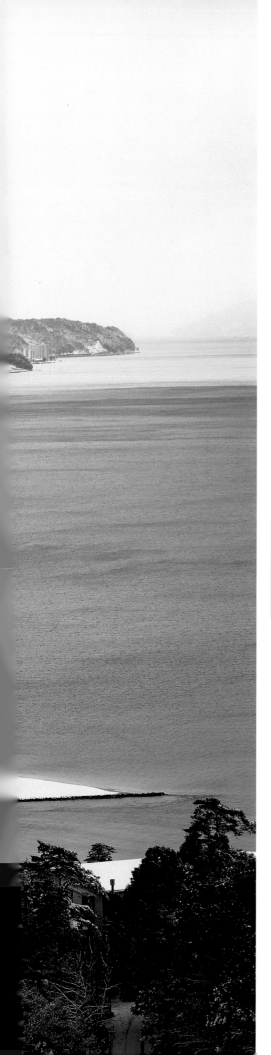

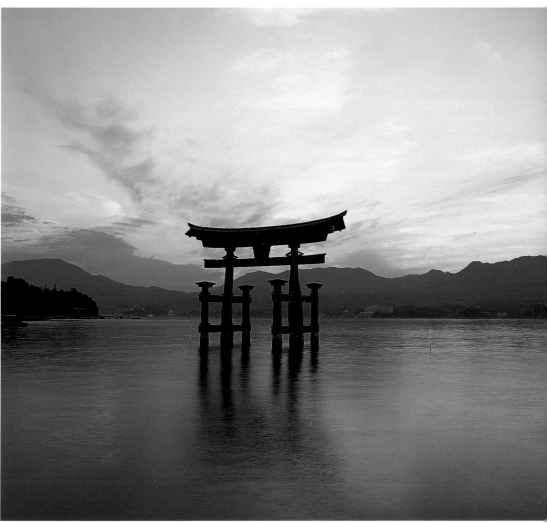

Since the scholar Razan Hayashi extolled them in the 17th century, three scenic areas embody the Japanese national ideal. Two of these are visible here: Ama-no-hashidate, the "heaven's bridge," a narrow tongue of land covered with Scotch pines in the Miyazu Bay northwest of Kyoto (**left**); and Miyajima, an island near Hiroshima. The red main gate (*torii*) of the old Shinto shrine stands in the middle of the water (**top**).

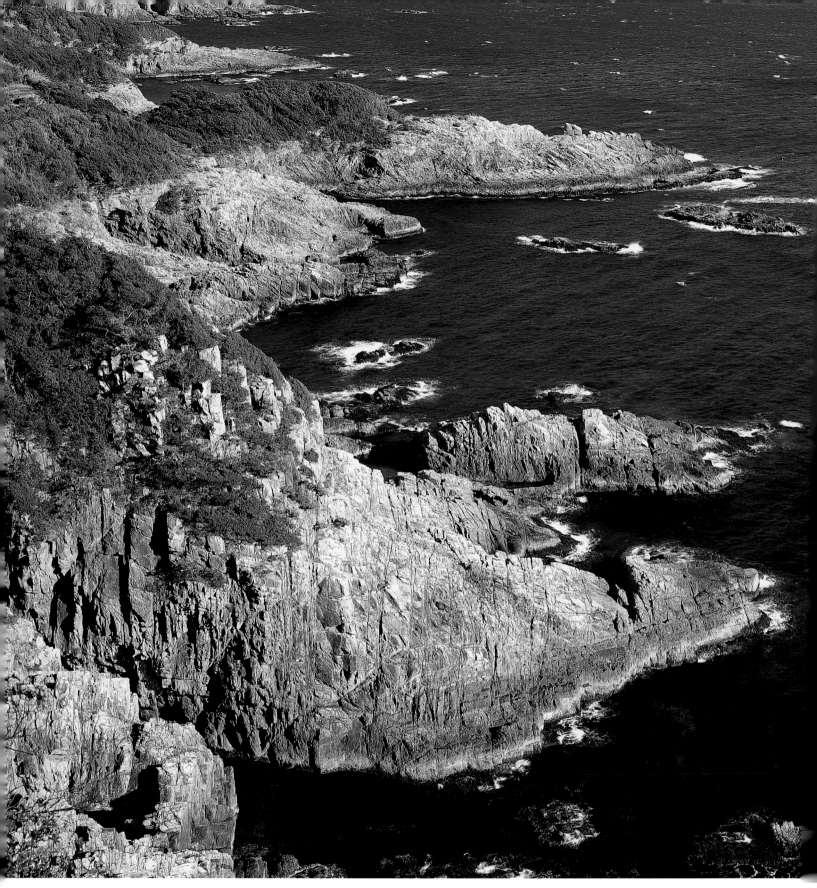

Top: The rugged southern coast of the island of Shikoku near Ashizuri-Misaki, one of Japan's most beautiful and untouched coastal areas. Here one can still find many small, primitive fishing villages.

Opposite, top: Since 1985, the more than 1,600-meter-long white O-Naruto Bridge has connected the islands of Awaji and Shikoku.

Opposite, middle: A string of fishing boats in the port of Muroto on the southern coast of Shikoku, the largest island in the south. Shikoku and West Honshu surroun the so-called Inland Sea, with its 950 small islands.

Opposite, bottom: Since April 1988 the Seto-Ohashi Bridge has linked the main island of Honshu with Shikoku. The bridge consists of ten bridges: six bridges with combined length of 9,368 meters and four other bridges that feed into them.

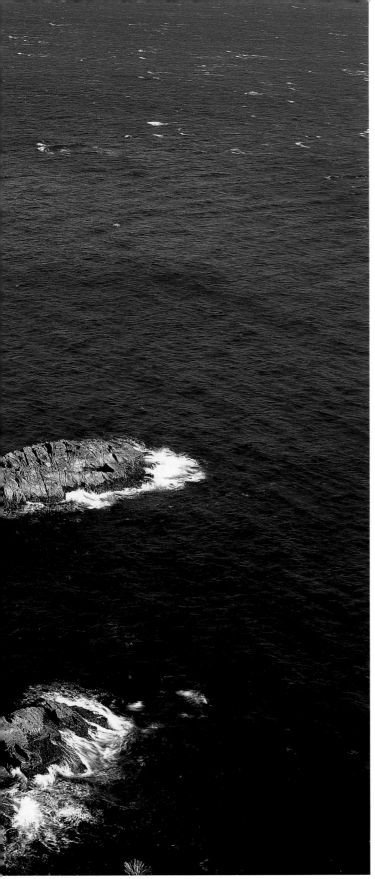

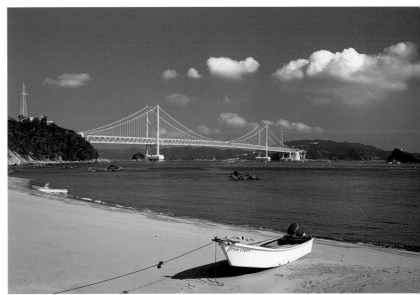

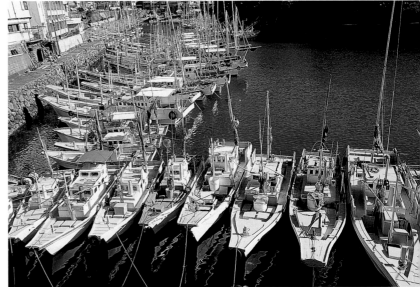

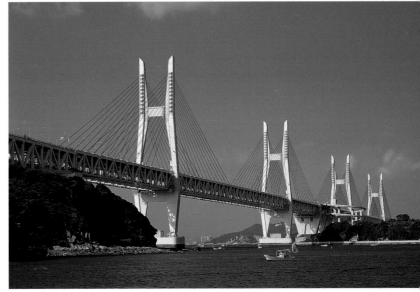

49

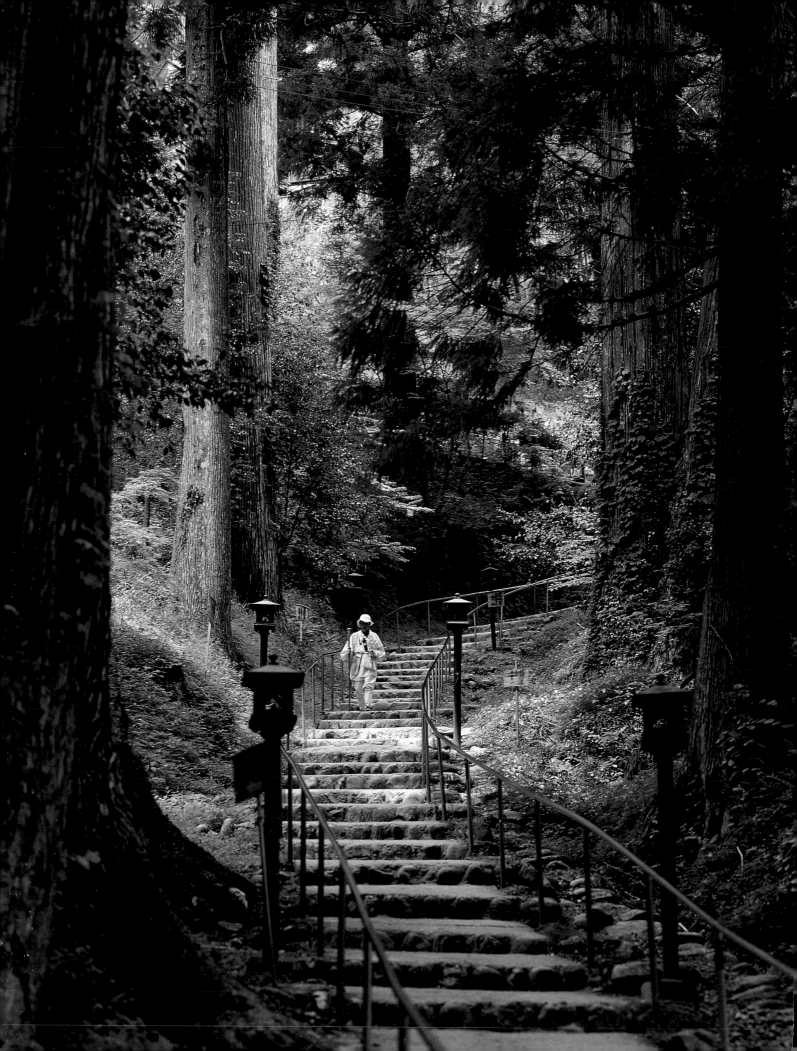

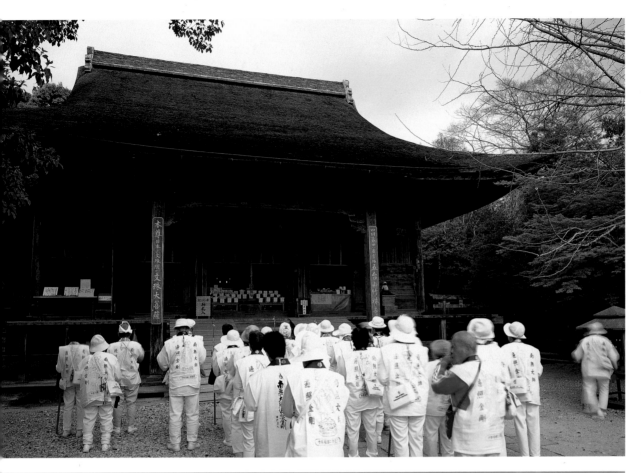

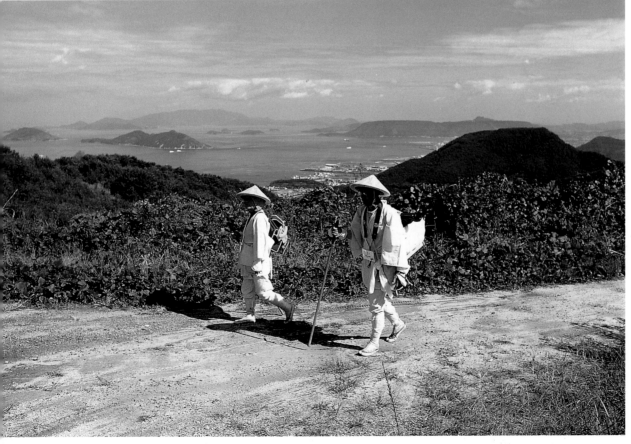

Opposite: The island of Shikoku is famous not only for its natural beauty but also for its 88 temples, which were erected around 1,200 years ago by Kobo Daishi, the founder of Shingon Esoteric Buddhism.

Top: Many travelers to Shikoku are pilgrims, who visit the island's numerous shrines. The men and women wear white clothing and carry wooden staffs, whose silver bells tinkle when they walk.

Left: Only traditionalists still make the pilgrimage on foot; most now travel on excursion buses.

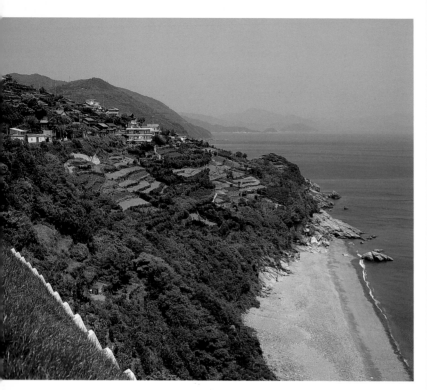

Top: Terraced fields overlook the charming coastal landscape near the port city of Uwajima on Shikoku's west coast. **Above:** Time stands still on the island of Shikoku: brilliantly green rice fields on the eastern coast. **Right:** A picturesque view of Japan's south: coastal landscape with sea, beach and cliffs, on which storm-tossed pines grow.

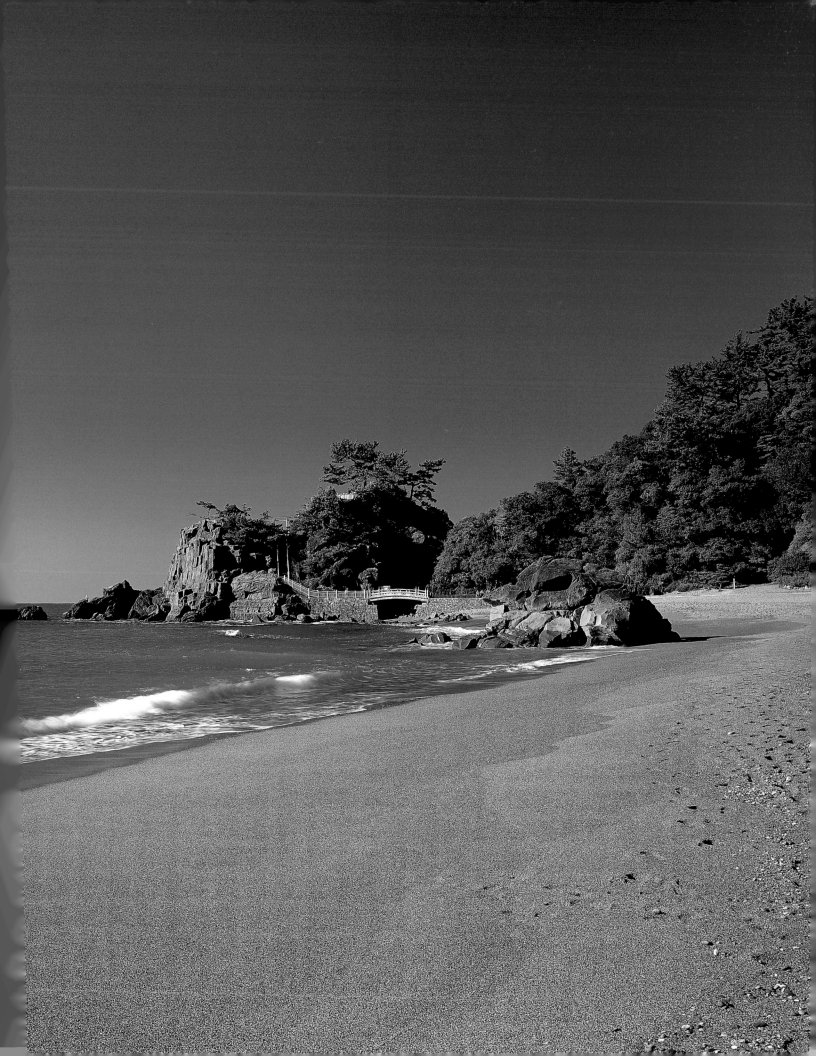

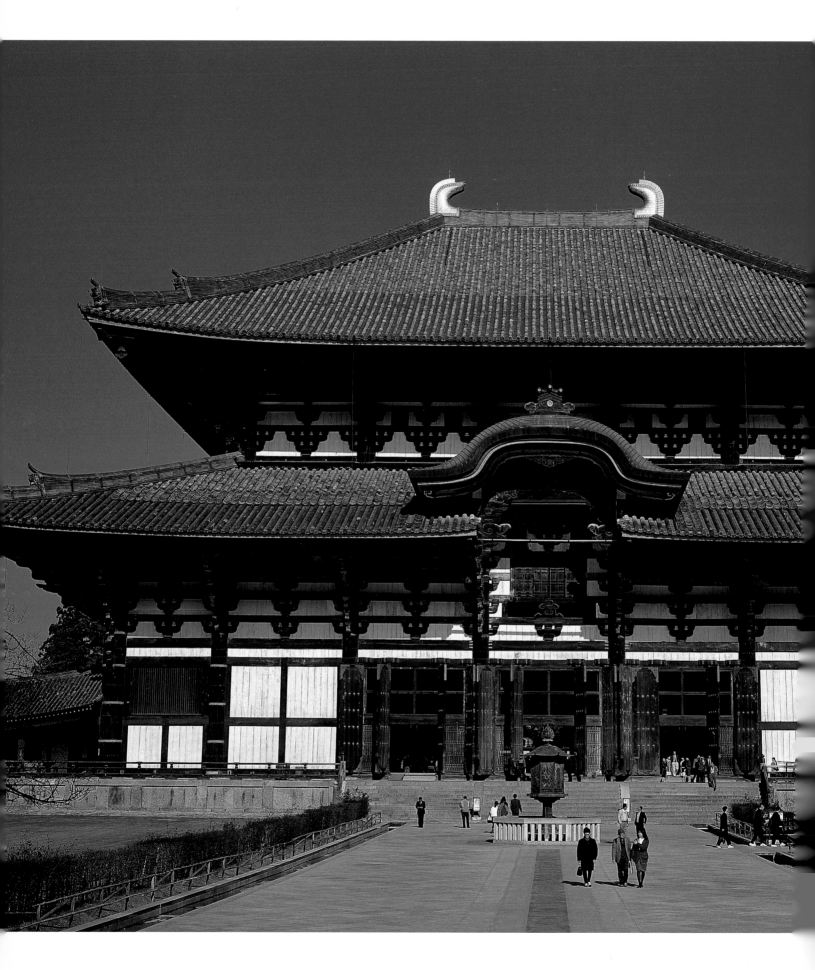

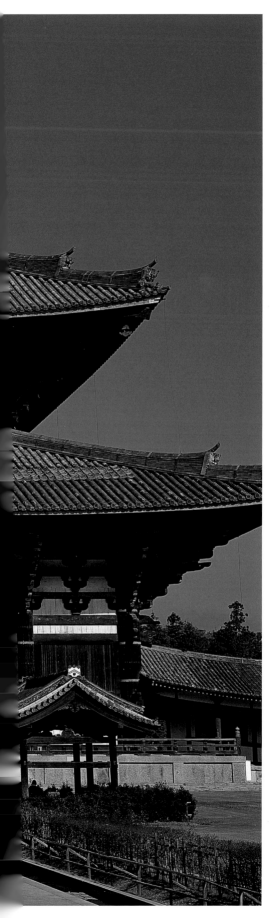

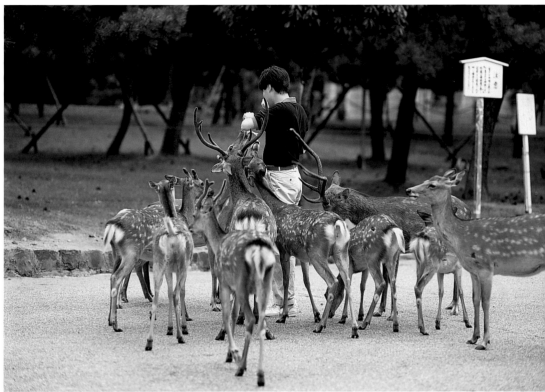

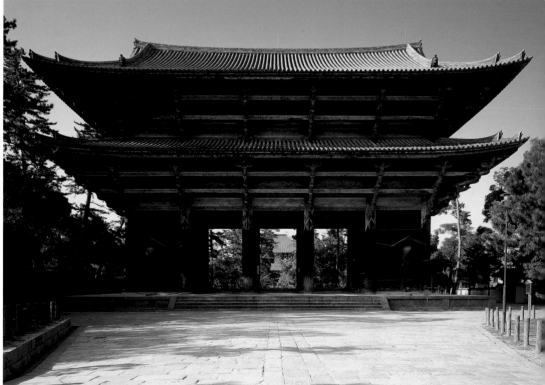

Opposite: The Todaiji Temple, one of the seven great temples of the old imperial city of Nara, is thought to be among the largest wooden buildings in the world. It is the principle shrine of the Buddhist Kegon sect.

Top: Tame deer in Nara Park—with more than 500 hectares, the biggest park of its kind in Japan. The animals, which are reputed to be holy, are fed too often by visitors and consequently are hard to shake off.

Above: Held up by 18 pillars, the big south gate Nandaimon forms the entrance to the Todaiji temple complex in Nara.

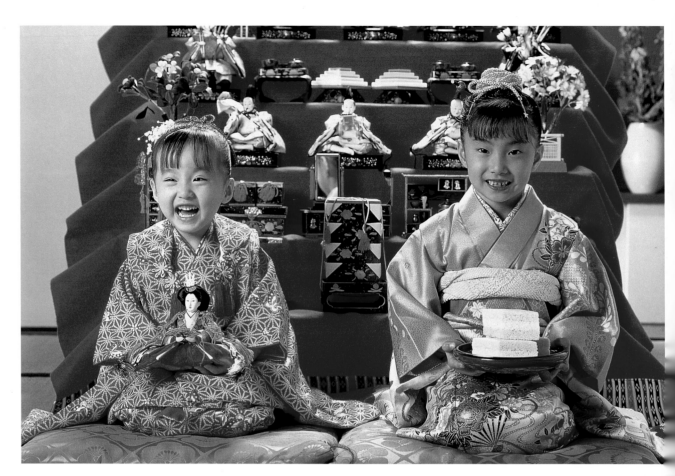

Above: Pomp and circumstance: On the third of May, Hina Matsuri, the girls' festival, is celebrated. Elaborate decorations are typical. The magnificent dolls on the stair landing represent the 11th-century imperial household.
Right: Naturally, there is also a boys' festival, referred to as a "children's festival." Carp flags are flown in the garden: black for the father, red for the mother and a small carp flag for each boy in the house. Girls are left out.
Opposite: Colorful kimonos for the festival: The official Shichi-go-san festival takes place on the 15th of November. On this day, children are blessed in the shrines— girls at the ages of three and five, boys at the age of seven. This picture shows the Meiji Shrine in Tokyo.

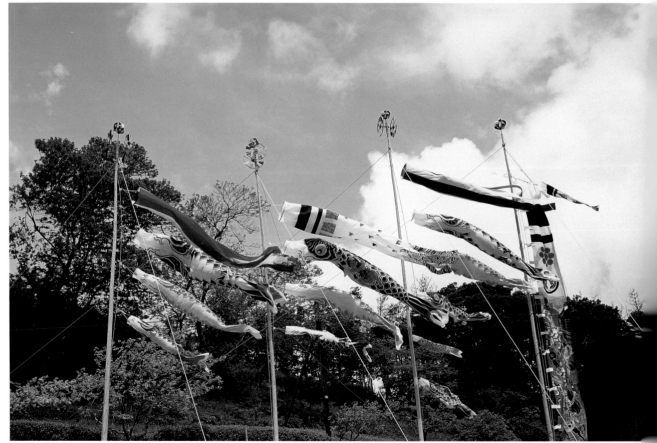

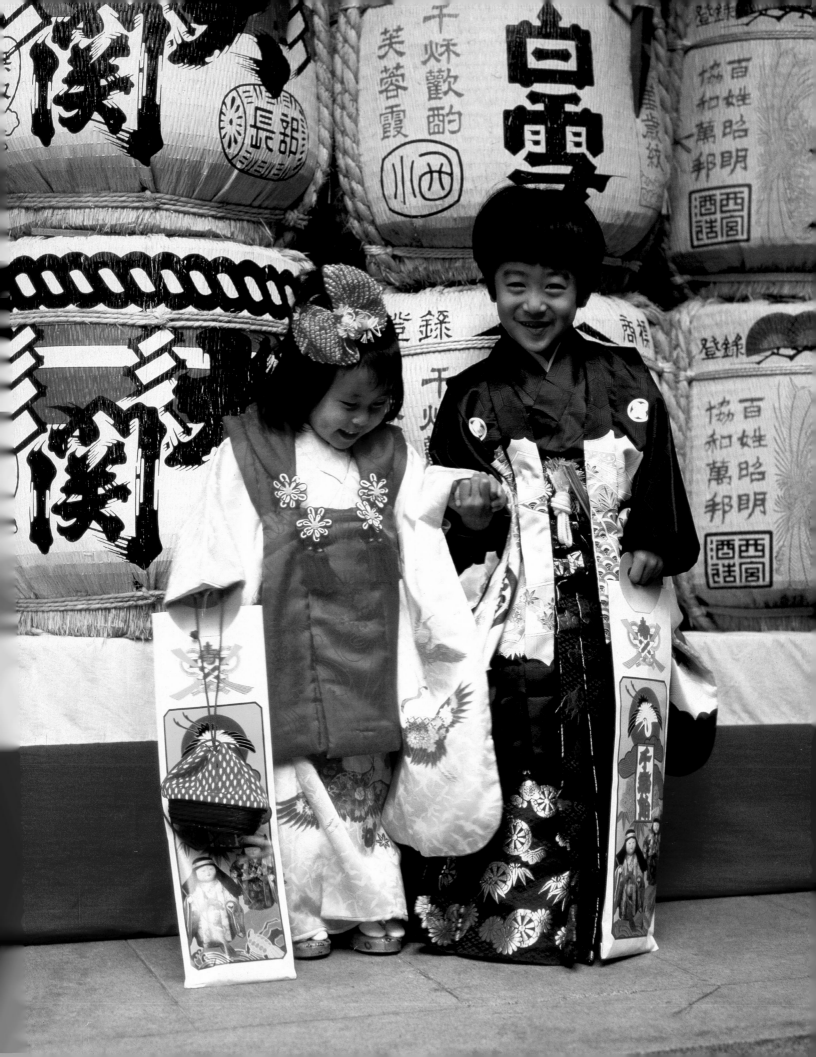

ARTS AND CRAFTS
The Beauty of Perfection

The most famous rock garden in Japan is at Ryoan-ji Temple in Kyoto. It is thought to have been created in the 15th century. Bordered on the south and east by a clay wall topped by bricks, it is about as big as a tennis court and composed mainly of raked sand, 15 different-sized stones and a small amount of moss. The stones are arranged from left to right in five groups. No one knows what they represent: mountain peaks poking through a sea of clouds? Lonely islands in an infinite ocean? Tigers swimming across a mountain stream? What nobody disputes is that the Ryoan-ji rock garden is an extraordinary example of Zen art. Here is reflected the aesthetic of self-denial, the search for inner truth. A stone is a stone, but at the same time it also expresses a larger cosmic truth. In the Ryoan-ji garden one can actually hear silence.

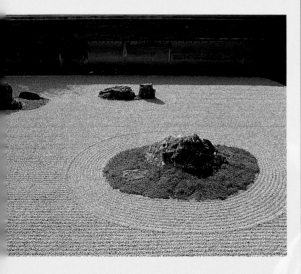

Japan's artistic aesthetic is different from Europe's, where formal gardens have always been manifestations of worldly power. Straight rows of trees, symmetrical flowerbeds, precisely measured gravel paths—in Europe nature is subject to man. In Japan, however, many garden elements are imbued with the ideas of Shintoism or Buddhism. Japanese gardens are symbols of man's place in nature.

Above: The rock garden of Ryoan-ji in Kyoto is an extraordinary work of Zen art. **Above, right:** A splendid bonsai is watered in a nursery in Omiya. **Right:** Lacquer bowls, enriched with gold and silver dust.

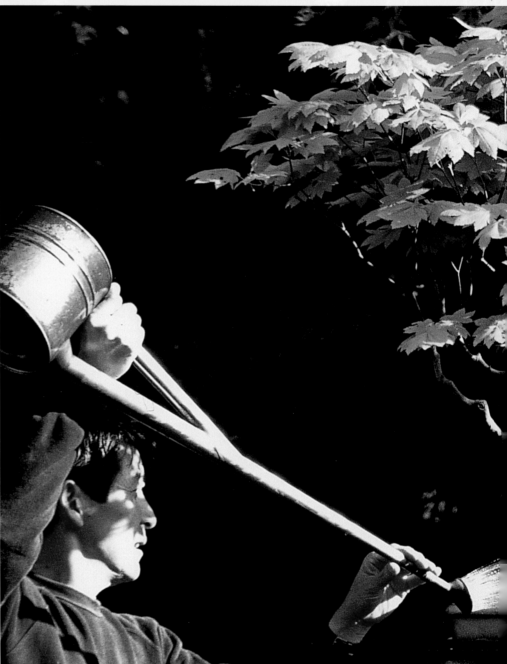

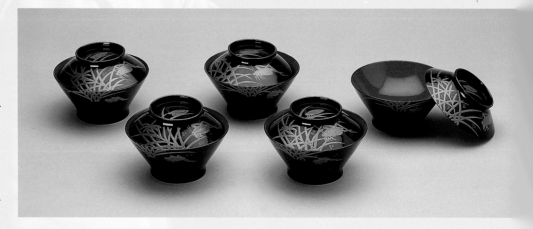

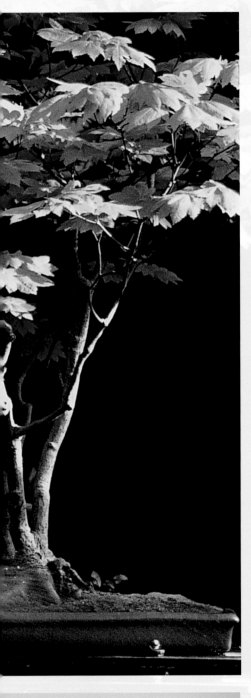

Sources of Japanese Art

China, Korea and even India were the wellsprings of Japanese art. From the Asian mainland came horticulture and flower arranging, bonsai and lacquer work, ceramics, calligraphy and water-color painting. At the same time the Japanese improved upon what they had adopted to such an extent that it took on a new quality. The Japanese version was more perfect that the foreign model. One example is bonsai, the "tree in a bowl." The miniature trees are still cultivated in China and Vietnam, yet it was in Japan that the art reached masterful heights. Omiya, a suburb of Tokyo, is the bonsai artists' center. In the district of Bonsai-cho they show their unusual creations: Scotch pines that only appear to be wind-tossed, cypress groves, a blooming apricot tree more than 120 years old yet only 55 centimeters high.

In the fields of ceramic and lacquer art, the pupils also have overtaken the masters. In Japan, up to 50 different steps are necessary to supply wooden dishes, trays, jewelry containers and pieces of sculpture with their reflective coating of lacquer. By sprinkling gold or silver dust over a moist lacquer base, Japanese artisans decorate their creations. After applying more layers of lacquer, they polish the surface with charcoal until the delicate, glossy decorations reappear.

As early as the 12th century, ceramics were made professionally. Each region has its own kind of clay, its unmistakable design, its special firing technique. Pots, vases and teacups are made either by hand or on a potter's wheel. The color spectrum ranges from dark gray to yellowish. The glazes often contain iron or feldspar, which impart a transparent brown or black tone to the final product.

Another factor distinguishes Japan from the West. Even up to the present day there is no sharp division between art and crafts. A fine ceramic work or a precious lacquer plate is prized as highly as an oil painting or a piece of music. In addition, those who emulate a great artist are not damned as plagiarists. To emulate is to submerge oneself in the spiritual current of the past. As Confucius said, "Only by venerating the master will the pupil himself become a master." In Japan craftsmanship is an important step toward art. Simplicity and clarity, naturalness and harmony are admired. A person who achieves all these receives Japan's highest honor, the designation of "Living National Treasure." Those who have received this honor include painters and potters, puppet masters and weavers, bamboo carvers and architects whose talents are deemed of inestimable value to the entire nation.

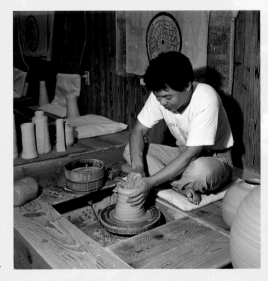

Above: Potters at work. Japan is known as the land of ceramics, whose present-day form can be traced to the influence of Korean masters. **Bottom, left:** Art to cool oneself with: A handmade fan even has its own holder.

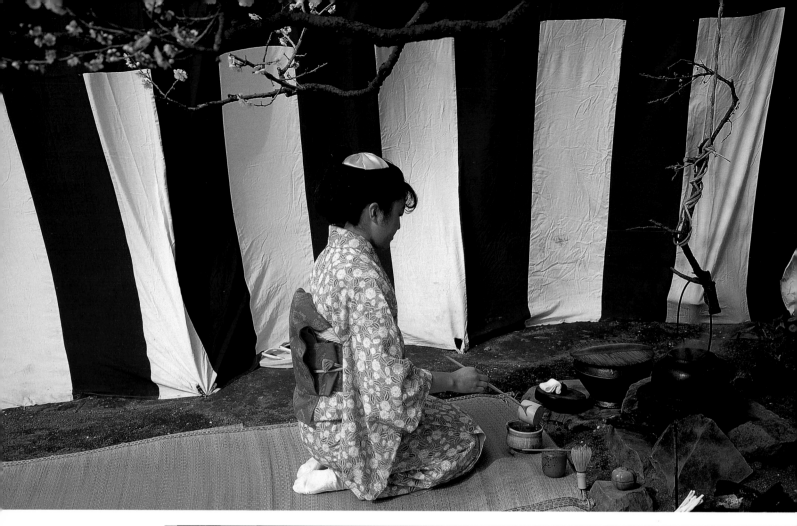

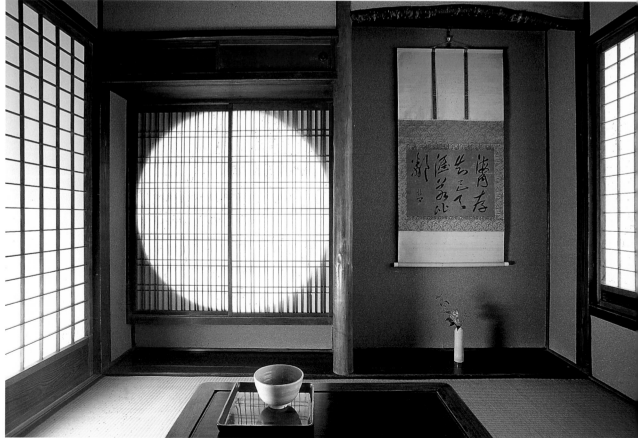

Above: Tea ceremony: Using a long-handled bamboo ladle, water is poured into a bowl containing tea powder.
Right: The tea ceremony takes place in an unpretentious setting: A picture scroll, a few flowers and sliding doors provide the only decoration.

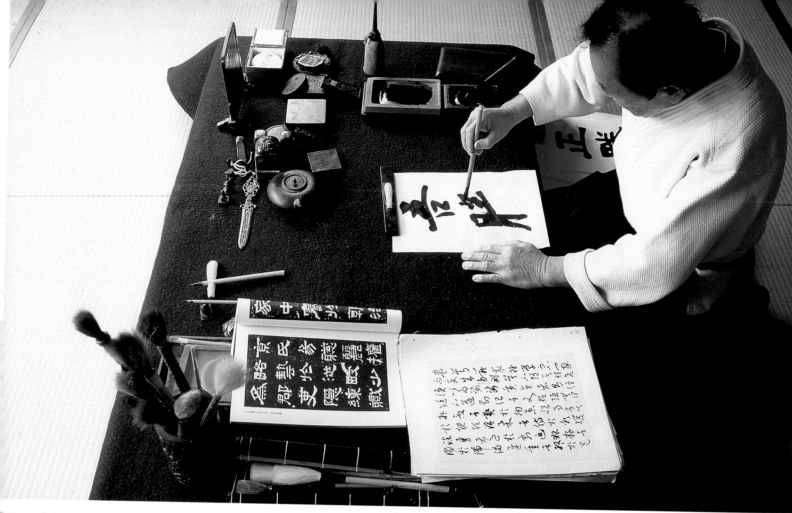

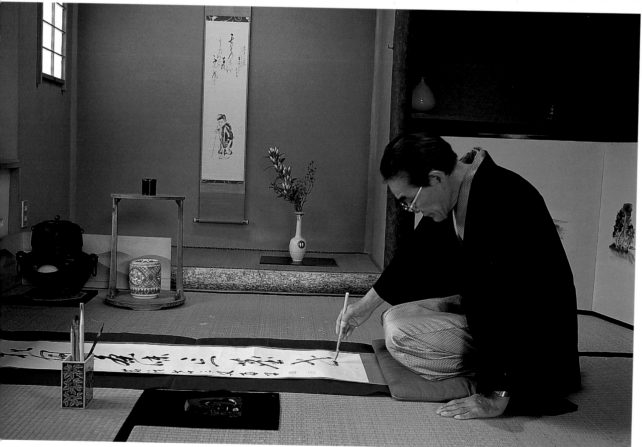

Above and left: Writing is more than a method of communication in Japan; it is an art form. *Shodo*—calligraphy—is taught not only in the public schools but also in private writing schools. Practicing the art of writing is thought to build character. It requires a large amount of study, since the number of Japanese characters is estimated at approximately 10,000.

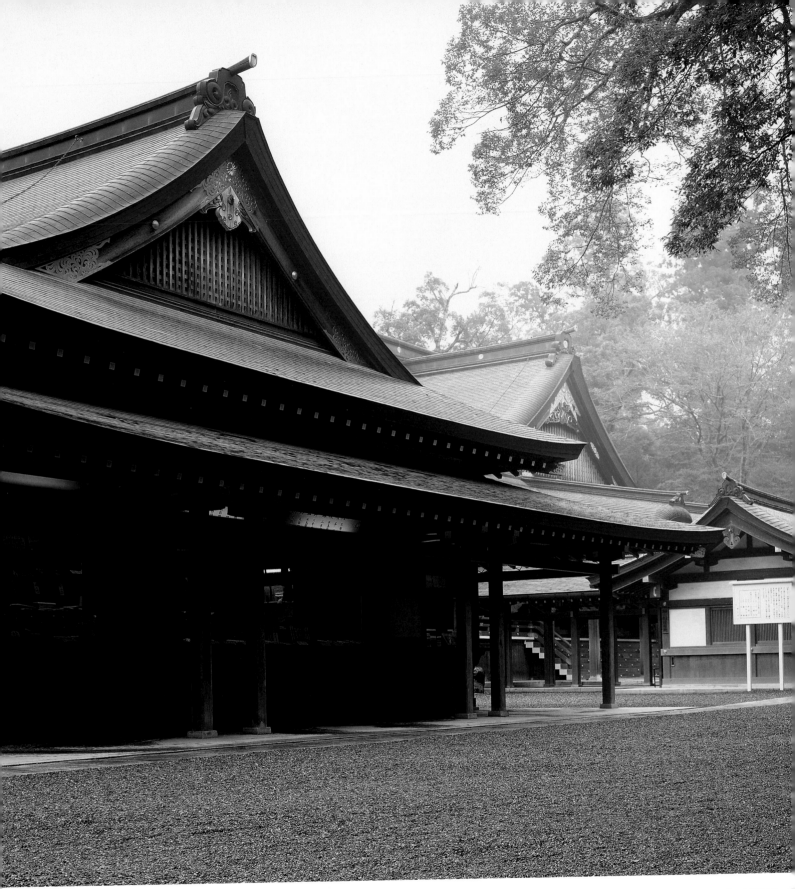

Above: The Inner Ise Shrine, called Naiku in Japanese, is the most important holy site in the country. Now on the Shima Peninsula, it once was part of the imperial palace before being relocated. The Ise shrines are free from any influence of Buddhist architecture.

Opposite, top: Freestanding gates called *torii* mark the area of a Shinto shrine. These are located at the large Ise Shrines.

Opposite, middle: The path to the Inner Ise Shrine goes over the wooden Uji Bridge. pilgrims undergo a ritual cleansing of the hands and mouth in the river.

Opposite, bottom: The Ise shrines are dismantled every 20 years. The wood is distribu as consecrated building material to other shrines in Japan. The Ise shrines are then reb to match the originals beside the old locations. The next ceremony takes place in 201

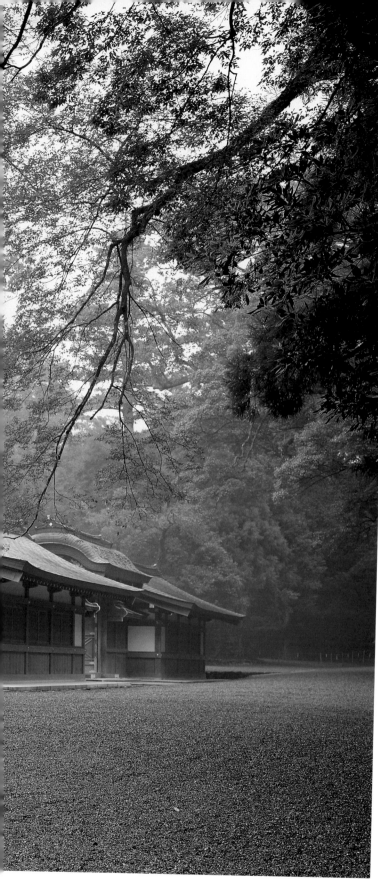

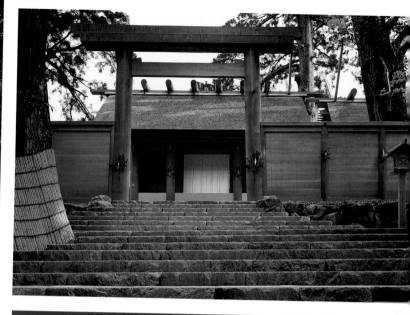

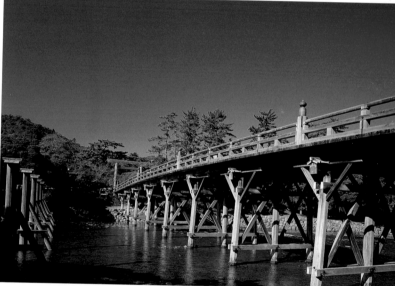

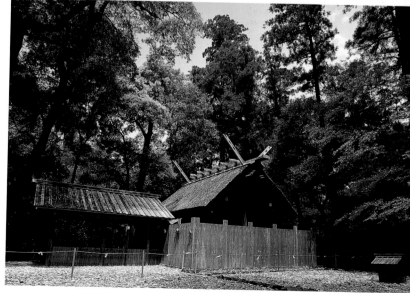

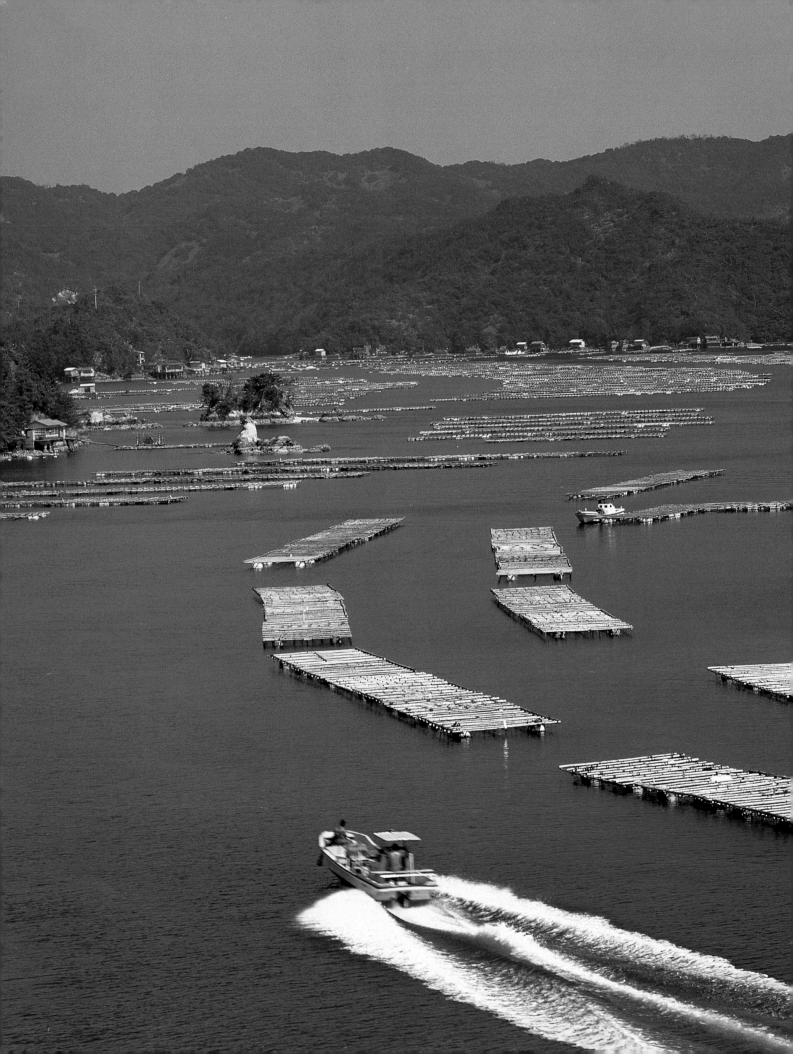

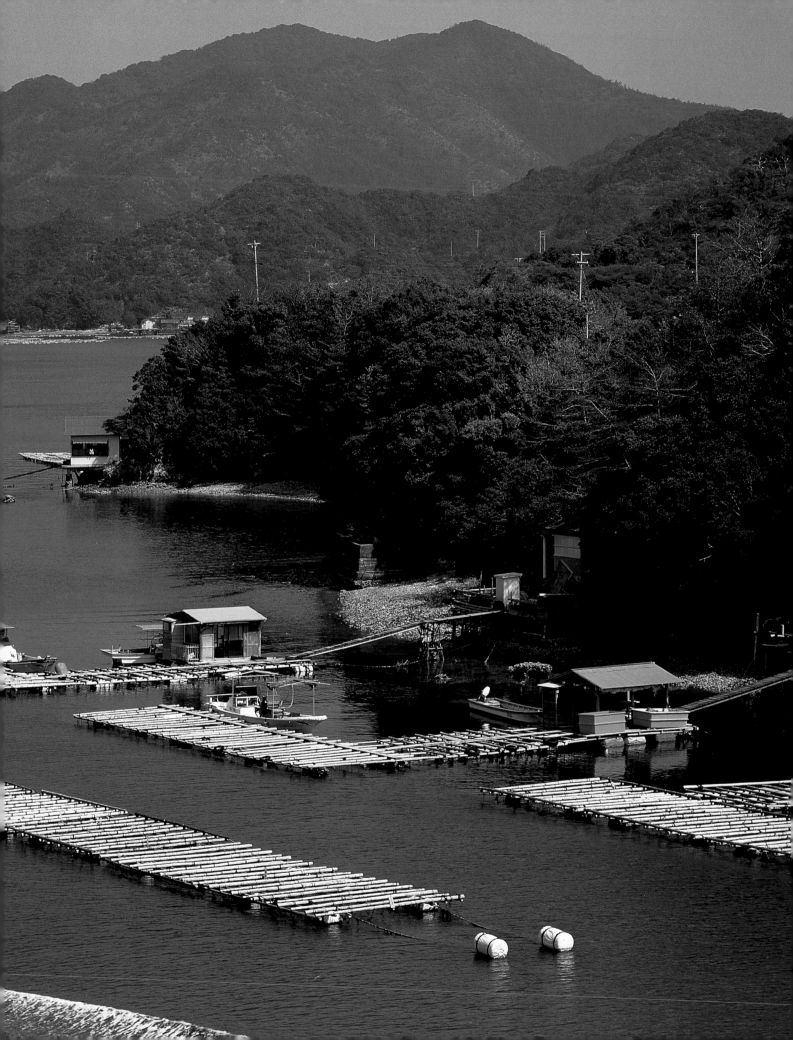

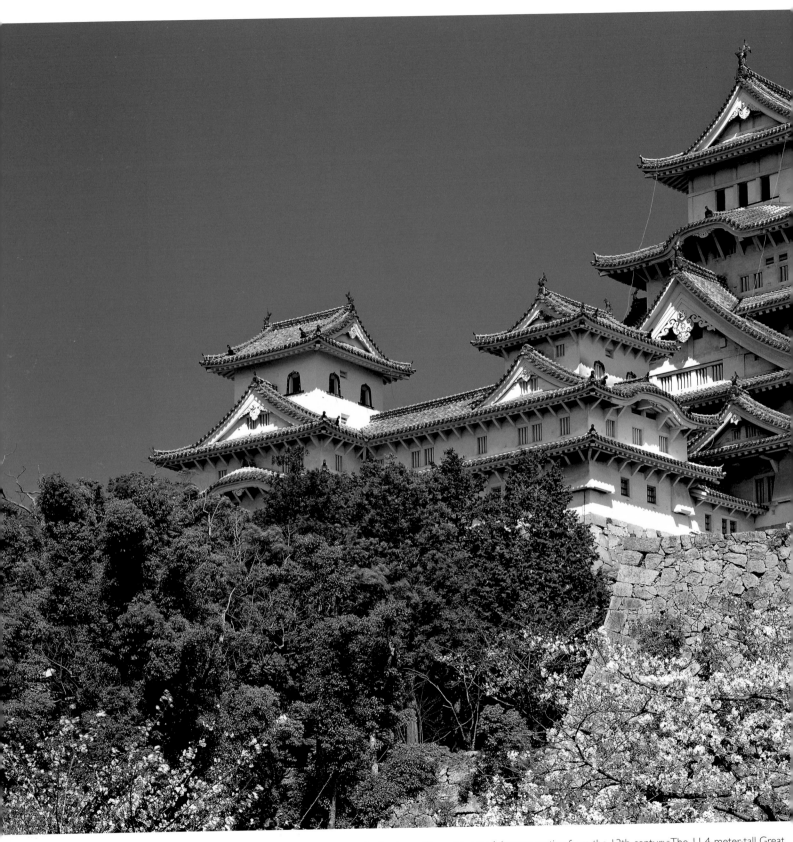

Previous page: Cultured-pearl farms in the bay of Nie on the Shima-Hanto Peninsula.
Above: The city of Himeji in western Honshu would be a completely ordinary industrial and trade center were it not for this extraordinary, perfectly preserved castle. Even its name, Shirasagi-jo, means the "castle of the white heron."

Opposite, top: A bronze casting from the 13th century: The 11.4-meter-tall Great Buddha of Kamakura just outside of Tokyo is an impressive sight.
Opposite, bottom: A brilliant red maple before the Engakuji Temple in Kamakura. T temple, which belongs to the Rinzai sect, was established by Hojo Tokimune in 128

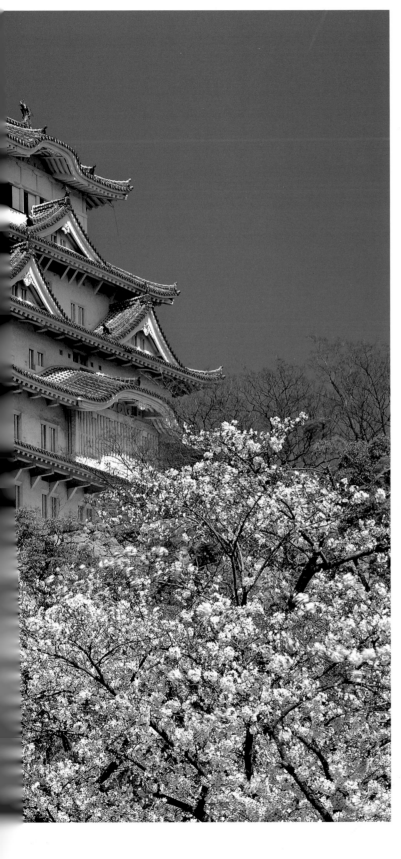

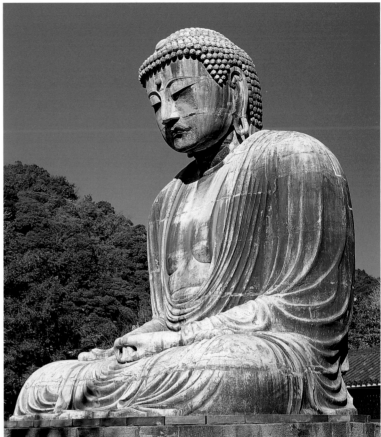

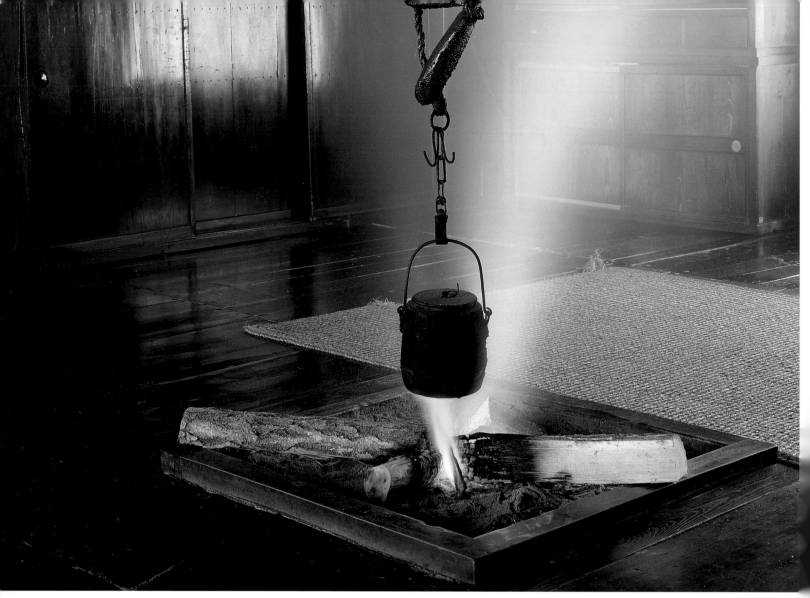

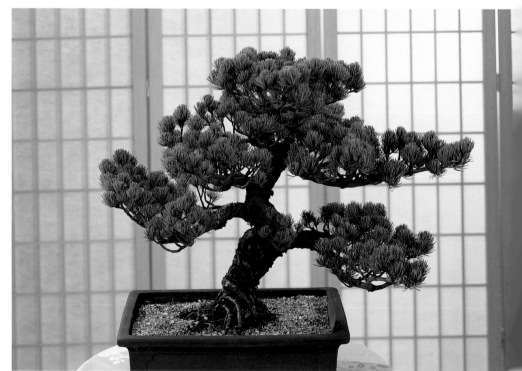

Above: A cast-iron kettle hangs above an open fireplace in an old farmhouse in Honshu's Gifu Prefecture.
Right: Scotch-pine trees are among the favorite kind of plants used in bonsai creations. The "tree in a bowl," which originated in China, was already known in Japan by the 11th century.

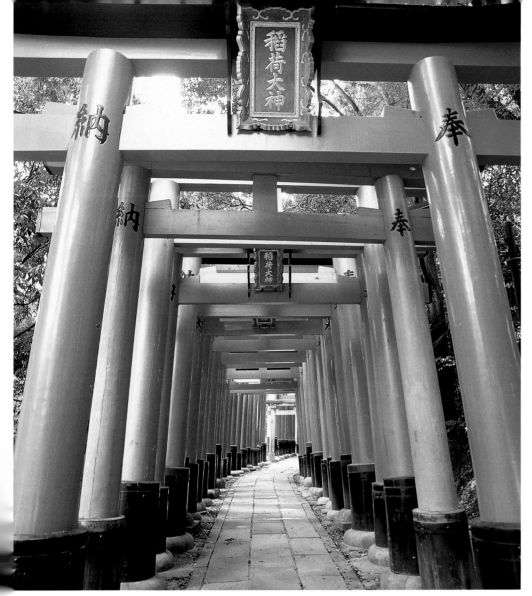

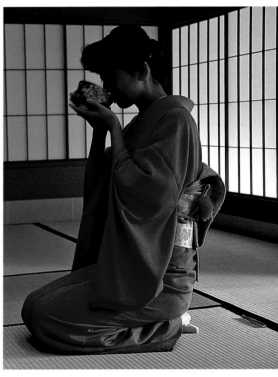

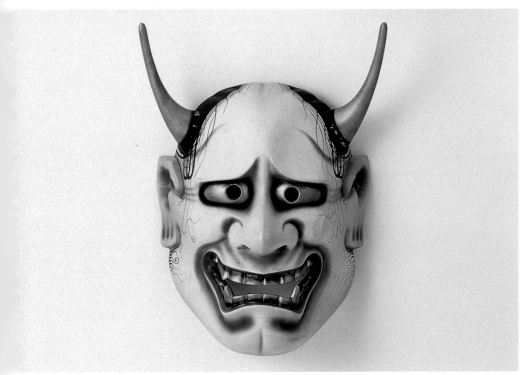

Above, left: The unusual aspect of the Fushimi-Inari-Taisha Shrine in Kyoto is a four-kilometer-long circular path through a tunnel made up of more than 10,000 *torii*. The path was donated by companies and private individuals.

Above, right: The tea ceremony has its roots in the aesthetics and religious feelings of the Japanese. While drinking, the teacup is held in both hands.

Left: This wooden mask for a No performance is called "Hannyo" and represents—surprisingly—a female demon.

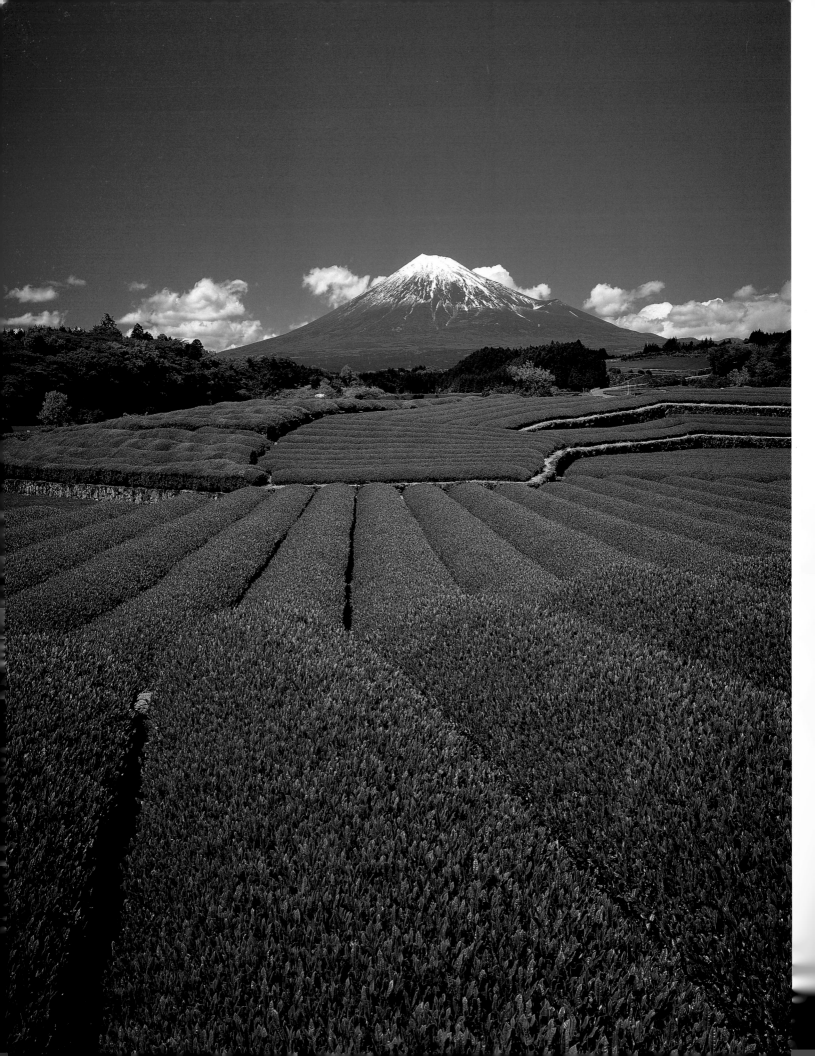

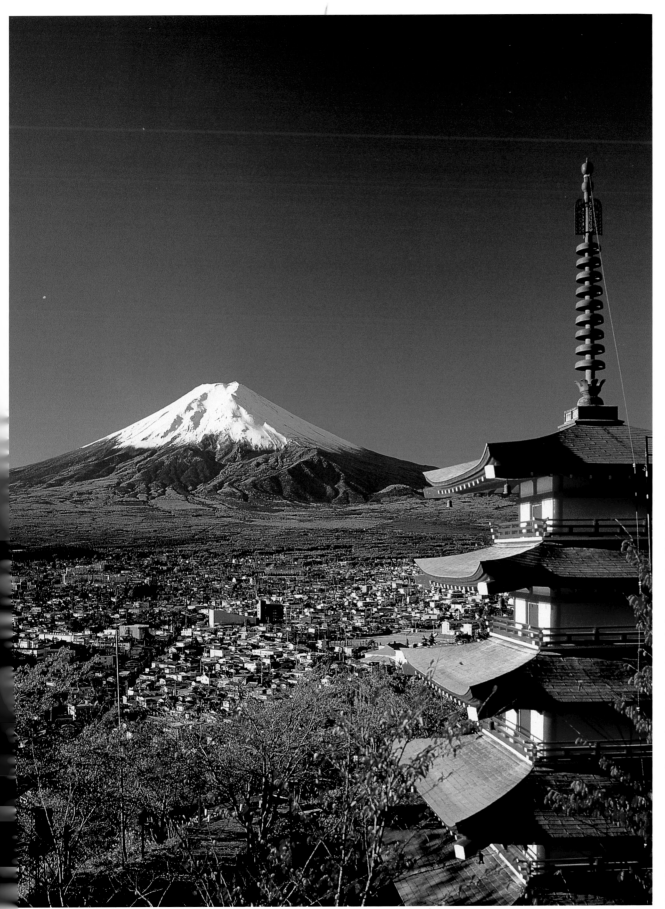

Opposite and left: From every angle, no matter what is in the foreground—tea fields or a pagoda—Fuji-san (the name "Fujiyama" is not used in Japan) has a perfect form. To the Japanese, the highest mountain of the central Fuji chain of volcanoes is both a sacred place and a symbol of the country. Viewed as the seat of the gods, Fuji-san has since the 12th century been described by Buddhist teaching as the gate to another world. From the scientific perspective, Fuji-san is a strato volcano that originated in the Quaternary period. It has an almost perfectly round base with a circumference of 35 to 40 kilometers and has experienced 18 confirmed eruptions.

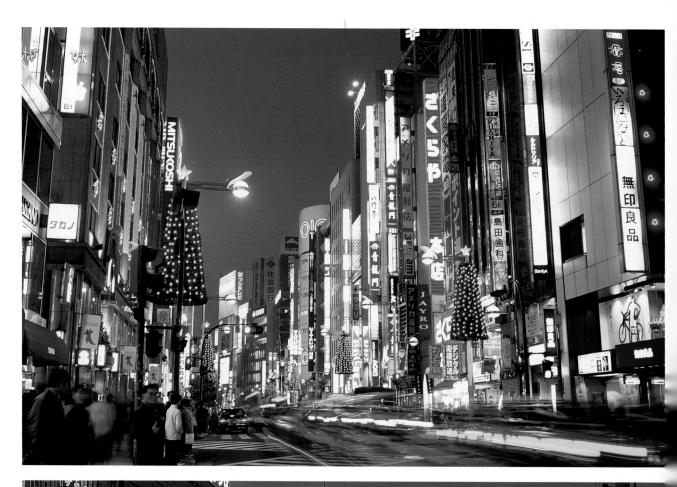

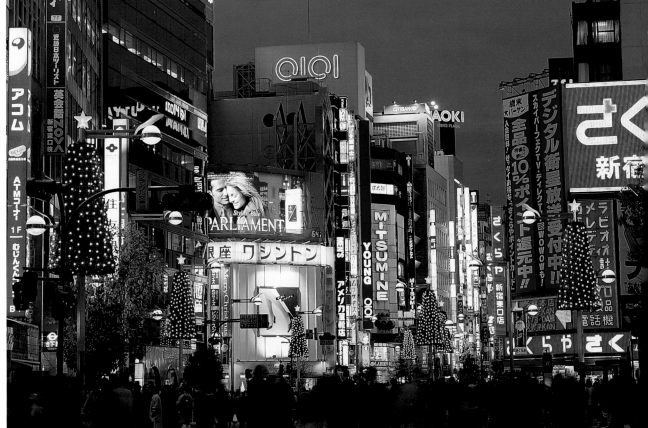

Above and right: When darkness falls, Shinjuku's neon signs send their blinking messages into the night. This northern district of Tokyo is one of the city's most lively junctions, with department stores, shopping arcades and diverse places of entertainment.

Opposite: When does the working day end in Japan? In the 234-meterhigh Shinjuku Park Tower (front) and the 235-meter Tokyo Opera City Building, the offices are still brightly lit at night.

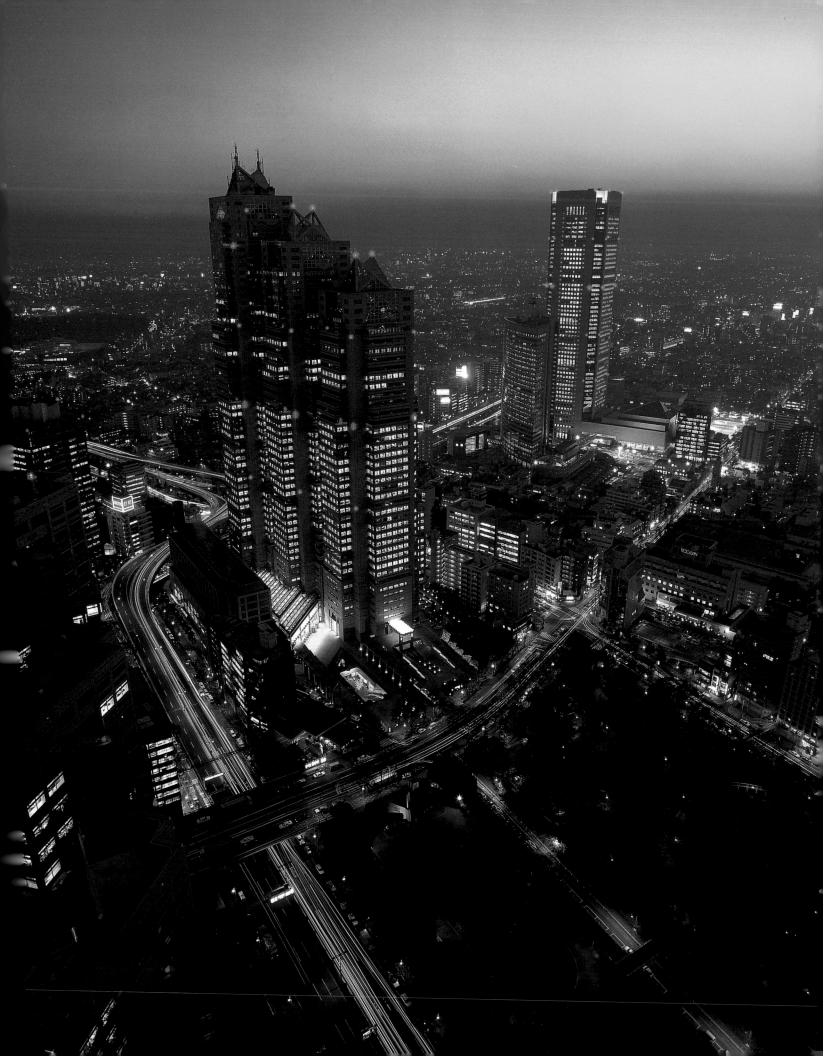

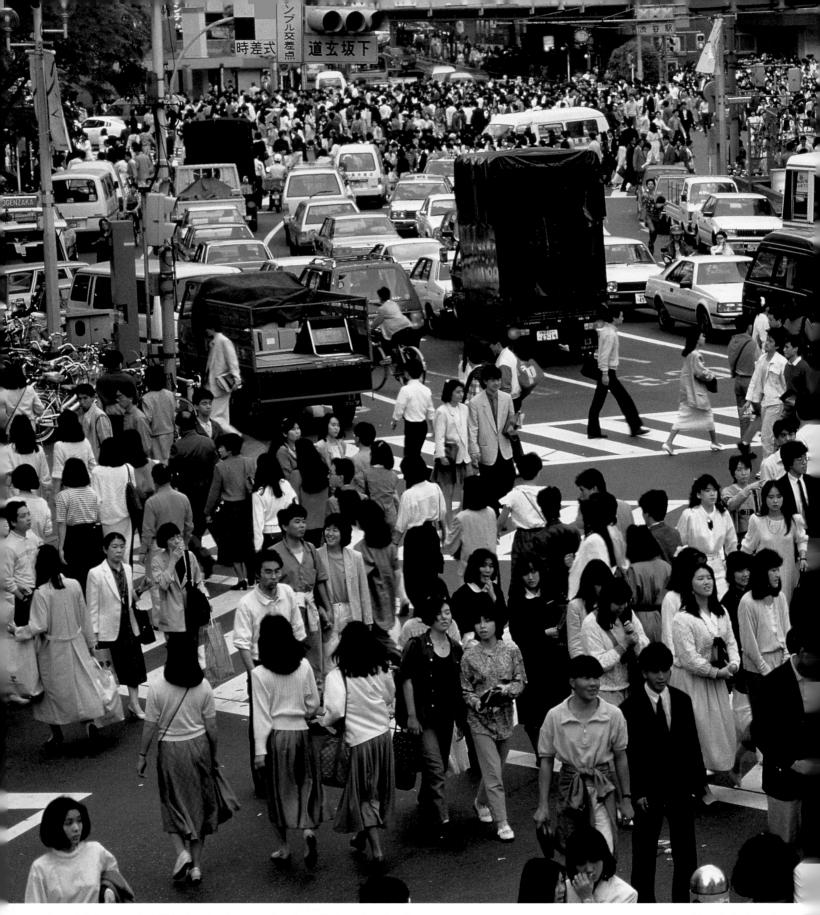

Above: A Shibuya tangle: At Tokyo's major street crossings the traffic lights stop all traffic. The masses then stream over the zebra crossings from every direction.
Opposite, top: Shinkansen, pride of the railway: The 16-car trains carry 1,300 travelers. The main station in Tokyo is the interchange of the Shinkansen lines.

Opposite, middle: Evening rush hour on the Yamamote line, Tokyo's circular railway. T' trains carry many commuters daily as they pass through residential and business distr
Opposite, bottom: White gloves are required: a railway employee in a station—emp for once.

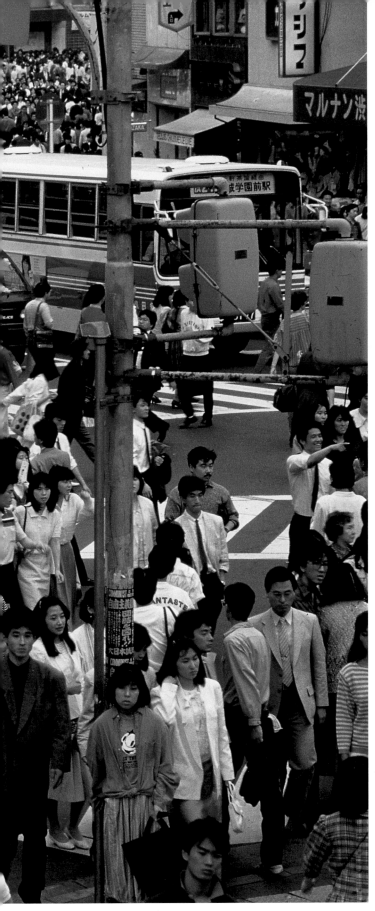

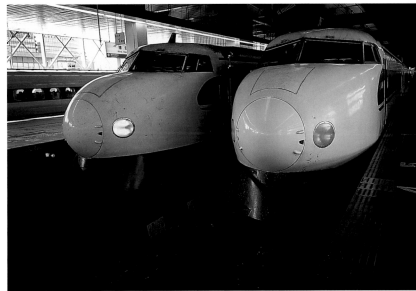

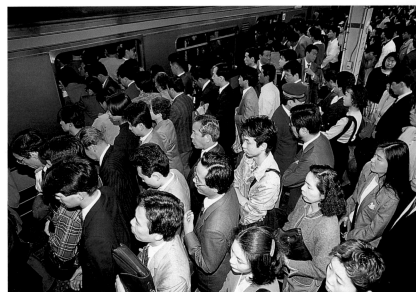

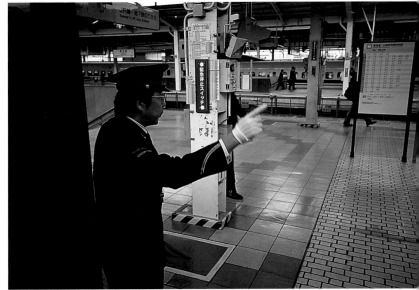

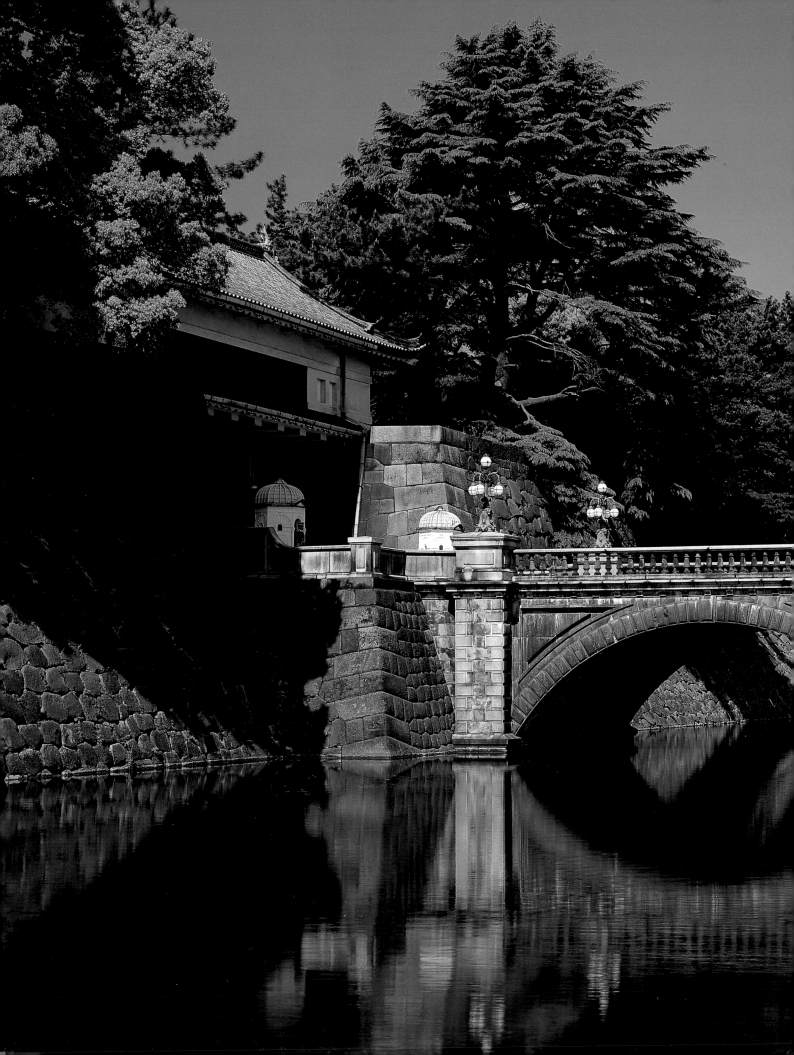

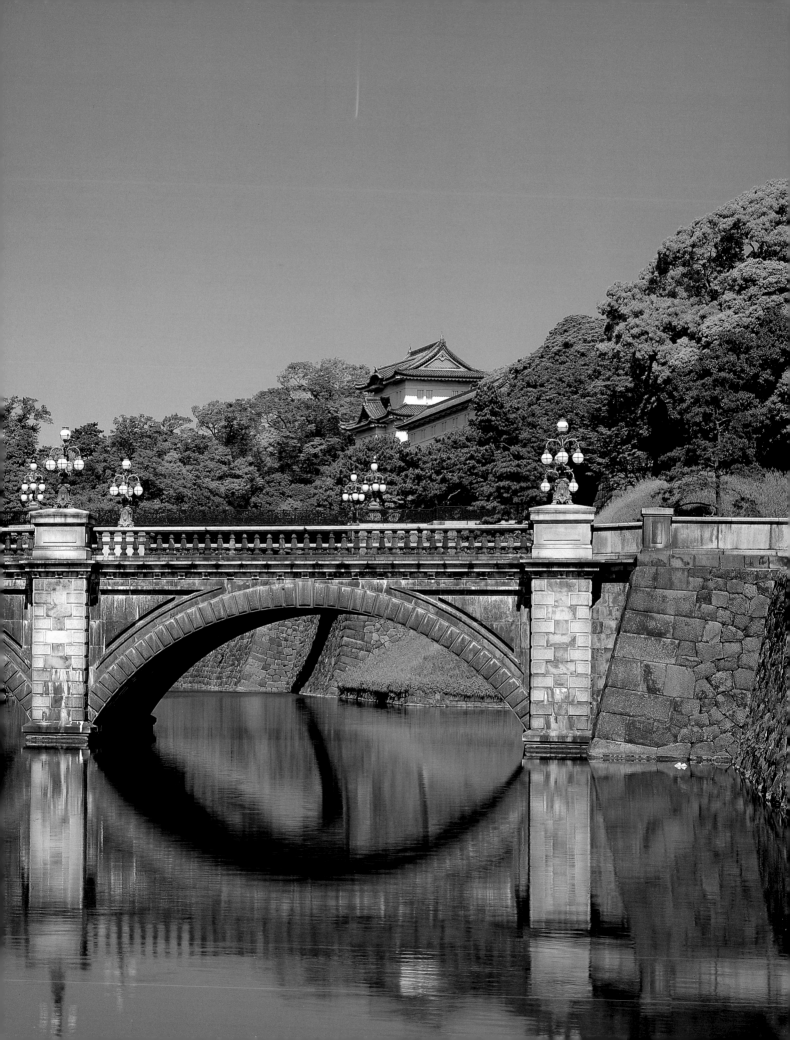

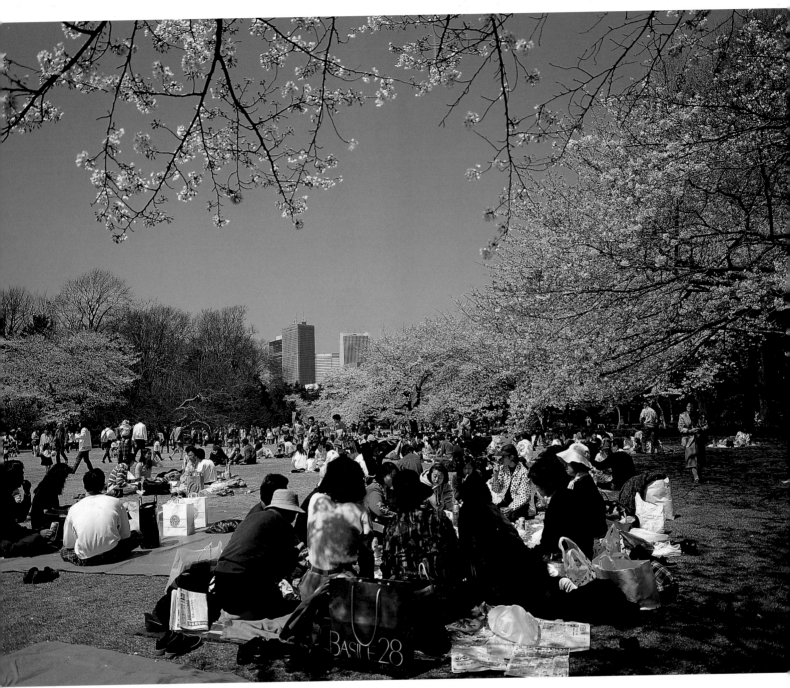

Previous page: Niju-bashi, the "Twin Bridge", leads to the imperial palace at the center of Tokyo. Citizens can cross it twice a year: on the 23rd of December, the emperor's birthday, and for the New Year's festival in January 1st.

Above: Only those who come on time get a place: cherry-blossom party in Shinjuku Park. Once the almost-60-hectare park belonged to the emperor, but after the Second World War it was opened to the public.

Opposite, top: The Senso-ji in the Asakusa district is the most characteristically Japanese temple in Tokyo. It is also called Asakusa Kannon, after the god who is worshiped here. According to legend, the temple was established by three fishermen who found a statue of the god in their nets.

Opposite, bottom: Temple festival in Senso-ji. Women and men from the district carry a transportable shrine. The short jacket they are wearing is known as a *happi* in Japanese.

Next page: The name says it all: This neighborhood in the city district of Akihabara called "Electronic City." Here more than 600 discount stores sell electronic items. Loudspeakers blare out an uninterrupted stream of advertising slogans, and sunglasses protect visitors from the dazzling neon lights.

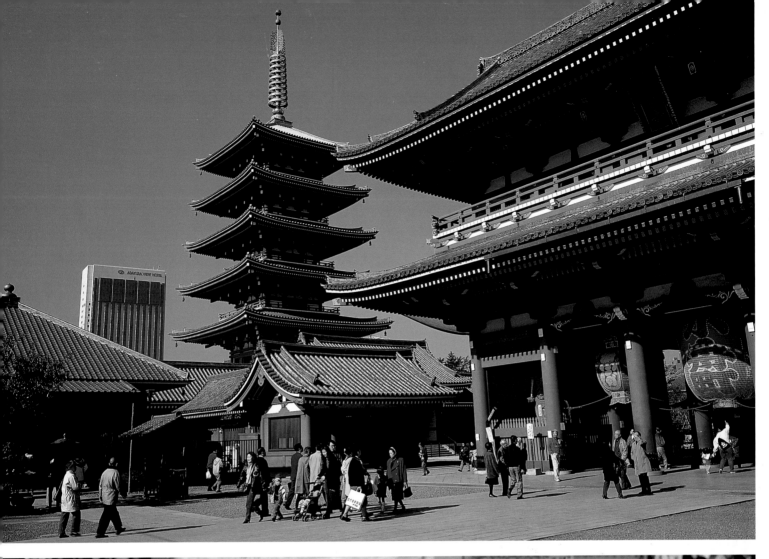

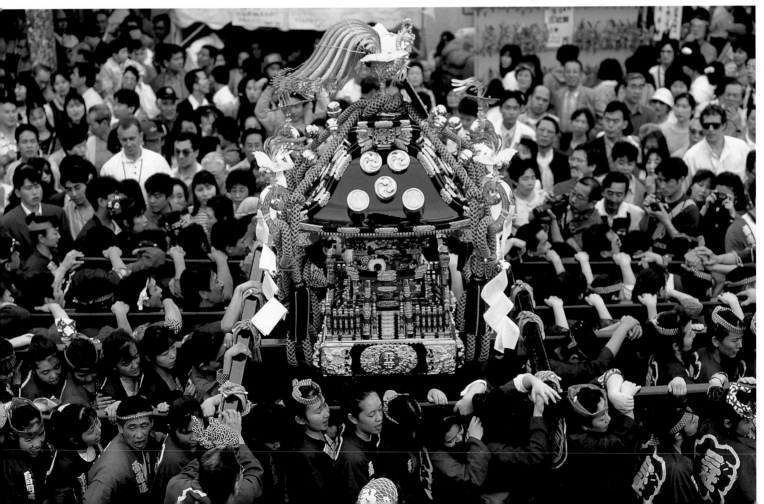

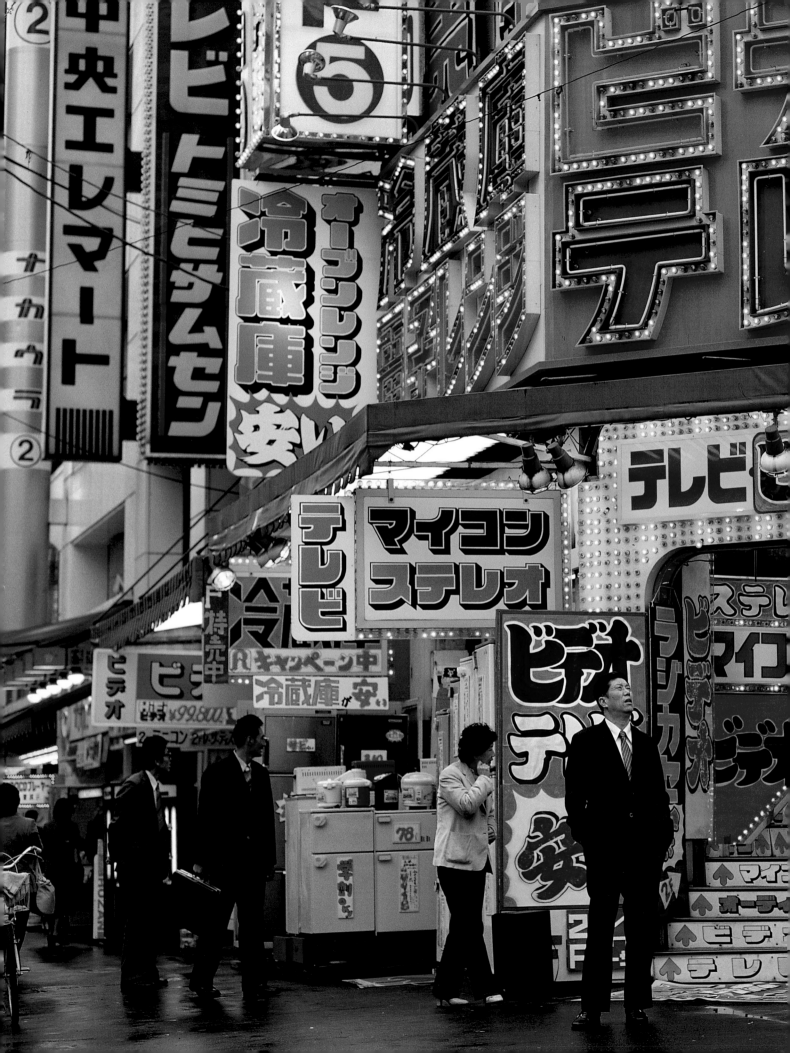

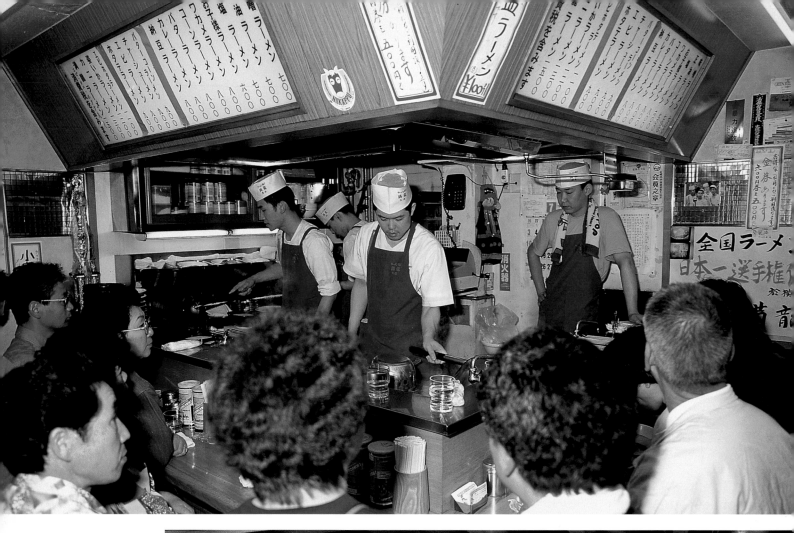

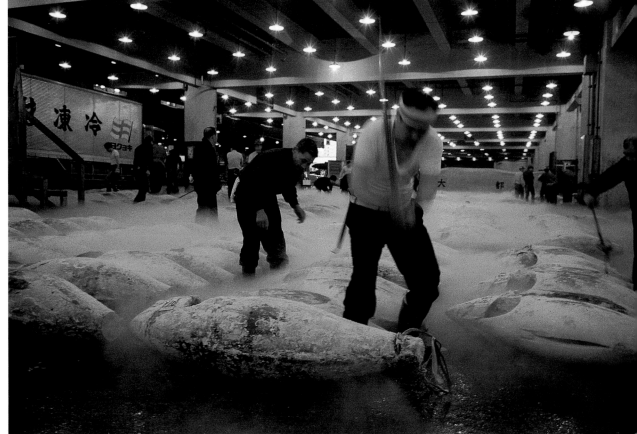

Above: Slurping is allowed: A noodle-soup restaurant in Sapporo, the capital of the northern Japanese main island of Hokkaido.

Right: Frozen tuna fish in the Tsukiji Fish Market. Here 90 percent of Tokyo's entire fish requirement is sold.

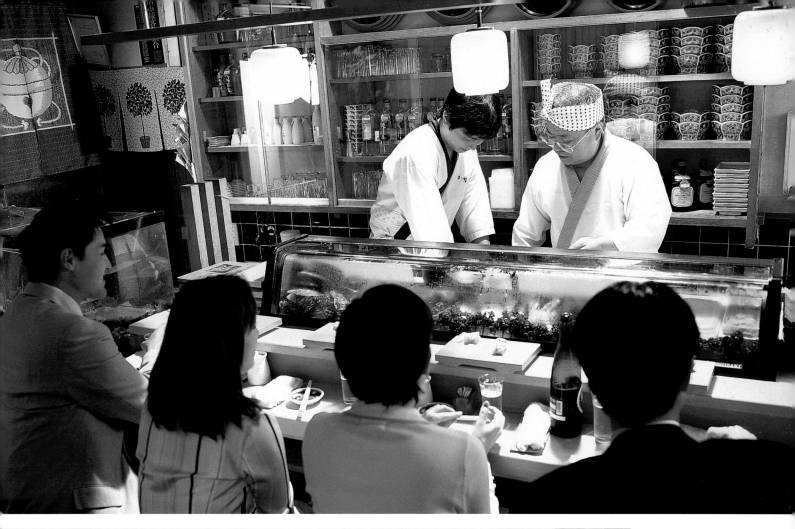

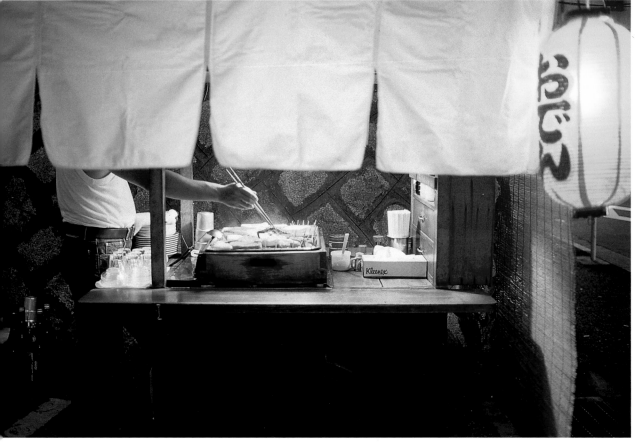

Above: Everything is freshly prepared bhind the counter in this sushi restaurant. Sushi consists mostly of balls of vinegared rice on which slices of various kinds of fish are placed.

Left: This food stand sells oden, beer and sake, which is made from rice. Sake has an approximately 15-percent alcohol content and is drunk cold as well as warm.

JAPANESE FOOD
A Feast for the Senses

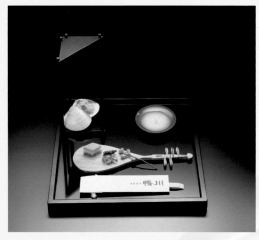

There is a name for everything. In the vernacular, Tsukiji, the largest fish market in Asia, is called "the stomach of Tokyo." When Tsukiji opens its doors around three in the morning, trucks and minivans are already waiting outside. In the old halls and run-down storehouses, lit by glistening halogens, greenish neons and naked light bulbs, the daily hurly-burly of buying and selling begins. At the Tsukiji Fish Market, chain stores, supermarkets, delicatessens, sushi restaurants, chefs and housewives load up on oysters, shrimp, langoustines, salmon, swordfish, squid, cod, sea urchins, sea cucumbers and dried seaweed. Frozen tuna fish are cut up using circular saws. Every day more than 2,500 tons of fish and shellfish are sold. Around 5:00 a.m., trade begins in the auction halls. Depending on the season, eight to ten auctioneers sell the catch. Afterwards, gourmets meet in the little restaurants near the market for an early breakfast of sashimi (slices of raw fish) and sushi (raw fish on vinegar-soaked rice balls) dunked in green horseradish and soy sauce.

Japanese cuisine has long since captured the palates of diners around the world. Japan's cuisine is light and healthy, freshly prepared and beautifully presented.

Until the last century meat was almost unknown in Japan; Buddhists did not eat four-legged animals. The only exception was the rabbit, which, because of its large, winglike ears, was designated a bird. After the war, under the influence of the American occupiers, eating habits changed. Today's Japanese are familiar with bread and sausage, cheese and meat. What remains unchanged is the meaning of rice. In the olden times, rice was used as a currency and a standard for tax payments. Rice, called *gohan* in Japanese, was the synonym for a meal. Even today rice is eaten twice daily—at breakfast and at dinner, when it accompanies the main dish.

For the visiting gourmet, a trip to a *ryokan*, a traditional Japanese restaurant, is a must. Here specialties of the region are served at dinner and breakfast. A delicious set menu might include raw slices of carp; grilled flounder; catfish, pork and mushrooms in a spicy sauce; and meat rolls and homemade noodles, all served with miso soup and rice.

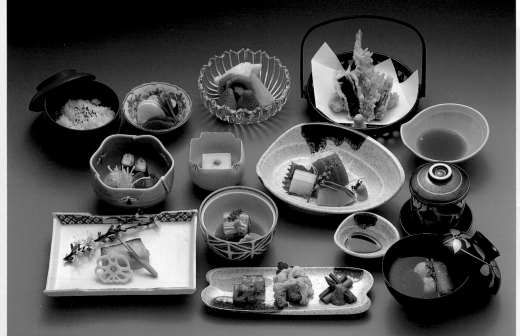

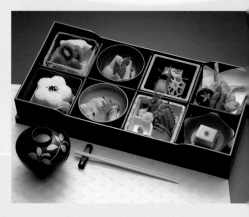

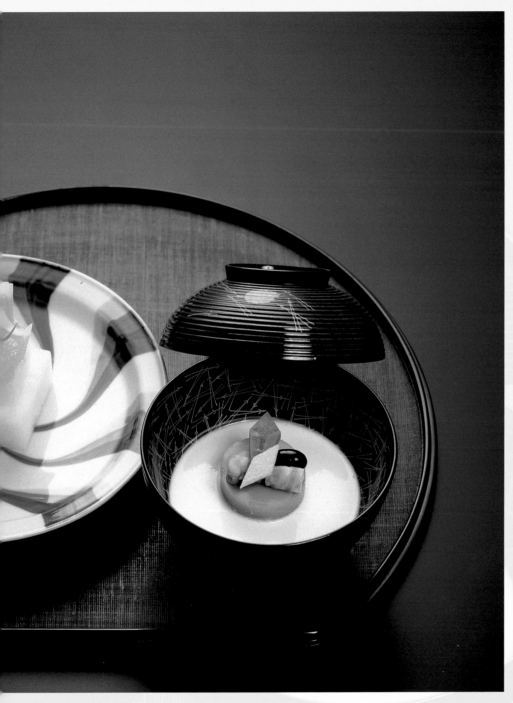

Japanese Delicacies

Nabe

Japan's beloved winter stew is prepared in a pot placed over a gas cooker at the center of the table. Chicken or salmon is chopped up small; tofu is cut into squares; leek, Chinese cabbage, mushrooms and viper's grass are chopped into appropriate-sized pieces. All ingredients are then arranged on a large plate. Meat and vegetables are then simmered briefly in a hearty broth, after which the mouth-sized morsels are dipped in a special sauce. In the remaining broth, thick soba noodles are cooked or a creamy rice soup is prepared.

Soba

This is the perfect food for a hot summer's day. Buckwheat noodles are boiled briefly, cooled with cold water, then served on a bamboo tray. To enhance their taste, the noodles are dipped in a sauce made of soy, sweet sake and wasabi (green horseradish).

Yakitori

This popular meal is the ideal accompaniment for beer and sake. Every part of a chicken (for example, wings, skin and liver) as well as boiled quail eggs, shitake mushrooms and balls of chopped meat are threaded onto bamboo spits and grilled over an open charcoal fire. Before being grilled, the items are either salted or dipped in a special sauce.

Ramen

A tasty snack that consists of wheat noodles in a hot meat broth made up of soybeans, bamboo sprouts, shallots and thin slices of pork. The noodles are eaten with chopsticks, which create an unmistakable sound. Anyone who has stood on a train platform beside a ramen stand knows that five noodle-slurping Japanese easily drown out the noise of an incoming fast train.

Opposite, top: Artistically draped sashimi is a special delicacy. The raw fish is dunked in a soy sauce flavored with ginger and grated radish. **Opposite, bottom:** The highest form of Japanese cuisine is called Kaiseki ryori. This many-coursed meal is served in special restaurants and in *ryokans*, the traditional Japanese guesthouses.

Above: A feast for the eyes: In gourmet restaurants great attention is paid to presenting sashimi aesthetically. This meal consists of morsels or slices of raw fish. **Left:** Fast food, Japanese-style: O-Bento is the Japanese name for take-out or fast food. The dishes—ranging from sashimi, tempura, tofu and pickled vegetables to rice and soup—are served in bowls and lacquer boxes.

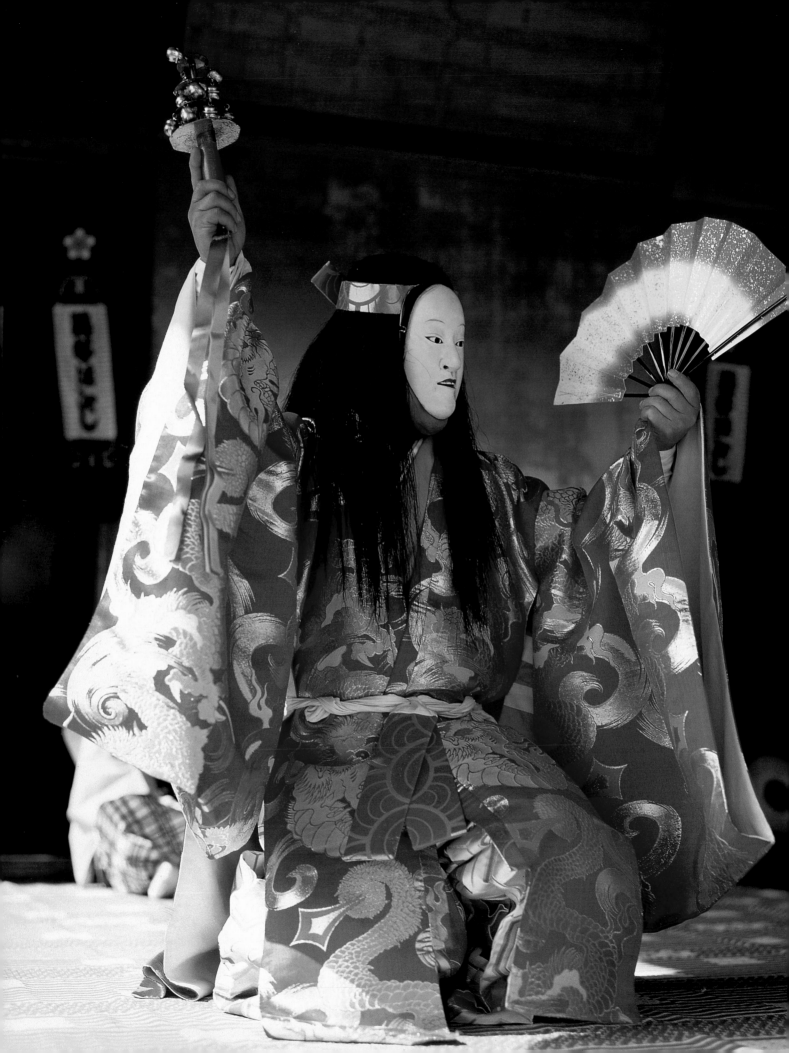

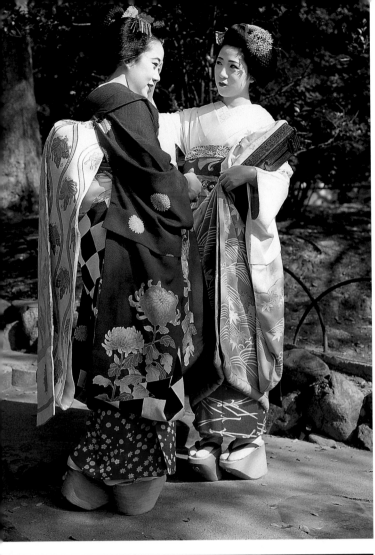

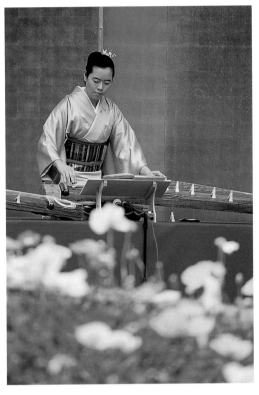

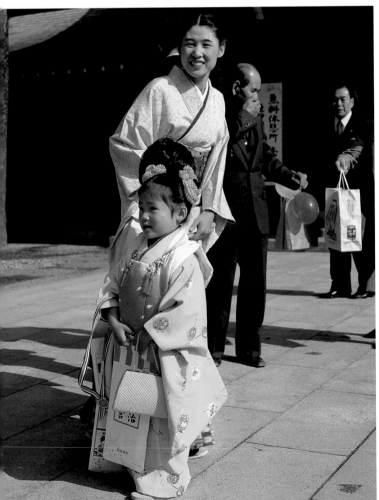

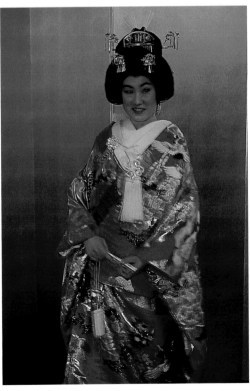

Like so many other things, the kimono came to Japan from China—in this case, in the eighth century. But it was in Japan that it was perfected. The eight parts of a kimono are cut from a single piece of cloth. It is fitted to the wearer using gathers and held together with a broad sash called an *obi*. The result is pure elegance, whether worn in a No performance (opposite); by two *maikos*—young girls studying to be geishas (above, left); by a musician playing a string instrument called the *koto* (above right); by a mother and daughter on girls' day (far left); or by Mrs. Yuko Kiyono, who is wearing a splendid wedding kimono (left).

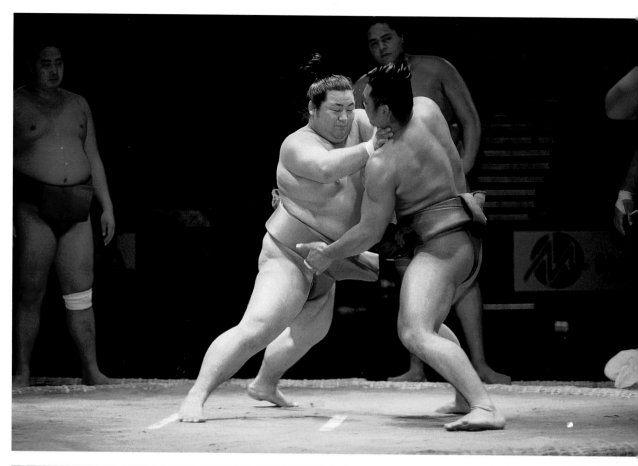

Above: Along with baseball, which was brought to Japan after the Second World War by the Americans, sumo is the most popular sport in Japan. Famous sumo wrestlers, few of whom weigh less than 100 kilos, are looked upon as national heroes. The loser is the first to be forced out of the 4.55-meter-diameter ring or to touch the ground with anything other than the soles of his feet.

Right: Sumo symbolizes a battle between two gods who are fighting over the possession of a province. At the beginning of each contest, purifying salt is thrown to ward off evil spirits.

Opposite: The shrine-like roof over the ring is a reminder that sumo once had a religious connection.

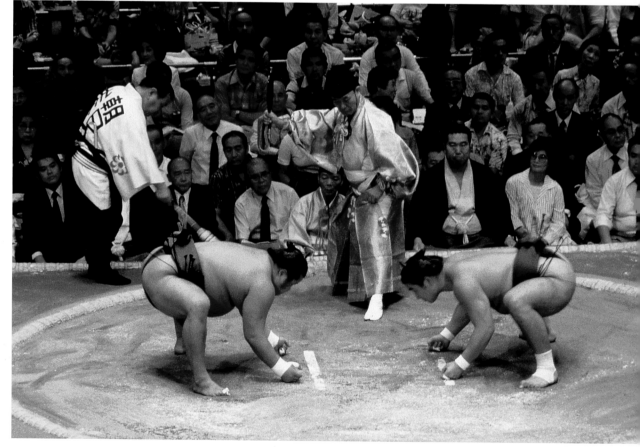

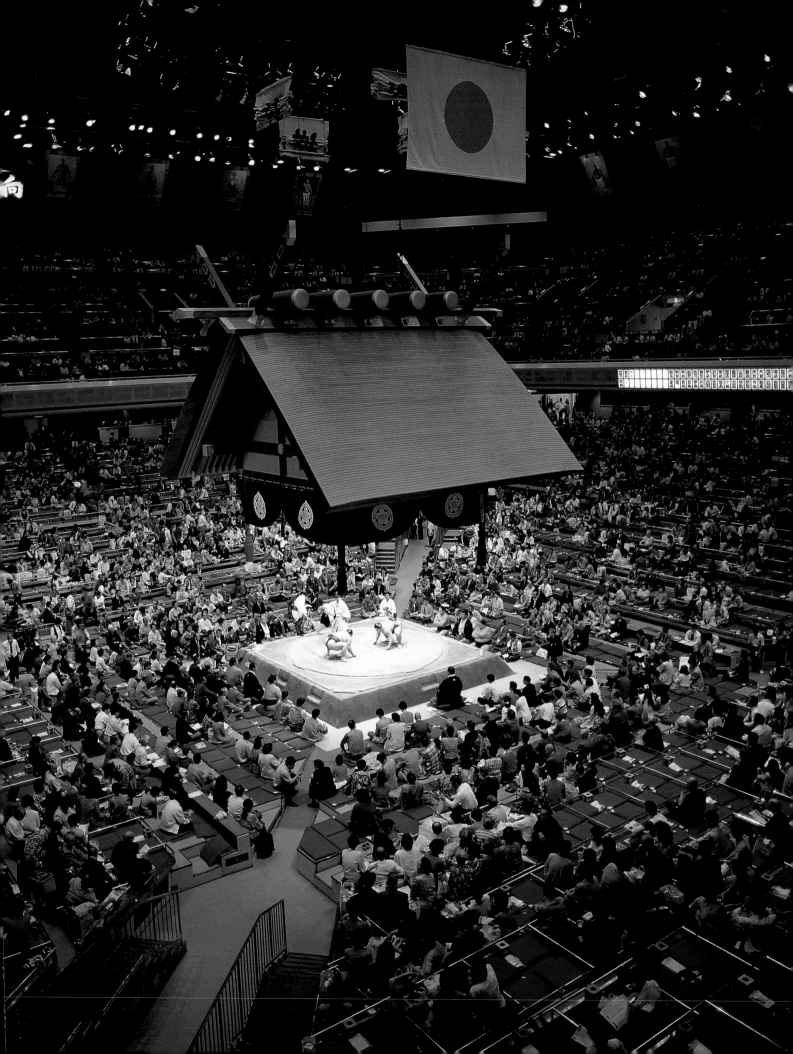

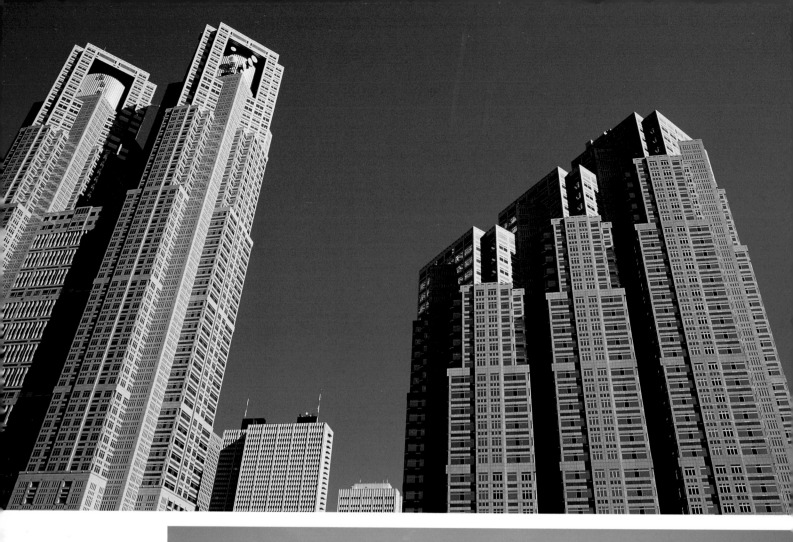

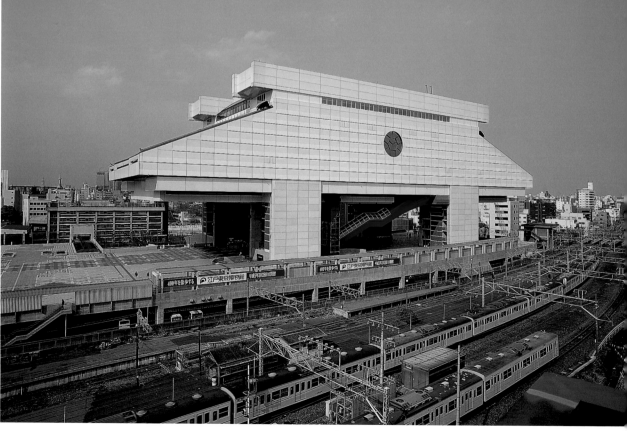

Above: The twin towers of the "Tokyo Metropolitan Government Office" are a Shinjuku city district landmark. The 243-meter-high towers were erected in 1996.

Right: The "Edo-Tokyo Museum" in the district of Sumida has as its theme the history and culture of the capital city. The modern building is modeled after an old department store.

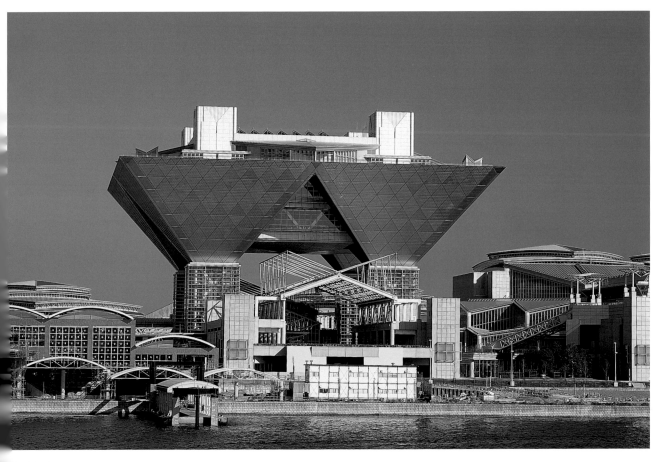

Left: Modern architecture with reversed pyramids: "Big Sight" is the name of the fair and exhibition buildings in Tokyo Bay.
Below: The Fuji TV station offices are located in this futuristic building on Tokyo Bay.

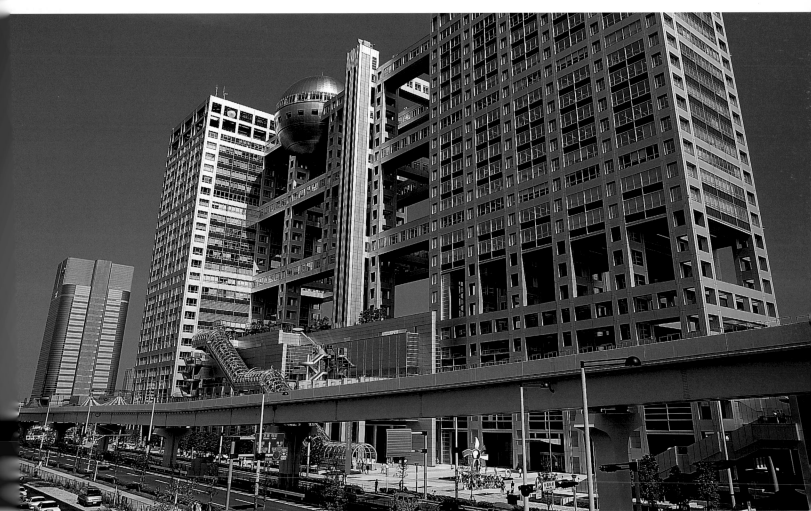

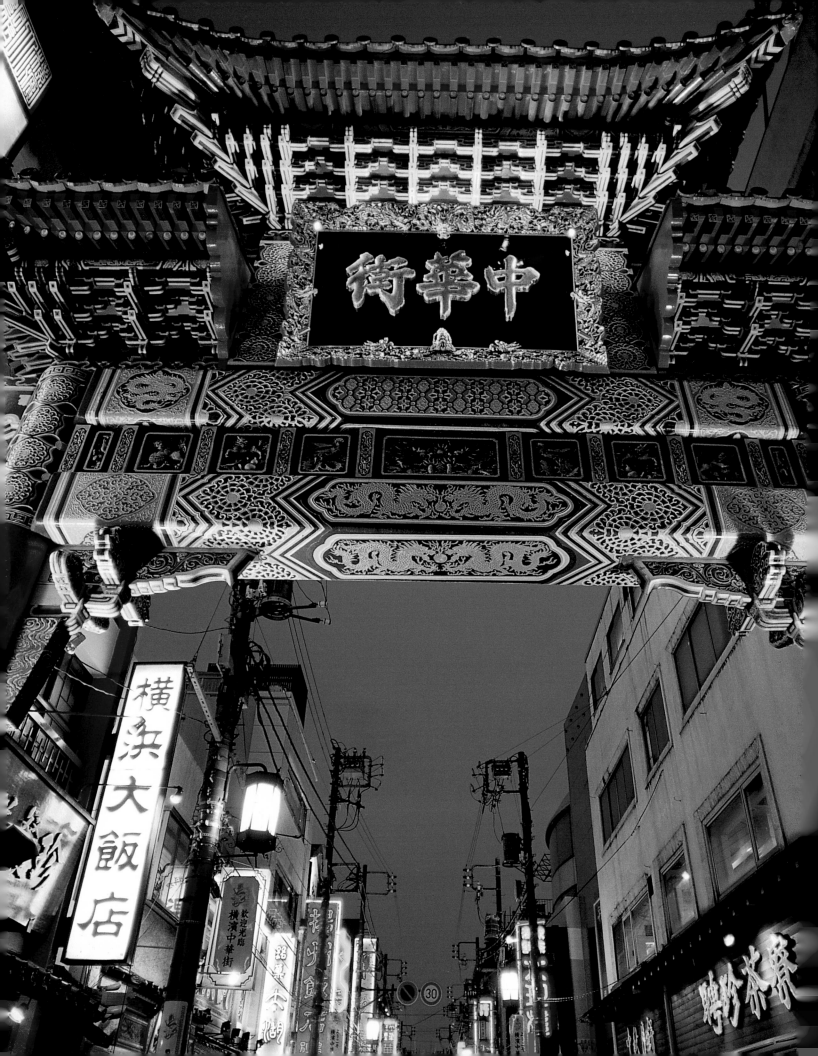

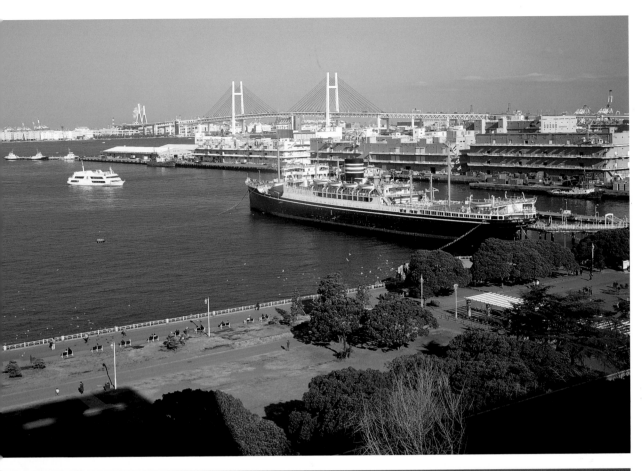

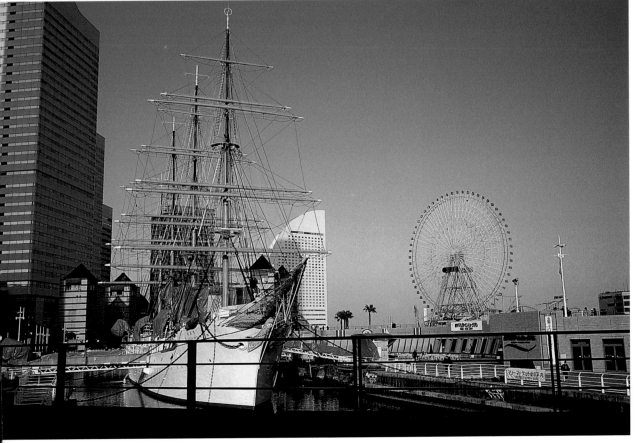

Opposite: Entrance to Yokohama's Chinatown, one of the largest Chinese communities in Japan. Yokohama became an important port after the opening of Japan to the West.

Above: The former passenger and hospital ship *Hikawa Maru* is anchored on Yokohama's waterfront. Today it serves as a museum.

Left: Sailing ship, Ferris wheel and skyscrapers: Minato Mirai, Yokohama's new city neighborhood, is both playful and modern.

93

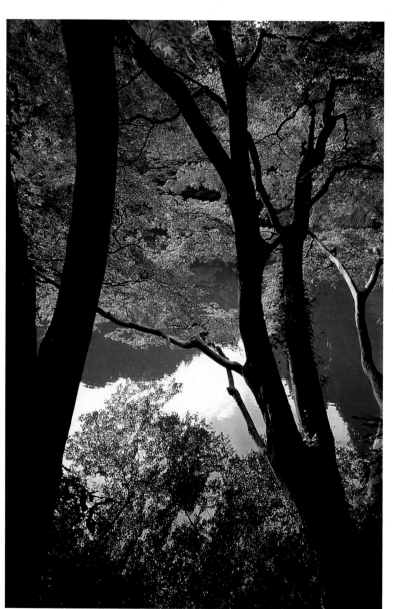

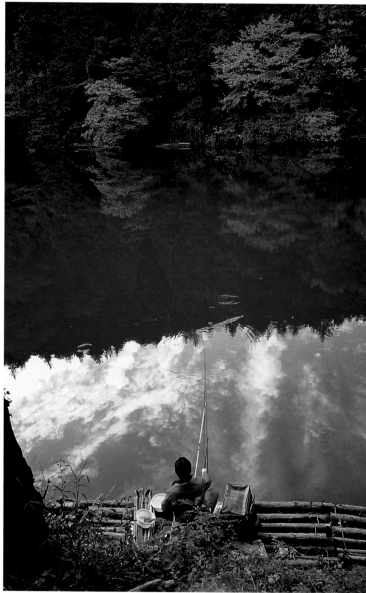

Above, left: From Tokyo, it takes only 50 minutes on a suburban train to reach beautiful Chichibu-Tama National Park, which extends over the Kanto Mountains northwest of the capital city. **Above, right:** In the Chichibu-Tama National Park, hectic big-city life is forgotten. Instead, one can fish in peace and solitude.

Opposite, top: Cause for contemplation: the romantic old farmhouses in Chichibu-Tama National Park. **Opposite, bottom:** Rowboats rest on the waters of the artificially made Chichibu Lake, located northwest of the Mitsumine Mountain.

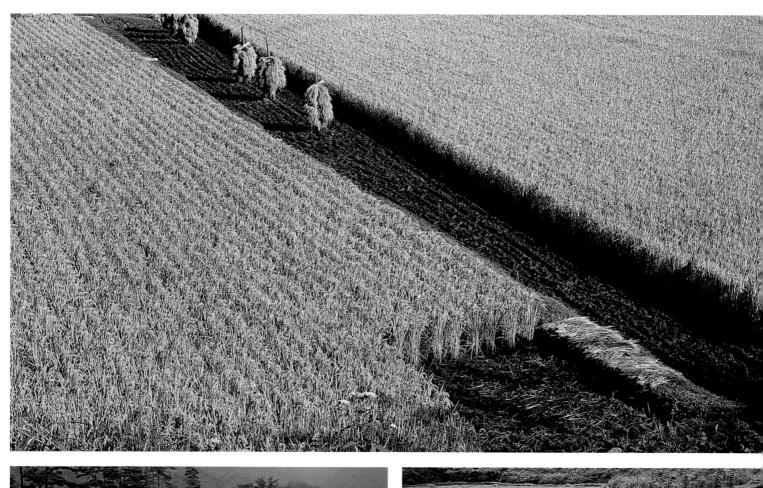

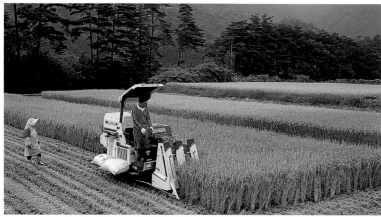

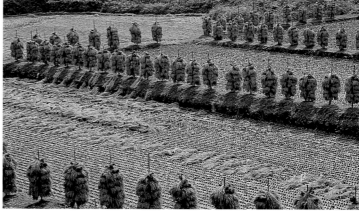

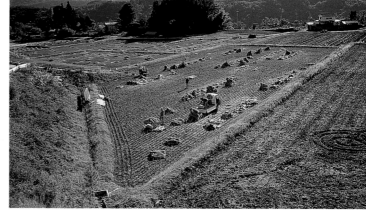

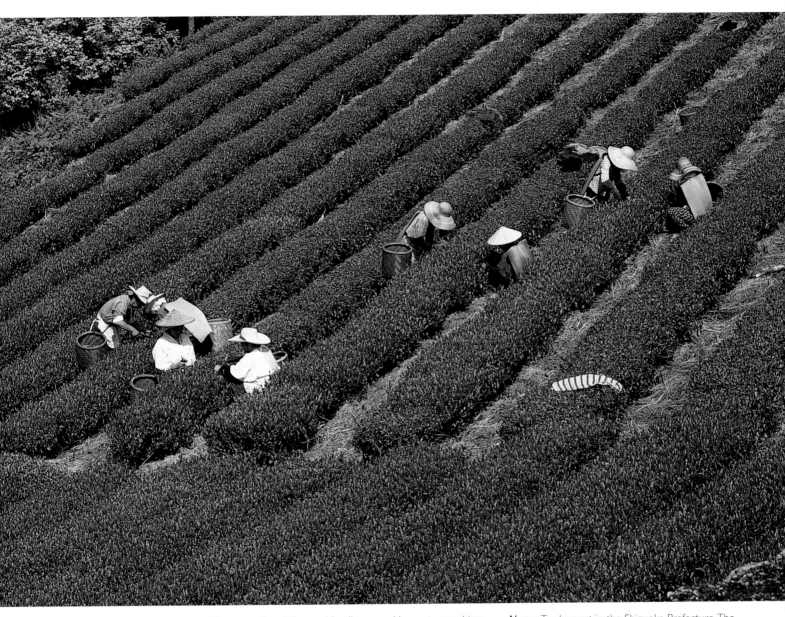

osite: The pattern of rice fields covers the land like tchwork quilt. Rice is Japan's most important culti- d agricultural product and the number-one basic dstuff. Its cultivation is a family business; the fields are

small, and the machine-jiggers and harvester combines look like toys. Nevertheless, rice fields make up approximately half of all cultivated land in Japan. The main area of cultivation is the island of Honshu.

Above: Tea harvest in the Shizuoka Prefecture. The leaves are still picked by hand. Tea is one of Japan's most important cultivated crops.

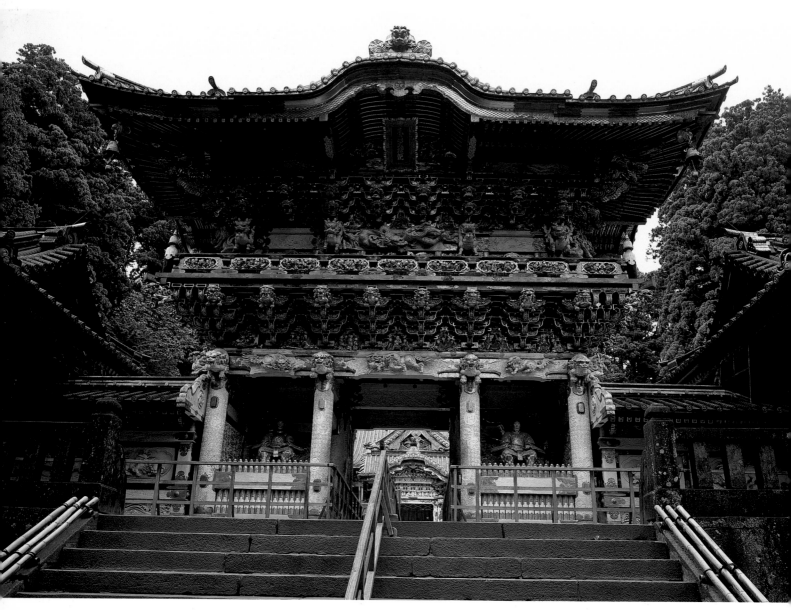

Above: The Toshogu Shrine is the most significant holy site in Nikko. More than 15,000 workers took part in erecting the original 22 buildings that make up the complex. Work still continues here virtually non-stop, since the richly decorated shrine buildings are restored every 20 years.

Opposite: A red bridge leads to the Godaido Temple on an island in Matsushima I More than 260 little islands densely covered with wind-tossed pines lie in the broa bay opposite the city of Sendai on Honshu's Pacific coast. Matsushima is considere to be one of Japan's three most famous scenic areas.

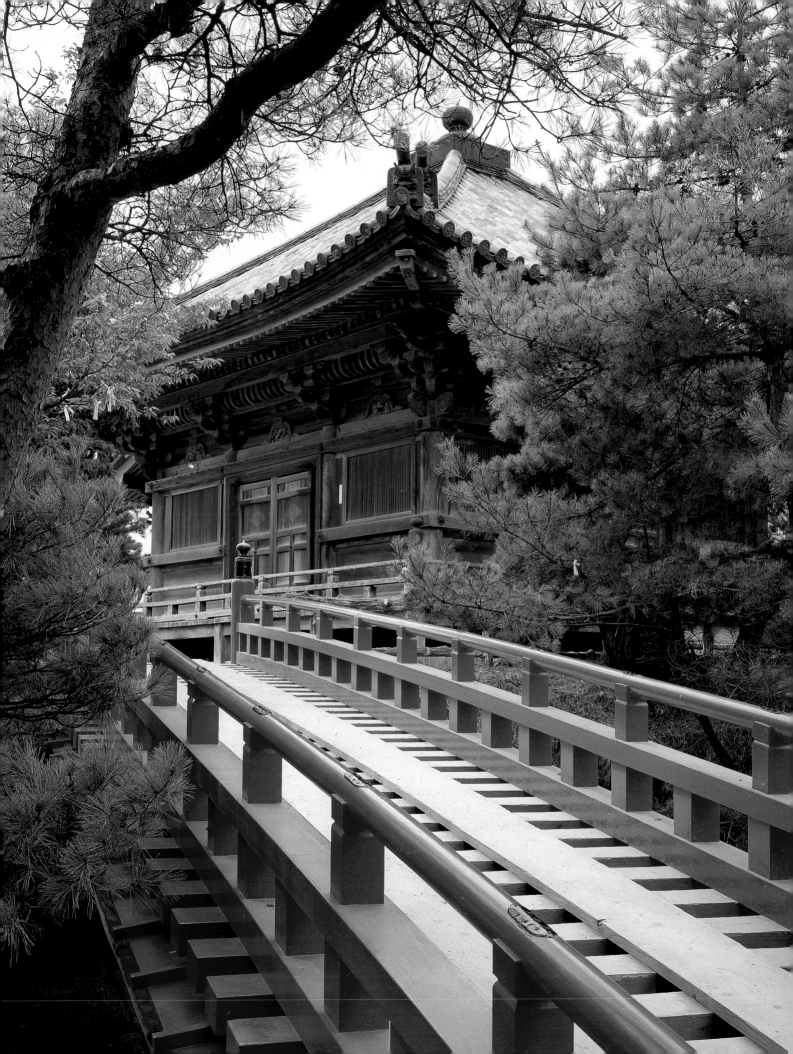

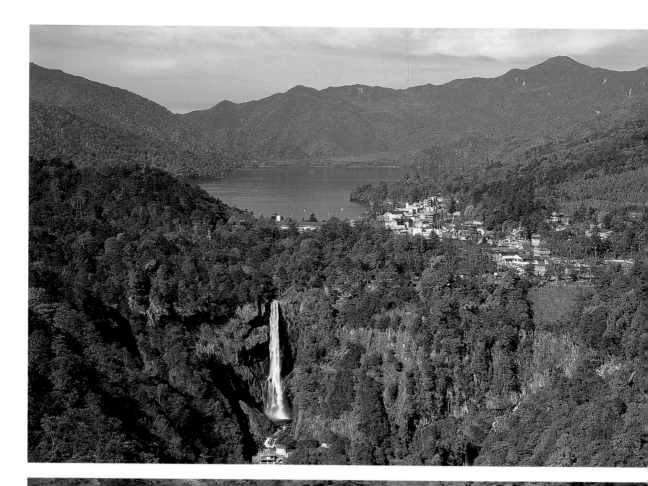

Above: The Kegon Waterfall in Nikko National Park is 100 meters high. With its majestic mountains, ancient forests, lakes and waterfalls, this national park is one of the most popular tourist destinations in Japan.

Right: Leaves on fire: Autumn colors in Nikko National Park west of the city of Nikko. The park is more than 1,400 square kilometers.

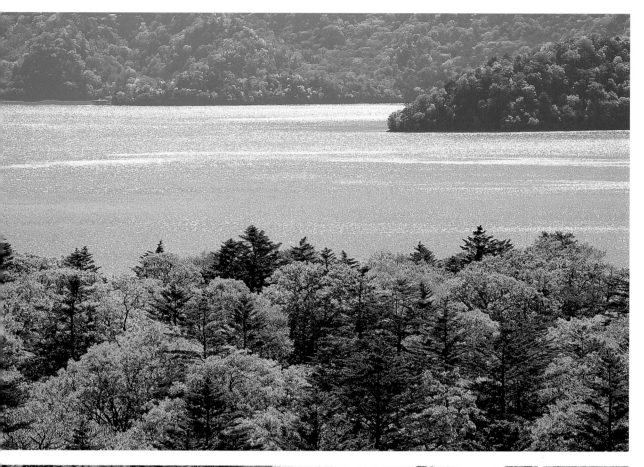

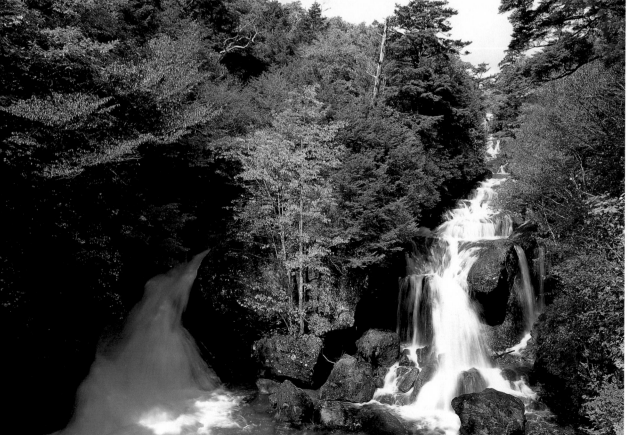

Above: Mirror of the heavens: Chuzenji Lake is located in the western section of Nikko National Park. On the eastern side of the lake, the waters plunge over the Kegon Waterfall.
Left: Numerous waterfalls, lakes, woods and marshlands attract visitors to Nikko National Park.

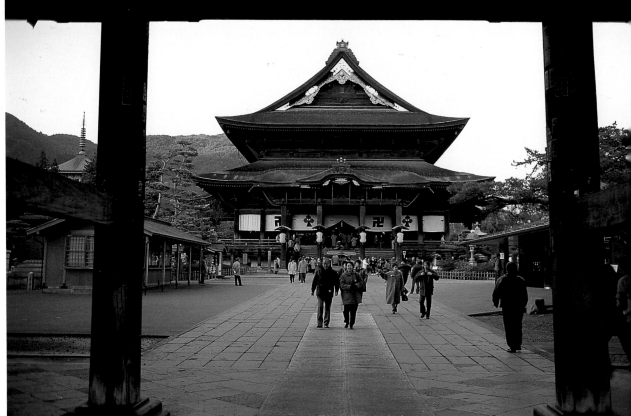

Above: What looks like equestrian banners are actually advertising flags before a temple dedicated to the Buddhist saint Bodhisattva.

Right: Place of pilgrimage in an Olympic city. The Buddhist Zenko-ji Temple in Nagano was established by Zenko in 624.

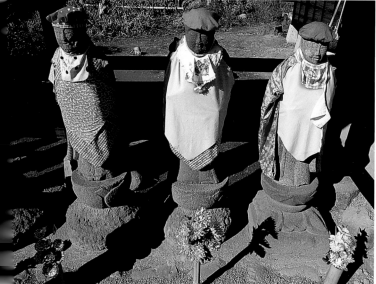

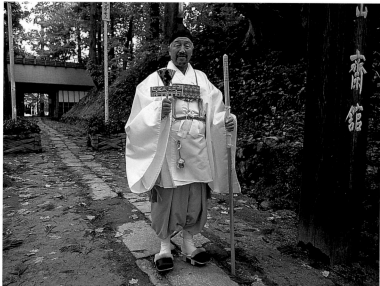

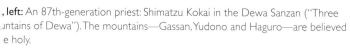

, left: An 87th-generation priest: Shimatzu Kokai in the Dewa Sanzan ("Three
~~untains~~ of Dewa"). The mountains—Gassan, Yudono and Haguro—are believed
~~~e~~ holy.
**~~ve~~, left:** Decorated with caps and bibs: Jinzo statues. In Japan religious artworks
~~~other~~ visible and tangible godly symbols are greatly respected.

Top, right: Two yamabushi (mountain ascetics) on the Haguro Mountain in Yamagata
Prefecture, one of the three Dewa Sanzan mountains. All three mountains are famous
pilgrim destinations.
Above, right: Mountain ascetics are among the most esoteric sects of Tendai
Buddhism. Their white clothing symbolizes both death and purity.

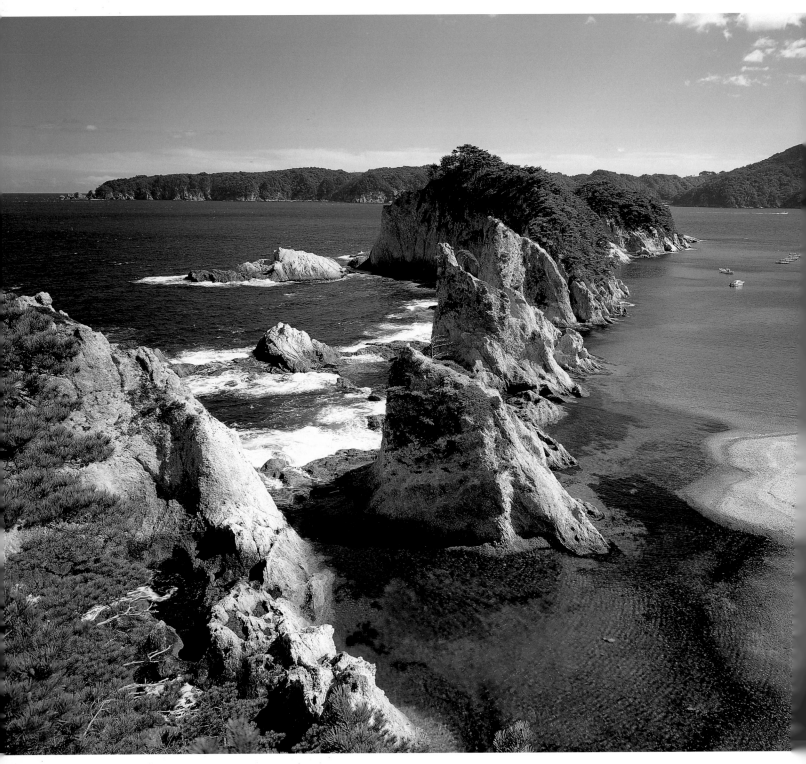

Above: Dark-green Scotch pines, white-sand beaches and clear blue water make Jodo Beach in Iwate Prefecture one of the most beautiful in Japan.

Opposite: The steep cliffs along the coast of Kitayama-Saki in the Iwate Prefecture reach as high as 300 meters.

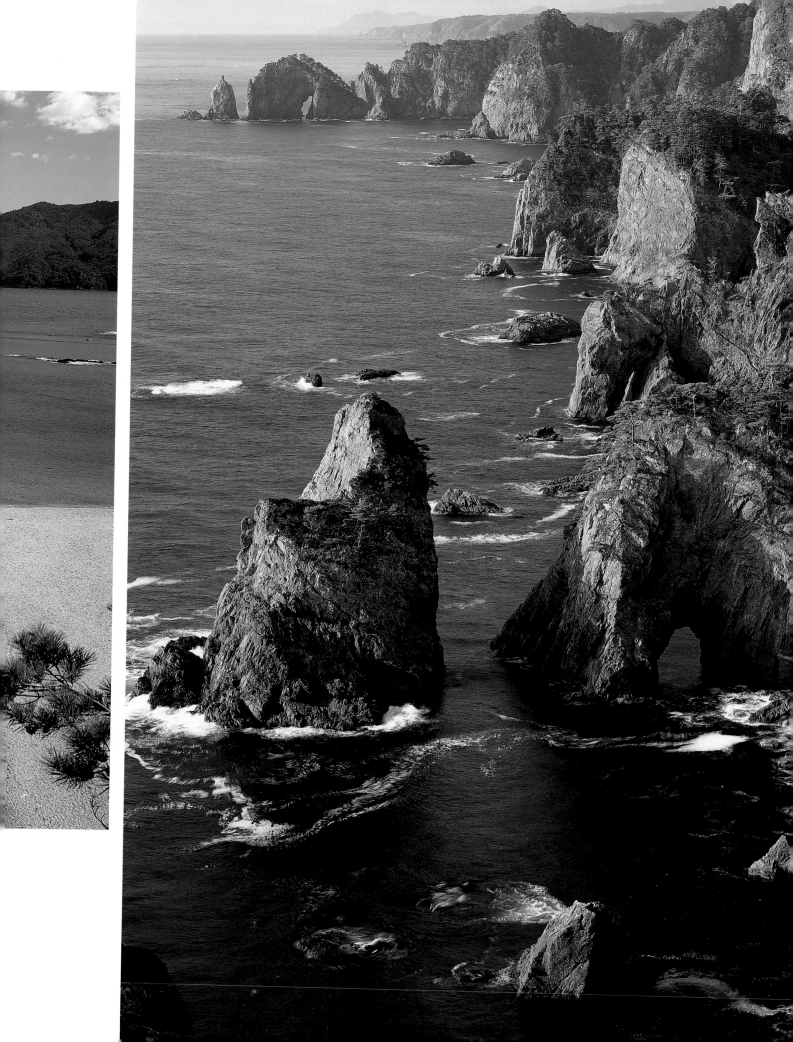

KYUSHU AND OKINAWA
Japan's Southern Gateways

Travelers crossing the Kammon Bridge out-
side the city of Shimonoseki, soon begin to
notice a change in their surroundings. The colors
are stronger, the air milder; life proceeds at a
more leisurely pace. In this dreamlike landscape
elegantly curved fishing boats lie moored in
small ports hidden behind protective walls. Here
seaweed is cultivated on bamboo rafts, and canal
systems irrigate broad plains of rice fields. Volca-
noes, hot springs and wild mountain streams
abound. Traditional two-storied houses are cov-
ered with glazed roof tiles, whose green, blue and
gray colors glisten in the sunlight.

For centuries Kyushu, the Japanese archipel-
ago's third-largest island, was the point of inter-
section between Japan and the rest of the world.
Here pottery, weaving, sculpting and tea cultiva-
tion were brought to Japan by Chinese and Kore-
an immigrants. Here Chinese script and Bud-
dhism arrived via the Korean peninsula. In 1549
the Spanish missionary Franz Xavier landed in
Kagoshima and established the first Christian
congregation. When Japan isolated itself hermet-
ically from the rest of the world for approximate-
ly 250 years, only one small window to the out-
side was left open: Dejima, the manmade island
off the city of Nagasaki. Here, under strict con-
trols, the Dutch East India Company was allowed
to conduct trade.

Approximately 500 kilometers farther south
lies a subtropical paradise—a chain of more than
70 bigger and smaller islands set in an azure-blue
Pacific. In Japanese, these are called Nansei-
shoto, or the "Southwestern Archipelago," of
which the main island is Okinawa. Coral reefs,
beautiful beaches, pineapple plantations: here
life means not rush and stress but a long, hot day.

A perfect beach on the island of Miyako, south of
Okinawa. The island itself is covered in sugar-cane fields.

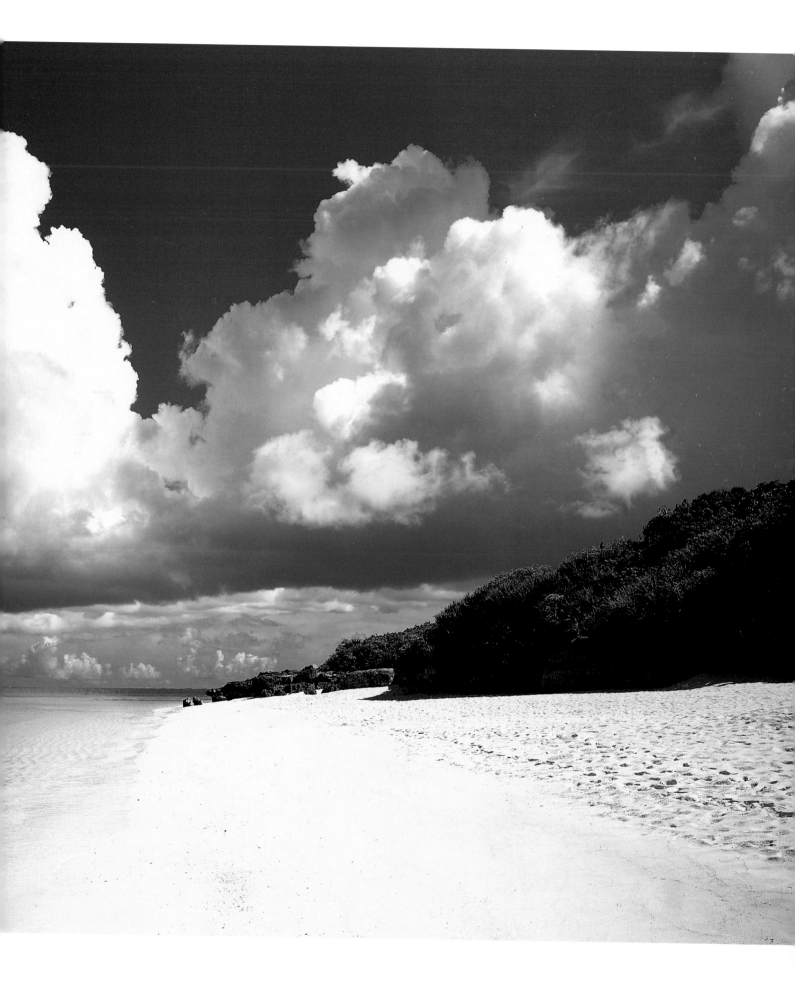

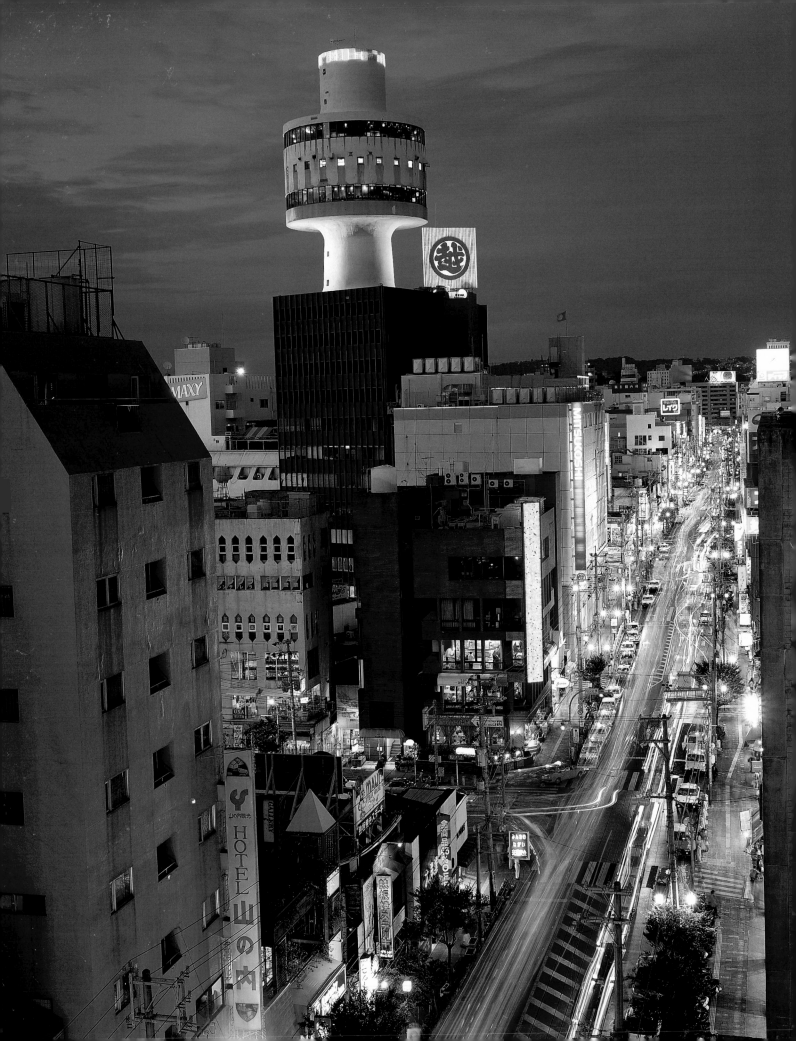

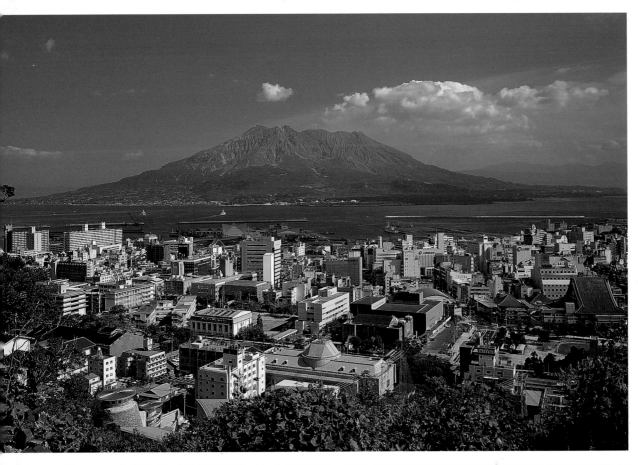

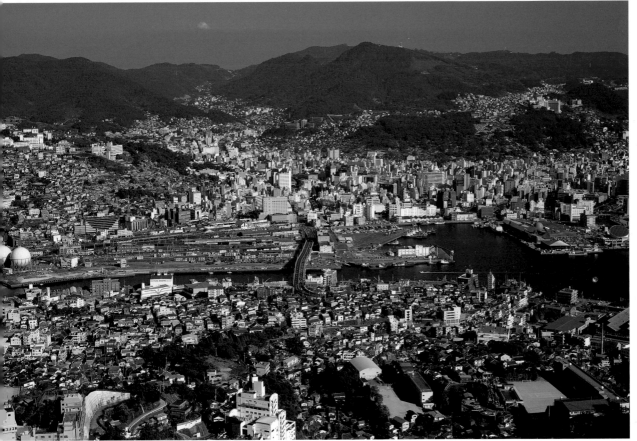

Opposite: With its department stores, restaurants and shops, Kokusai-o-dori is the most important street in Naha. During the Second World War, this metropolitan center of Okinawa was completely destroyed. Afterwards, it was rebuilt as a modern city.

Above: Living under a volcano: Kagoshima is located in the southern part of the island of Kyushu. The active volcano Sakurajima overlooks the city.

Left: Nagasaki is considered to be one of the most scenic cities in Japan. Here, on the 9th of August 1945, the second American atomic bomb was dropped (the first fell on Hiroshima).

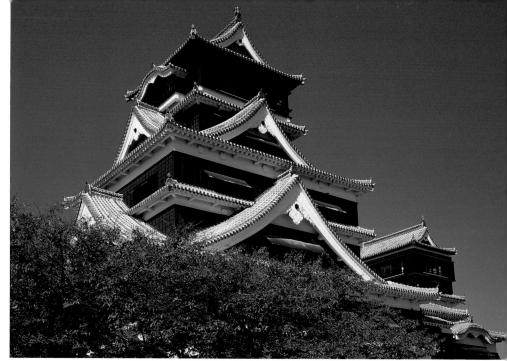

Right: Kumamoto Castle's huge main tower was reconstructed in 1960.

Below: Clouds of smoke rising from the 1,157-meter-high Aso Mountain proves that the volcano remains active. When it quiets down, visitors are allowed up to the crater's edge.

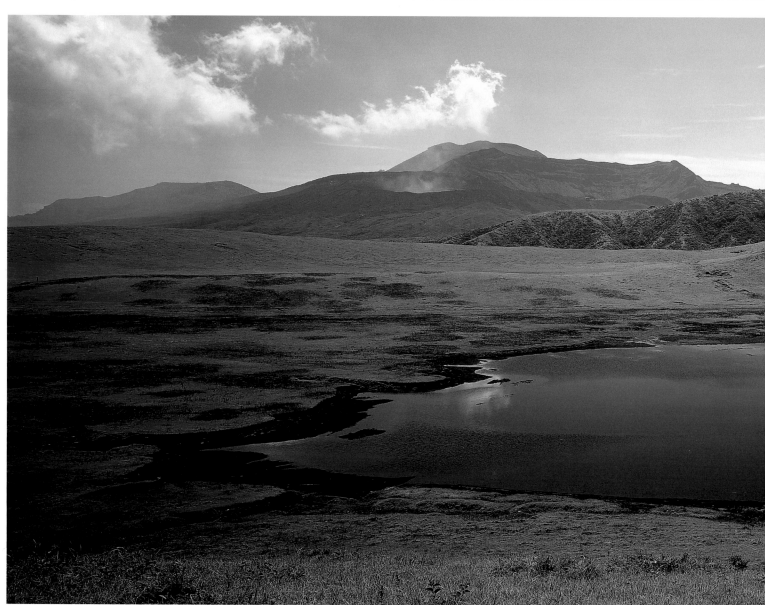

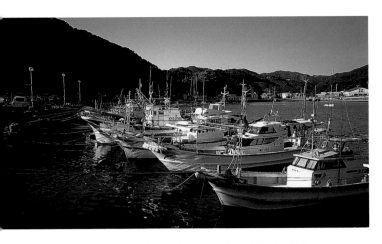

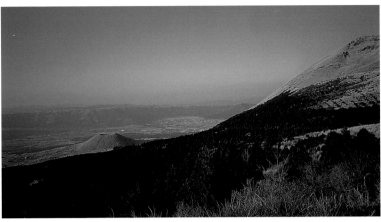

ove: Fishing boats in the port of Sakitsu in the Amakusa Islands off the west coast Kyushu. This group of islands is notorious for an uprising by Japanese Christians in 3 during which almost 37,000 were killed.

Above: 23 kilometers long and 16 kilometers wide, the crater of Aso Mountain is one of the largest in the world.

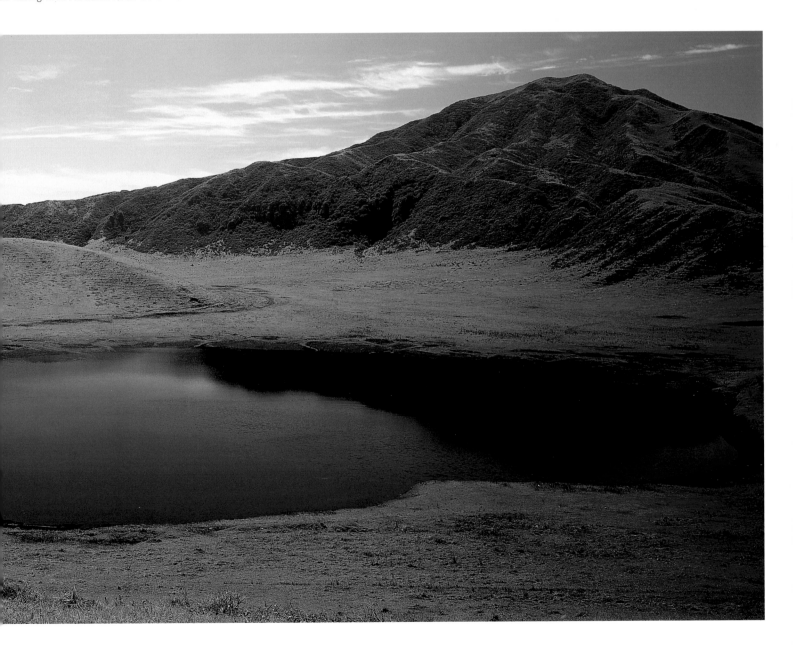

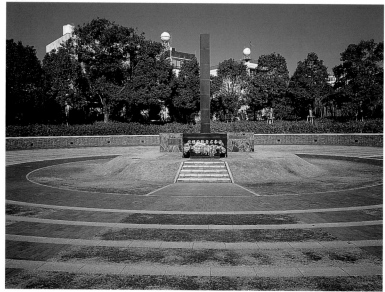

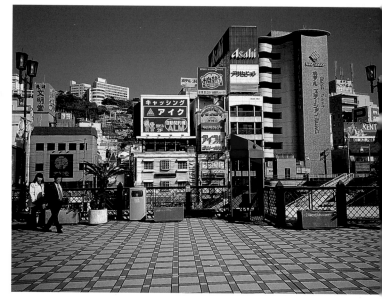

Top: A group of tourists is photographed before the colossal statue of Kitamura Seibo in Nagasaki's Peace Park.

Above: Martyrs' Memorial in Nagasaki's Nishizaka Park. On this hill in 1597, six missionaries and 20 Japanese Christians were crucified.

Opposite, top: The old villa of a British merchant named Glover is located on "foreigners' slope" in Nagasaki. Held to be the scene of Puccini's opera "Madame Butterfly," the villa is now an expensive tourist site.

Top: A dark marble pillar marks the epicenter of the atom-bomb strike on Nagasaki on August 9th, 1945.

Above: The sea of houses around the train station of Nagasaki, the capital of the prefecture of the same name. From the 17th to the 19th century, Nagasaki was the only Japanese port open to European ships.

Opposite, bottom: Beppu is an El Dorado for those who love hot baths. The bathing resort boasts more than 3,000 hot springs, whose steam vapors define the area.

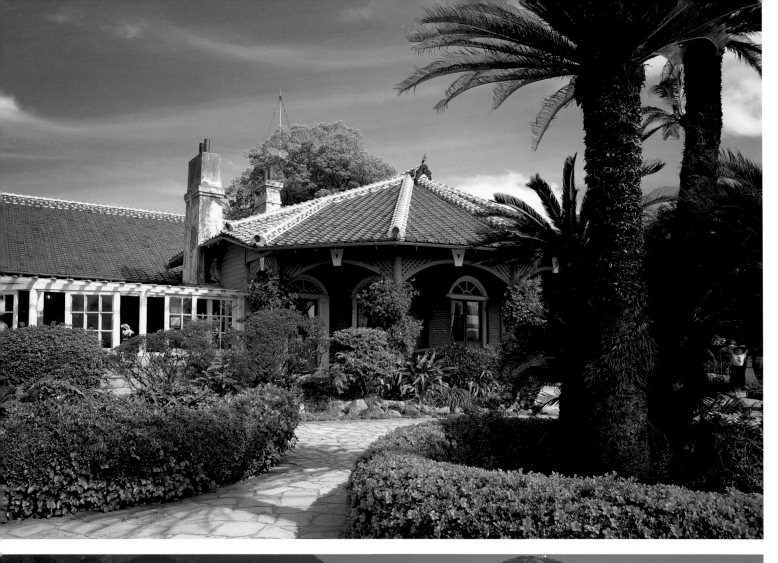

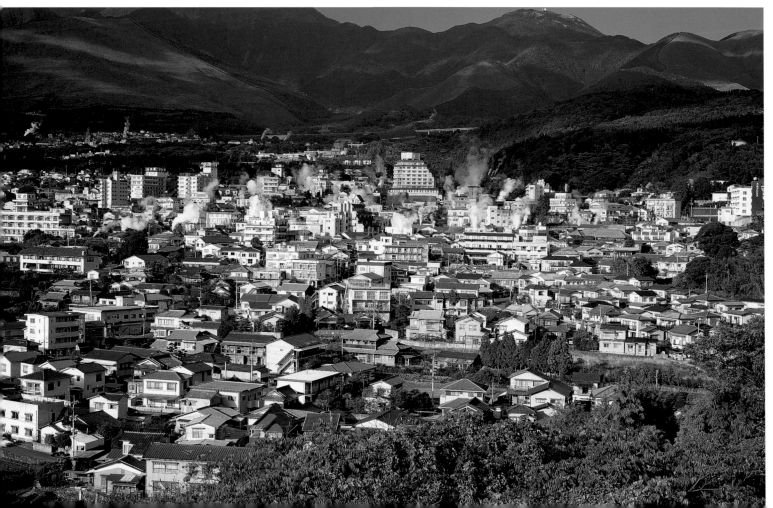

ONSEN
Japan: The Hot Spring Paradise

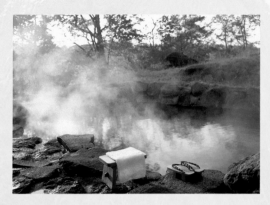

Sukayu is a small resort town in the Hakkoda mountains of northern Honshu whose greatest treasure is its sulfurous hot spring. Among its most important sights is a many-angled wooden building called *senrinburo*, the "bath of a thousand people." Sukayu is a typical Japanese *onsen*, a name that is given to all bathing resorts with hot springs, whether they are made up of one or hundreds of guest- and bathhouses. They are places of relaxation, of health, of affordable happiness. To enter the senrinburo, one pays the equivalent of two euros. A cotton towel and a toothbrush are included in the price. Two entrances lead to the baths, one marked on a web of cloth with the Japanese character for "women" and the other with the character for "men." Behind the entrances, the sexes meet again. The establishment is larger than a dance hall and contains different-sized wooden pools with water temperatures ranging from hot to boiling. Synthetic mats of a poisonous green color cover the ground. Water faucets protrude from one of the walls; large plastic bottles containing liquid soap and shampoo are deposited on a nearby rack. The guests squat on a footstool before the faucets and mix hot and cold water in a plastic bowl, then wash themselves from head to toe using the towel as a washcloth. Finally, they lower themselves carefully into one of the pools. Ahhh! Black heads protrude above the water vapors like

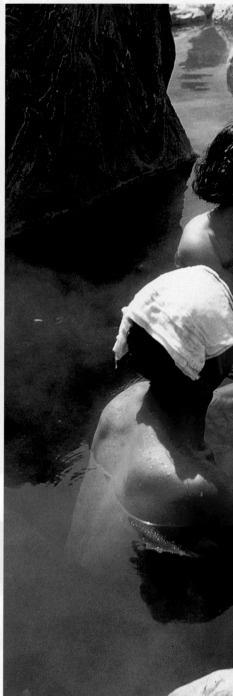

bodiless spirits. When the bathers climb out of the pools, they cover their private parts with a towel—an unnecessary precaution, since water temperatures of more than 40 degrees Celsius banish all thoughts of sex.

Japan is a country with few mineral resources. The only raw material it possesses in abundance is water. The nation has around 20,000 hot springs, of which more than 2,000 are believed to have therapeutic effects. The radioactive copper-, iron- or sulfur-filled waters reach temperatures of up to 130 degrees Celsius. Depending on their composition, they are used to combat arthritis and rheumatism, acne and skin diseases, stomach pain, and high and low blood pressure. According to the Japanese, hot springs can cure everything except a broken heart.

Cleanliness for Body and Soul

In Japan cleanliness always has something of a ritual character to it. Before entering a Shinto shrine, worshipers wash out their mouth and rinse off their hands at a water basin, thus cleansing not only their body but also their soul. The patron saint of bathhouses is the Empress

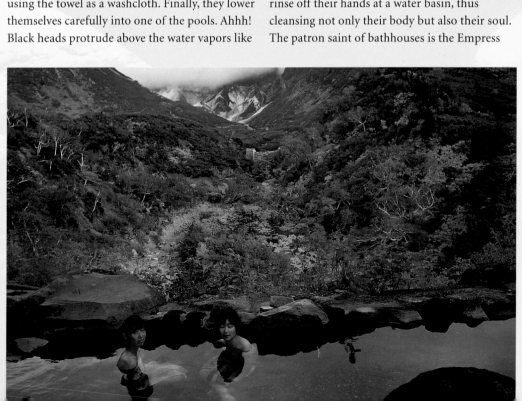

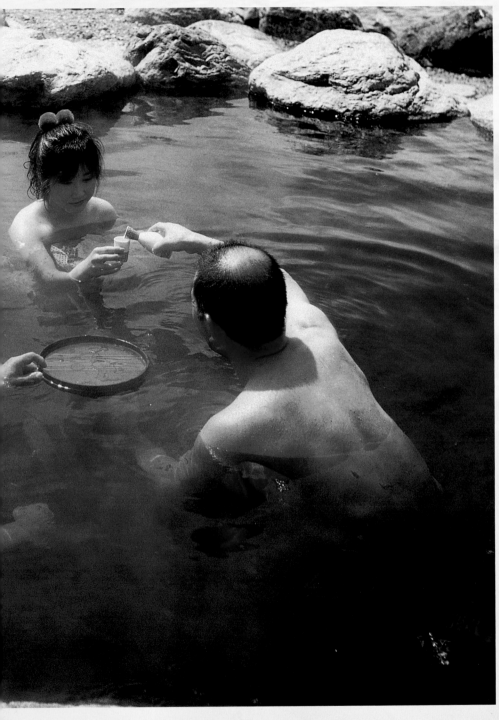

Komyo, who set up Japan's first public bath in the ninth century. Until then, only noblemen and samurai had the right to own a bath in their house. Eventually a law was passed stating that every block of houses had to have its own public bathhouse. In this way the government ensured not only that its subjects were clean but that enough water was on hand in case of fire.

Today visiting an onsen is one of the Japanese's favorite recreational activities. Company outings usually take place at an onsen; businesspeople host their important customers there. City residents travel to the countryside to experience the magic of timelessness at a hot bath. Farmers recover there from their hard work. Onsen come in all sizes and shapes: old-fashioned wooden houses, functional concrete lodges or luxurious waterscapes with grottos, palms, water slides, saunas and solariums.

The highest form of onsen is the rotenburo, the hot bath in the open air. These can be found beside streams, in the mountains or directly by the sea. Especially on a cold winter night, the bath at a rotenburo is an unforgettable experience. Ice and snow cover evergreen trees and cliffs. Thick snowflakes fall, lit by the light from a single lantern. One lies up to one's neck in hot water, cozy and warm, as close as it is possible to be to a Japanese paradise.

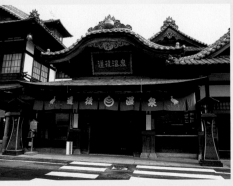

Opposite, top: Hot water, white steam: *rotenburo* in beautiful Akita Prefecture. **Opposite, bottom left:** Private lodges for viewing autumn colors: *rotenburo* on the island of Hokkaido. Only bathing under the stars is more romantic. **Opposite, bottom right:** At a Japanese bathhouse, the water is drained out and the wooden basins are cleaned daily. **Above:** The bathing resort

Kusatsu on the island of Honshu. The originator of the Japanese bath culture was actually a German doctor: Erwin von Bälz, who came to Japan in 1876. **Left:** Traditional bathhouse in Ehime Prefecture on the island of Shikoku. Japanese bathhouses are social institutions where people meet, discuss politics and forget their work burdens.

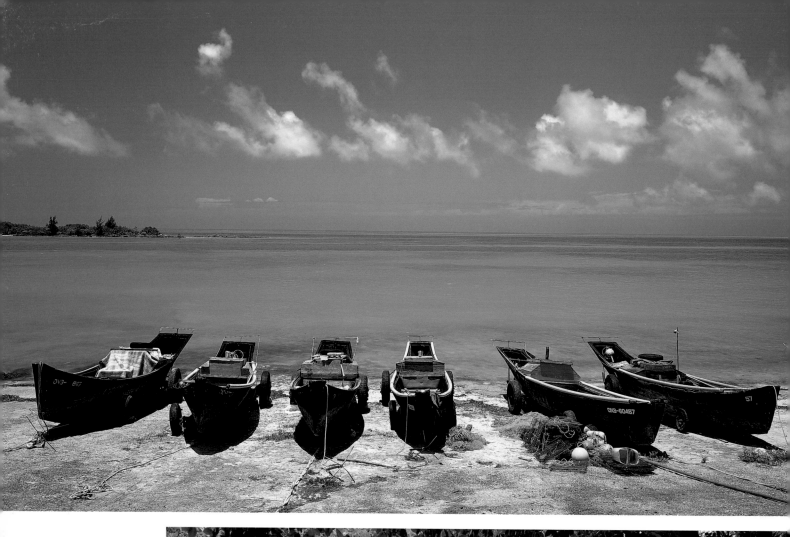

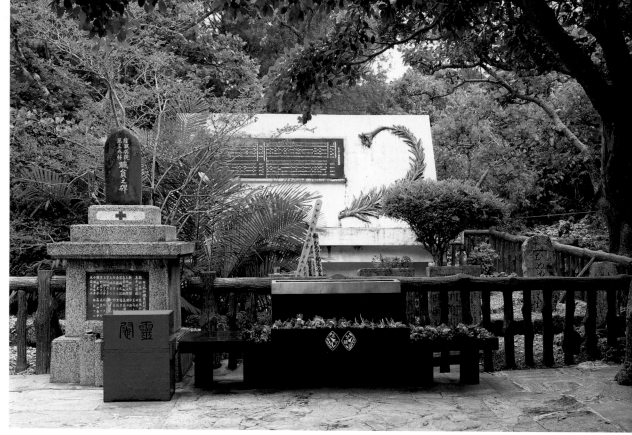

Above: Fishing boats on a beach on Miyako Island. The island has an unusual memorial donated by German emperor Wilhelm I to mark the rescue of shipwrecked German sailors in 1873.
Right: War memorial to the dead of Okinawa. During the bloody battles at the end of the Second World War, more than 237,000 civilians and soldiers lost their lives.

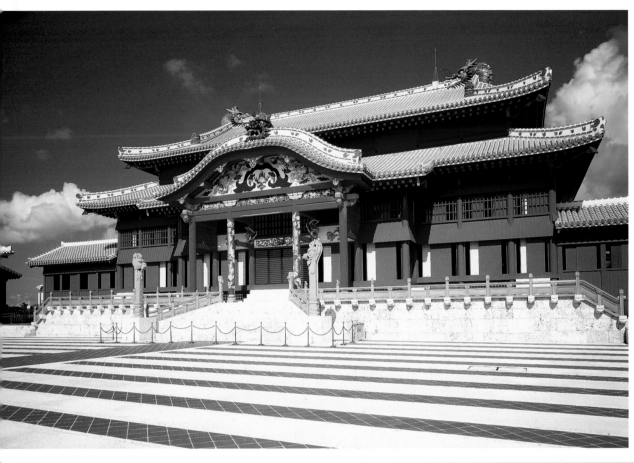

Left: The Shurijo Castle in Naha is a reminder that Okinawa was once an independent kingdom.
Below: A beach on the island of Ikema, one of the Miyako Islands between Okinawa and Taiwan.

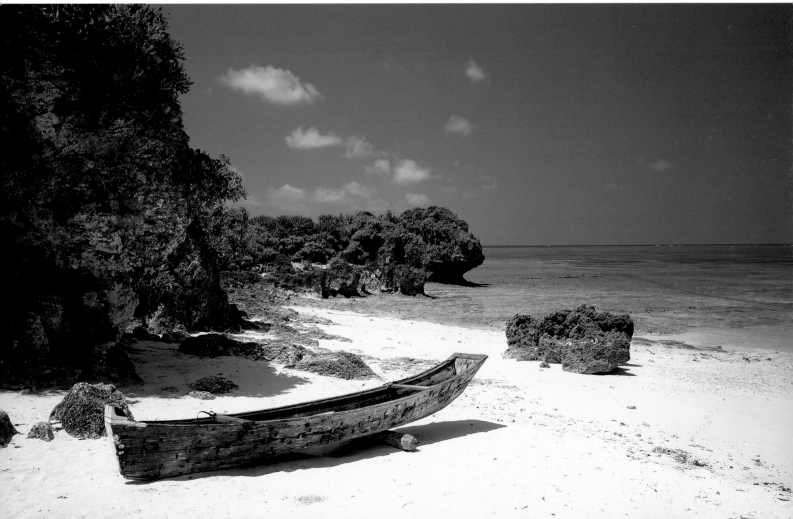

INDEX

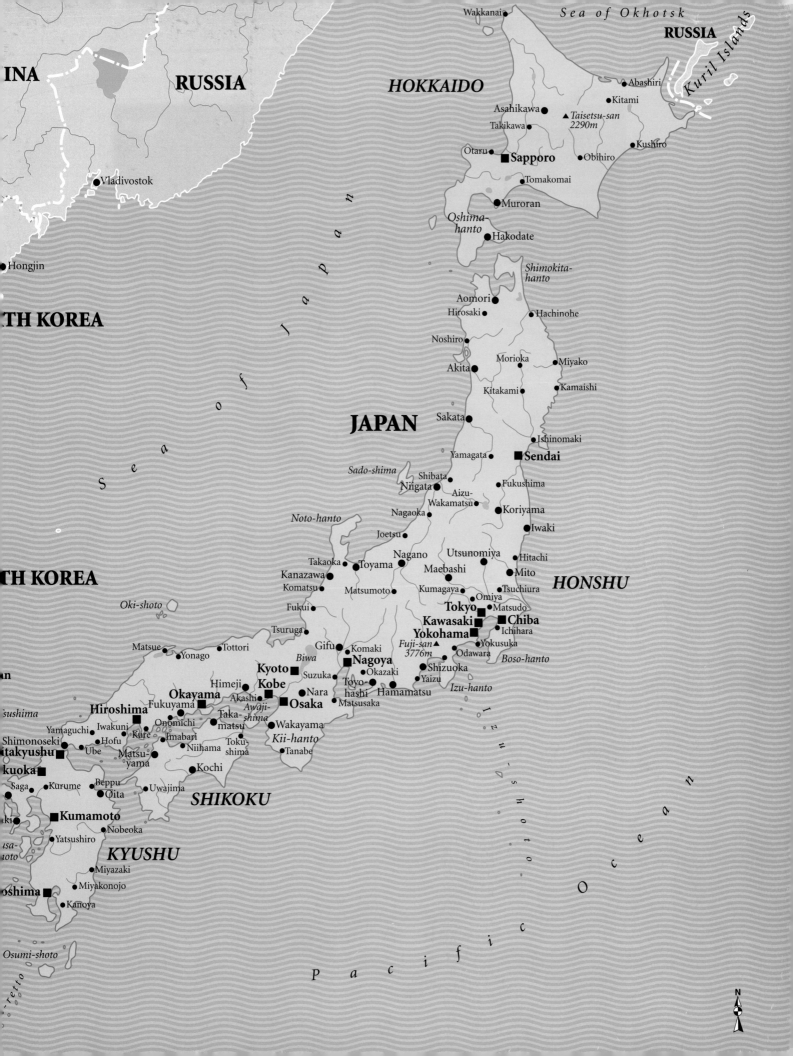

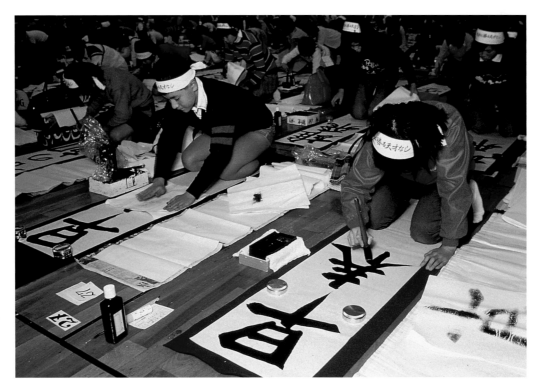

During the twelve years of school, Japanese pupils are taught approximately 1,850 characters. It is estimated, however, that the language actually has about 10,000 different characters.

Published by Tuttle Publishing, an imprint of Periplus Editions, with editorial offices at 153 Milk Street, Boston, MA 02109 and 130 Joo Seng Road, #06-01/03, Singapore 368357

ISBN 0-8048-3639-6

Distributed by:

North America, Latin America & Europe
Tuttle Publishing
364 Innovation Drive
North Clarendon, VT 05759-9436
Tel: (802) 773 8930 Fax: (802) 773 6993
Email: info@tuttlepublishing.com
www.tuttlepublishing.com

Japan
Tuttle Publishing
Yaekari Building, 3rd Floor
5-4-12 Osaki, Shinagawa-ku
Tokyo 141-0032
Tel: (03) 5437 0171 Fax: (03) 5437 0755
Email: tuttle-sales@gol.com

Asia Pacific
Berkeley Books Pte. Ltd.
130 Joo Seng Road, #06-01/03
Singapore 368357
Tel: (65) 6280 1330 Fax: (65) 6280 6290
Email: inquiries@periplus.com.sg
www.periplus.com

Design
hoyerdesign grafik gmbh, Freiburg

Map
Fischer Kartografie, Fürstenfeldbruck

Reproductions: Artilitho, Trento, Italien
Printed by Konkordia Druck GmbH, Bühl
Manufacted by: Josef Spinner
Großbuchbinderei GmbH, Ottersweier
© 2002 Verlagshaus Würzburg GmbH & Co. KG
© Photographs: Keystone/Keyphotos Japan
 und Hans H. Krüger

Photo credits
All pictures are by Keystone/Keyphotos Japan with the exception of the following photographs by Hans H. Krüger:
Pages 26/27, 29 (3 images), 40/41 except for 40 middle (4 images), 42/43 (4 images), 62/63 middle, 73 right, 79 above right and below right (2 images), 88/89 above left and middle (2 images), 91 below right, 97 below, 98/99 (4 images), 100 except for middle left (5 images), 106/107 (6 images), 115 little pictures above (2 images), and 116 (4 images).

09 08 07 06 05
5 4 3 2 1

Printed in Singapore